The Arts in Canada

A STOCK-TAKING AT MID-CENTURY

The Macmillan Company of Canada Limited 1958

EDITED BY MALCOLM ROSS

The Arts in Canada

PAINTING SCULPTURE

MUSIC BALLET OPERA

THEATRE IN ENGLISH-SPEAKING CANADA

LE THÉÂTRE AU CANADA-FRANÇAIS

POETRY THE NOVEL CREATIVE SCHOLARSHIP

FILM RADIO AND TELEVISION

TRADITION ET ÉVOLUTION AU CANADA FRANÇAIS

ARCHITECTURE AND TOWN PLANNING

INDUSTRIAL DESIGN HANDICRAFTS

Acknowledgement

The publishers thank the Canadian Conference of the Arts, formerly the Canadian Arts Council, for initiating and developing the idea of this book and for sponsoring its publication.

TO BERTRAM BROOKER

COPYRIGHT, CANADA, 1958
BY THE MACMILLAN COMANY OF CANADA LIMITED

PRINTED IN CANADA

Foreword BY HIS EXCELLENCY THE RIGHT HON. VINCENT MASSEY, C.H. GOVERNOR GENERAL OF CANADA

This is clearly a good moment for the appearance of a book on the state of the arts in Canada. The years since the Second World War have seen a striking growth of creative activity in this country. The arts already well established, such as painting and poetry, have acquired new dimensions and have developed in a way possible only when a tradition exists deep enough and lively enough to entertain innovation. In other arts, younger in Canada, such as ballet and the film, one notes an eager concern for contemporary modes of expression and, at the same time, a responsible effort to put down roots in new but hospitable soil.

This book, as the editor suggests, is not a 'puff' but an appraisal of the present state of the arts in Canada. It is gratifying to realize that our critics can now afford to be critical — a sign that the growth in this field is sound and sturdy.

Government House
Ottawa

July, 1958

Contents

FOREWORD: The Right Hon. Vincent Massey, C.H. V

INTRODUCTION: Malcolm Ross 2

PAINTING: Robert Ayre 9

SCULPTURE: William S. A. Dale 34

MUSIC: John Beckwith 44

BALLET: Ken Johnstone 54

OPERA: Boyd Neel 62

THEATRE IN ENGLISH-SPEAKING CANADA: Mavor Moore 68

LE THÉÂTRE AU CANADA-FRANÇAIS: Jean Béraud 78

POETRY: Northrop Frye 84

THE NOVEL: C. T. Bissell 92

CREATIVE SCHOLARSHIP: F. E. L. Priestley 98

FILM: Guy Glover 104

RADIO AND TELEVISION: Mavor Moore 116

TRADITION ET ÉVOLUTION AU CANADA FRANÇAIS: Guy Sylvestre 126

ARCHITECTURE AND TOWN PLANNING: Warnett Kennedy 134

INDUSTRIAL DESIGN: Warnett Kennedy 150

HANDICRAFTS: A. T. Galt Durnford 156

TRANSLATIONS: Glen Shortliffe

Theatre in French Canada (Béraud) 160

Tradition and Change in French Canada (Sylvestre) 163

NOTES ON CONTRIBUTORS 170

PICTURE CREDITS 172

INDEX 173

Illustrations

PAINTING

ROLOFF BENY Prairie Lights 10

GHITTA CAISERMAN Concert 11

BRUNO BOBAK The Big Dipper 12

TOM HODGSON March Pond 13

B. C. BINNING Ships in Classical Calm 14

JACK SHADBOLT Medieval Town 15

MOLLY LAMB BOBAK S. S. Beaumont 16

PAUL V. BEAULIEU L'Oiseleur 16

JEAN-PAUL RIOPELLE Chevreuse 17

HAROLD TOWN Deadboat Pond No. 2 18

SIDNEY WATSON East-Coast Design 19

GOODRIDGE ROBERTS Pine Trees by the Sea 19

PAUL-ÉMILE BORDUAS Épanouissement 20

R. YORK WILSON Mural 20

JACQUES DE TONNANCOUR The Clearing 21

JACK HUMPHREY Black Sky 21

FRITZ BRANDTNER City from a Night Train 22

JOCK MACDONALD The Iridescent Monarch 23

ALFRED PELLAN Jardin Mauve 24

ALEX COLVILLE Two Pacers 24

GERALD TROTTIER Medieval Images 25

KENNETH LOCHHEAD The Dignitary 25

KAZUO NAKAMURA Landscape 25

CHARLES COMFORT Timeless Fable 26

GORDON A. SMITH Pruned Trees 26

JEAN-PAUL LEMIEUX Le Visiteur du Soir 26

JACK NICHOLS Mess Deck 27

Illustrations

PAINTING continued

LEON BELLEFLEUR Aigle-Feu 27

LAWREN HARRIS SR. Abstraction 28

ANDRÉ BIÉLER Nathalie 29

JEAN DALLAIRE Sodome 30

JOSEPH PLASKETT Le Peintre émerveillé devant le Monde 30

HENRI MASSON Joys of Summer 31

MARIAN SCOTT Field 31

DONALD JARVIS A Section of the Populace 32

SCULPTURE

LOUIS ARCHAMBAULT Night and Day 34

ELFORD COX Face of the Moon 34

JOHNNY INNUKPUK Woman Holding a Fish 34

ANNE KAHANE Unknown Political Prisoner 34

SYLVIA DAOUST Madone 35

LOUIS ARCHAMBAULT L'Oiseau de fer 36

LOUIS ARCHAMBAULT Wall, Canadian Pavilion, Brussels 37

FRANCES LORING Lion, Queen Elizabeth Way 38

ELFORD COX Ground hog 39

FLORENCE WYLE Summer 39

ARTHUR PRICE Blackboard 40

ANNE KAHANE Air Show 40

BALLET

SWAN LAKE (National Ballet) 54

INTERMEDE (Royal Winnipeg Ballet) 56-7

THE FISHERMAN AND HIS SOUL (National Ballet) 58

DARK OF THE MOON (National Ballet) 59

ROUNDELAY (Royal Winnipeg Ballet) 59

OPERA

DON GIOVANNI (Vancouver Festival) 62

THE CONSUL (Opera Festival Association of Toronto) 63

SCHOOL FOR FATHERS (Opera Festival Association of Toronto) 64

THE ABDUCTION FROM THE SERAGLIO (Opera Festival Association of Toronto) 65

TOSCA (Opera Festival Association of Toronto) 66

THE TURN OF THE SCREW (CBC) 66

THEATRE IN ENGLISH-SPEAKING CANADA

GRANT MACDONALD: Gratien Gélinas as King Charles VI (Stratford Festival) 69

HUNTING STUART by Robertson Davies (Crest Theatre) 71

THE WORLD OF THE WONDERFUL DARK by Lister Sinclair (Vancouver Festival) 73

HAMLET (Stratford Festival) 73

MUCH ADO ABOUT NOTHING (Stratford Festival) 74

A NEW CANADIAN FLAG by Gordon Webber 75

LE THÉÂTRE AU CANADA FRANÇAIS

GRATIEN GÉLINAS as Fridolin 78

FONTAINE DE PARIS by Éloi de Grandmont (Théâtre du Nouveau Monde) 80

TIT-COQ 81

Illustrations

FILM

BLINKITY BLANK (N.F.B. - Norman McLaren) 105

THE LOON'S NECKLACE (F. R. Crawley) 106

NEWFOUNDLAND SCENE (F. R. Crawley) 109

THE SEASONS (Christopher Chapman) 110

THE STRATFORD ADVENTURE (N. F. B. - Morten Parker) 111

THE ROMANCE OF TRANSPORTATION (N.F.B. - Colin Low) 112

CITY OF GOLD (N.F.B. - Colin Low and Wolf Koenig) 113

RADIO AND TELEVISION

CLOSE-UP (CBC) 117

PEER GYNT (CBC Folio) 118

THE PLOUFFE FAMILY (CBC) 120

THE POUNDING HEART (CBC) 122-3

GATEWAYS TO SCIENCE (CBC) 124

ARCHITECTURE AND TOWN PLANNING

UNIVERSITY OF MANITOBA — Entrance to Library 135

HEADQUARTERS OF B.C. ELECTRIC CO., Vancouver 137

R. LAIDLAW LUMBER CO., Weston, Ontario 138

ST. ANTHONY'S CATHOLIC CHURCH, West Vancouver 139

YORKMINSTER UNITED CHURCH, Toronto 139

PORTER RESIDENCE, West Vancouver 139

JOHN C. PARKIN RESIDENCE, Don Mills, Ontario 139

ORTHO PHARMACEUTICAL BUILDING, Toronto 140

THE CANADIAN PAVILION at Brussels 140

ALEXANDER GRAHAM BELL MUSEUM, Baddeck, Nova Scotia 141

CONVENIENCE AND SHOPPING CENTRE, Don Mills, Ontario 142

PARK PLAZA HOTEL EXTENSION, Toronto 142

AIR TERMINAL BUILDING, Calgary 143

ANNACIS ISLAND INDUSTRIAL ESTATE, British Columbia 144-5

KITIMAT, British Columbia 146

THE NATIONAL CAPITAL PLAN 147

INDUSTRIAL DESIGN

SKI POLE GRIPS 151

WALL COAT RACK 151

CANADIAN OUTDOOR KNIFE 151

DINING-CHAIR 152

PHONOGRAPH RECORD STORAGE RACK 152

HANDICRAFTS

ENAMEL ON COPPER (Françoise Desrocher Drolet) 156

VASE AND BOWL (Rose Truchnovsky) 156

GROUP OF POTTERY exhibited in Montreal in 1950 157

TYPICAL JUNIPER ROOT CARVING (W. G. Hodgson) 159

MALCOLM ROSS

Editor's Introduction

EVERY BOOK has an aim—or should have. A book on the arts in Canada might aim at selling the wares of Canadian painters, sculptors, composers, architects. It might aim at convincing the sceptic (at home and abroad) that we have at last come of age, that this 'Child of Nations, giant-limbed' has grown in wisdom as well as in stature. Such a book as ours might even aim at discovering if there is such a thing as a Canadian—if there are indeed Canadian arts, not just arts in Canada.

The reader has a right to know what to expect in a book. This book was not conceived as an exercise in sales promotion, in self-congratulation, in patriotic self-consciousness. It is, rather, a stock-taking at mid-century. (To be sure, this is a propitious moment for such a stock-taking. For Canadians are sufficiently concerned with the state of the arts to have called forth the Canada Council—a fact which surely does suggest a coming of age and at least the beginnings of wisdom.)

The aim of this book will be evident enough in an excerpt from a letter sent by the editor to each of the contributors at the start of their labours. The letter reflects an agreement as to the nature and purpose of the book reached in conferences between the editor and the editorial committee appointed by the Canadian Arts Council:

'It was agreed that the book should be independent in spirit—not a puff in any sense. . . . However, we are anxious to produce a positive book. While we do not wish to conceal shortcomings and false directions wherever they may be found, we are concerned with the emergence of promising elements in our culture, and we hope that the book can have some influence in carrying us forward. It was further agreed that we should avoid, as far as possible, the simple historical survey and the mere parade of names and facts. We should instead try to discover new patterns. It was agreed that 1945 be taken as the point of departure and that, while our contributors might wish, for the sake of contrast, to refer to earlier work, the main emphasis should be on developments since World War II.'

Such was the editorial directive to our writers. The approach was to be 'independent' yet 'positive'. Is there a contradiction here? Surely not. The book was conceived in the spirit of enquiry but also in the faith that such a critical enquiry as this would show forth the 'promising elements', the significant new patterns while, inevitably, exposing the false starts, the sterile gestures, the traces of pretentiousness and servility. This book, then, was begun with some confidence—not unmixed with nervousness. For each critic was given his head. He was asked to *look* for promising elements, new directions. One could not be entirely sure that he would find them. . . .

Remember, too, that our writers were not chosen for their adherence to a single point of view. Compare William Dale's estimate of Eskimo sculpture with that of Galt Durnford. Northrop Frye, Mavor Moore, C. T. Bissell and the others scarcely constitute a 'school' of criticism. We did not aim at any simple consistency of critical bias or method. Our writers were chosen for their authority and their integrity and for nothing else—or less. A virtuous editorial principle, you will allow—but one not without its hazards. For if the unity of the book could not be assured by the predestinating bias of our writers, neither could it be assured by the nature and character of their subject matter. For example, one would not expect the critic of opera in Canada to approach his task from quite the same altitude as the critic of more sturdily rooted arts like painting and poetry. Robert Ayre and Northrop Frye can unhesitatingly apply 'world standards' to the work of men like Pellan, Borduas, Klein and Pratt. But critics of our opera, our film, our ballet must be concerned with beginnings, with barely emergent directions. They are concerned, therefore, not only with the appraisal of such

achievement as they can locate (and in some instances the achievement is considerable) but also with the conditions (technical, social, economic, geographical) which affect and, to a degree, determine the progress of certain of the arts in this country.

Mavor Moore's essay on the new catch-all medium of the arts—television—is, quite appropriately, a sociological analysis of the criss-cross of political, cultural, racial and regional impulses from which there begins to emerge at least the possibility of a creative expression uniquely our own. Guy Glover, in his study of Canadian film, cannot ignore the devouring demands put upon his medium by the Moloch of television. Nor can film-making in this country be examined without some account of the omnipotence and omnipresence of the sponsor. 'Few Canadian film producers have been able to transcend the demands of their production schedule in order to express themselves in film on subjects of personal and public importance unrelated to sponsor requirements. . . . As long as Canadian film-making tags along behind the sponsor and the audience it will be an art in servitude.'

Then, our music critic, John Beckwith, must perforce deal not only with the astonishing range and vitality of Canadian composition since 1945 but also with the equally astonishing dearth of performance for it. Ken Johnstone's story of ballet in Canada is the story of a battle against terrifying odds, a battle which could never be won at all without the kind of financial support given, in the very nick of time, by the Canada Council. (A battle worth winning, mind you. Surely Canadians have taken to ballet as happily as the Russians have taken to hockey.) At quite a different level, but again in terms which are necessarily extra-aesthetic, Jean Béraud assesses the stultifying effect of cultural isolation on the theatre of French Canada and the danger (as well as the advantage) to New France of the heritage of Old France.

Nowhere is the pressure of extra-aesthetic considerations upon the act of aesthetic judgment more nicely illustrated than in Warnett Kennedy's essay on architecture. For Mr Kennedy must take account of conflicting directions in modern architectural theory and then relate them to the facts of Canadian experience and practice, to our varying regional and social needs, to sentimental expectations and servile habits of mind. He must examine our architectural 'deposit'—what we have. And he feels constrained to plot a proper direction for us— to save us, if he can, from a permanent cacaphony of frozen music:

'What would be the Canadian ideal? . . . we would like to see whatever individuality we possess expressed in our architecture. Beyond this, and at the level where we share the same climatic, physical and social environment, we seek an authentic regional idiom. Yet again, in so far as we are part of the developing world consciousness, we shall expect to see international and universal ideas reflected in our architecture.'

Mr Kennedy, therefore, with this complex socio-aesthetic ideal in mind scrutinizes church, factory, office-block and shopping centre from Halifax to Vancouver.

Each of our critics has a different task. And (to repeat) each has been given his head. There has been no editing of opinion and, of course, each man stands by the evidence he submits in support of his judgments. He was, you will recall, given one negative directive. No cataloguing! The book was to be representative rather than comprehensive. Therefore our writers (on the advice of the editor) have not attempted to name all the names. We have not been able to include comment on every phase of artistic activity in Canada (the amateur theatre, for example. Interior design. Landscape architecture. And art education—an exciting phenomenon in this country just now). Inevitably, too, the hunt for new patterns has resulted in an emphasis (some might say an over-emphasis) on the latest. Admittedly, the latest is not always the best, and it may be that there are painters and poets and composers not mentioned here whose work will outlast the latest. Thus our book has not even the safe unity of the roll-call of honour. Not to mention the catalogue.

And, of course, any book on a Canadian theme is confronted from the start by another and more radical problem in unity. Two languages. Two cultures. Ideally, of course, a book on the arts in Canada should be fully bilingual. As yet, the conditions of the book trade in this country prevent the realization of such an ideal. We have attempted a compromise. As we could not envisage separate essays for each of the arts in English and French Canada (not even for each of the literary arts) we advised our writers in music and the visual arts to deal with the total Canadian situation. It becomes clear that significant new patterns in the non-literary arts show no break at the Ottawa River. There is no difficulty in placing Pellan and Town and Shadbolt within the frame of a single essay. Obviously, however, the study of literature and the spoken theatre demands a respect for the fact of language. Therefore, in both languages, we have a chapter on the French-Canadian theatre and an-

other on the present state of the French-Canadian culture as a whole, with particular and extended reference to recent literature.

Paradoxically enough, it may well be that the key to the pattern of this book—and therefore of the lavish if uneven artistic activity in Canada which this book reflects—is to be found in the very area where one might have expected to find only division and discord. This is a 'picture book' as well as a book of criticism. Look at the pictures. Look at the painting, the buildings, the ceramics. Is there anything to mark *this* as English, *that* as French? To mark them off, that is—to put them apart, hold them apart? The raid on the abstract (in music on the atonal) is mustered in Toronto as well as Montreal, Vancouver as well as Quebec City. So much is clear at a glance. But what of literature? The word is less easily free of the husk and habit of the idea. What, then, of writing in French Canada? Is it a thing apart, proper to a culture separate from the culture of the English Canadian? Guy Sylvestre has this to say about the tone and tempo of recent French-Canadian literature. 'The dominant feature of both poetry and the novel . . . is the testimony of a terrible spiritual solitude, a tragic search for joy and love in a world that has lost all feeling for either one. . . . Nowhere in English-Canadian writing, except perhaps in a few of the poets, do I find so urgent a spiritual quest or so tragic a picture of life.'

Sylvestre observes that his poets and novelists (his painters and sculptors, too) have 'turned their backs on romantic clichés'. They have questioned and discarded the traditional myths. Of a sudden the dark places are explored, the social order is at last subjected to satire, the self undergoes the severest scrutiny. Surprising new forms emerge, new bottles for these new wines. In all the arts a strange and novel idiom is uttered.

Both Jean Béraud and Guy Sylvestre testify to the ancient sense of pent-up solitude in their culture. Thus the leap into contemporaneity is compulsive and explosive, as if the bursting-point had just been touched. Certainly there are violences in the young Montreal painters seldom encountered in the work of the Toronto school. There is greater intensity and more experimentation in the French-Canadian novel than in our current fiction in English. But these are matters of degree—not of direction. And as one reads Guy Sylvestre and Northrop Frye and Robert Ayre and John Beckwith one cannot fail to see a common direction discernible in all the arts represented in this book. What is it? 'The international idiom'.—'The cosmopolitan note'.— 'The contemporary sense'. Such phrases at least

help to suggest the direction. Gone for instance, is The Maple Leaf School of Canadian poetry. Northrop Frye detects 'shadows of Frazer, Jung, Freud, Spengler and Toynbee lurking around the margins of our latest pages'. It is notable that Frye's essay on recent Canadian poetry is an essay on *modern* poetry, in the thematic, as well as the technical, sense of the word 'modern'. 'The modern poet,' Frye tells us, 'strives to break down the mutually aggressive barriers between the mind and the environment; he seeks some enveloping myth in which mind and nature become the same thing.' For better or for worse, this insight is as true for poetry in Canada as it is for poetry today in Britain or France or the United States. If no man is an island, no culture is an island in the day of Sputnik and the ICBM. But long before these dreadful signs of our littleness and our oneness had appeared in the heavens, the intermesh of the national cultures was far advanced. Communication does not always beget communion. But at least now, under the same dark sky, we can huddle together in a jiffy and, from Rome to New York, Toronto to Tokyo, trade our terrors and forge our hope. Let us not boggle over a phrase (and a fact) like 'the international idiom'. And let us not wonder that the Ottawa River seems to dry up and vanish before the very eyes of the poet and painter—if not, yet, of the politician . . .

I would not imply, of course, that all the elements of parochialism in our culture have been obliterated. Every once in a while an impatient literary critic will complain that we have no existentialists here, or that, alas, our young men are not angry enough. Such impatience is in itself a telling symptom (thirty years ago, even ten years ago we were much more inclined to like the woods the way they are—or were). Nowadays, despite gratifying successes at the International Festivals, despite Norman McLaren's highly original contributions to the art of the film (amounting to an extension of the possibilities of the medium), our film critic, Guy Glover, warning us against the 'cultural closed shop', urges a thoroughgoing cosmopolitanism. 'Out of the *exchange* and interpenetration of ideas in film new developments will come, and to the extent that Canada and Canadians take part in that kind of exchange, to that extent the Canadian film will develop.'

We are in a hurry—and all down the same street, although not all at quite the same pace. Remember, it is still *our* street, not a street in Soho or on the Left Bank. We have taken our bearings. We have the direction. Technically, intellectually, this is still largely a matter of *awareness*, of a new way

of looking for experience, searching *for* experience. Our culture cannot be expressed in terms of someone else's experience: If we have no existentialists, we had no Resistance movement. No angry young men? No brick universities. . . . Like other peoples, and whatever the direction, we must advance over our own cobblestones. The new awareness which seems to inform the vision and the touch of our latest poetry and painting is the awareness that goes with a search; it is an openness to experience perhaps yet distant, and to the great themes towards which time and the will of heaven may now be moving us.

In any event the cosmopolitan and contemporary note sounds in all these essays. John Beckwith, in considering recent musical writing, sees not only the indirect influence of composers like Stravinsky and Schoenberg but the direct and immediate influence of very new Canadians like Oskar Morawetz and Otto Joachim. In trying to account for the exciting renaissance in Canadian handicrafts, A. T. Galt Durnford stresses 'the pervasive power of contemporary design and the itch (seemingly an international itch!) to explore and expand all the media for formal expression of every kind.'

The painter, of course, is in the van. Robert Ayre quotes Joseph Plaskett on the revolution which has taken place—is still taking place—in Canadian painting: 'Many of us might still be hankering to paint the Canadian Shield if the war had not helped to put us more closely in touch with the contemporary thought of Europe.' In any event, Canadian painters like Pellan, Borduas and Riopelle have mastered the 'international idiom' sufficiently to invade Europe in confidence and with power.

Robert Ayre believes that we have taken instinctively to the abstract contemporary mode (non-figurative, non-representational, non-objective, what you will!). And he argues that 'Abstract painting in Canada reflects all the complexities of the world today, its shifting values and uncertainties . . . its delight in new freedoms and discoveries.' But, it might be asked, is there not a real and present danger in this exuberant escape from the Jack Pine? Are we not perhaps, being Europeanized, uprooted, drained of our identity, made as faceless as 1984? Our critic argues that the abstract movement in painting has Canadian roots that go back further than many people realize. ('The first Canadian abstract painter was Bertram Brooker. Thirty years ago this man of many talents was endeavouring to make music visible.') The roots, however tentative they may have seemed, have taken hold. No one can doubt the range and vitality and integrity of recent Canadian painting in the

contemporary mode. 'There is no going back.' Not all the way back—although, perhaps, 'the abstract and figurative modes will ultimately be fused.' Indeed, this process of 'fusion' is already well advanced.

Meanwhile, in all the arts, we seem to be engaged, simultaneously, in the twin acts of discovery and assimilation. Discovery is furthest advanced in painting, poetry, and music. But one also observes the thrust forward in our latest ballet choreography, to a degree in our sculpture, certainly in our architecture. And it is well to be reminded by F. E. L. Priestley that the cosmopolitan sense and the broader international commerce in ideas have been strengthened and enlarged by the work of our scholars and critics. (Think, for a moment, what young Canadian poets have learned from the critical essays of Northrop Frye.)

Of course, assimilation is just as necessary to our advance as discovery. Like other peoples everywhere we must advance over our own cobblestones. We have no desire to be 'Europeanized', made faceless. Perhaps we are tempted to cry 'Look homeward, angel!' Perhaps, some day, the cry will have meaning even for a Riopelle. But not yet, and let us not cry out too soon. Our work is not 'faceless'. If, for example, painting on both sides of the Ottawa takes the same contemporary direction, it does so at no expense to the individuality of artists like Pellan and Town. The personal vision takes charge of the 'international idiom'. There is no reason at all why the spectrum should shrink to grey, why, in the end, our varied culture should turn flat and single. We are learning a new idiom. We shall come to talk it with our own accent, our *several* accents.

In C. T. Bissell's essay on the novel we watch the progress of cultural phenomena wholly our own —the beginnings of cross-fertilization between the English and French traditions, the emergence in the work of writers like Adele Wiseman and John Marlyn of a new cosmopolitanism-in-little, neither French nor English, but 'new Canadian', and giving us a new dimension. In the theatre, as Mavor Moore points out, it is a sturdy native tradition which rises to the challenge of Guthrie's Stratford and promises now to speak to the world in an accent at once new and old.

We do not, we cannot desert ourselves. Perhaps these essays suggest that we have only now begun really to find ourselves.

At every stage in the preparation of this book I have had the advice and help of members of the editorial committee appointed by the Cana-

Malcolm
Ross

dian Conference of the Arts, formerly the Canadian Arts Council. Special mention must be made of one member, Miss Elizabeth Wyn Wood, whose zealous crusade for a new book on the arts in Canada brought the whole project into motion. I am particularly indebted, also, to Mr Arthur Gelber, Chairman of the Committee, Mr John Parkin, Past President of the Canadian Arts Council, and Mr Frank Upjohn of Macmillan of Canada. Never, I am sure, has an editor been given more assistance in his labours. Never has he been allowed more freedom of choice and decision.

This book is, in a sense, a successor of *The Yearbook of Canadian Arts*. The first Yearbook, edited by a committee of the Toronto Arts and Letters Club, was published in 1913. Subsequent volumes, edited by the late Bertram Brooker, were published by Macmillan in 1929 and 1936. It is no easy thing to come after Bertram Brooker, whose two volumes had a notable influence on the advance of the arts in Canada. However, in the belief that he would have been happy and gratified at the direction lately taken by the arts in this country as reflected here, we dedicate the present volume to his memory.

PAINTING

PAINTING

ROBERT AYRE

I

LET US start with Roloff Beny: not because his name comes at the beginning of the alphabet, but because he has travelled so far and because his journey is symbolic of the journey of Canadian painting itself in the quarter of a century since the Group of Seven disbanded.

Before Beny was born, Tom Thomson created Algonquin in *The Jack Pine* and *The West Wind*. Georgian Bay was fixed forever in Arthur Lismer's *September Gale* and in the wider prospect painted by Fred Varley on the same spot two years earlier. To generations of Canadians who had never seen it, the wilderness north of Toronto became as familiar as the face of a friend, through paintings at first execrated as travesties. And through these paintings people in other countries formed their image of Canada. Beny rejected the image. When he went into that country and painted his *Go Home Bay*, it was as if the face had become too familiar, as if he wanted to cut through to the essence. The water and the rocky islands in it, the beat of the sun and the pines wrestling with the wind are therefore distilled to featureless intensities of light and colour, to the pulse of red and the deeper, slower throb of black.

Would anyone but the painter recognize this picture as pertaining to Go Home Bay? And would it matter? His *Black Sun in Ontario* might as well be a landscape of the moon. It is all the same to Roloff Beny. His travels have taken him far from Muskoka and Georgian Bay, far from Medicine Hat, where he was born, to the Mediterranean and the Aegean, and farther still, *inward,* into the innermost imagination. While he attempts to evoke the spirit of place, it is never landscape he paints but what Gerard Manley Hopkins called *inscape*. He paints states of mind and emotions, his personal tensions and releases, and he exploits the resources

of his craft for his own satisfaction in the performance as well as in the result. The Canadian scene *as such means* nothing to him.

Yet, while he rejects the image made by others, Canada is nevertheless in his painting. He is seldom as obvious as in *Shadow of the Moon*, with its sharp pyramid Rockies, but Canada is there, the jumping-off place: it is transmuted, distilled into colour, telescoped into symbols. You will find it in the overwhelming, palpable sky, the dropping, spreading loops and skeins made by star tracks and the aurora borealis in *Prairie Night* and *Prairie Lights*, in the black-spattered turquoise sky, the converging criss-cross lines and the retreating figures in *Time of Peace*, one of the *Ecclesiastes* series. These figures, lightly poised on the ground or floating free in wheeling space, are the Beny idiom, memories of Alberta reduced to hieroglyph.

Without clues the vestiges of the Canadian scene that remain in Beny's painting are not recognizable. Moreover, he has kept this tenuous contact in only some of his work. The greater number of vital Canadian painters today have cut loose: they make no reference whatever to Canada. Many of them have never looked at it.

The first great excitement in Canadian painting, which carried beyond our own borders, came when the Group of Seven joyously proclaimed their discovery of the land. They arrived on the crest of the wave of national self-consciousness. Their image of Canada was rejected, on two grounds: as art and as a truthful picture of the country. Orthodox painters of the Canadian scene accused them of ignoring all the standards of art. Painters and connoisseurs who looked toward Paris and had no eyes for the Canadian scene at any price, no matter whether it was painted by over-enthusiastic experimenters or honest traditionalists, were contemptuous of grown men who took a childish delight in being Canadian in the Canadian outdoors, like

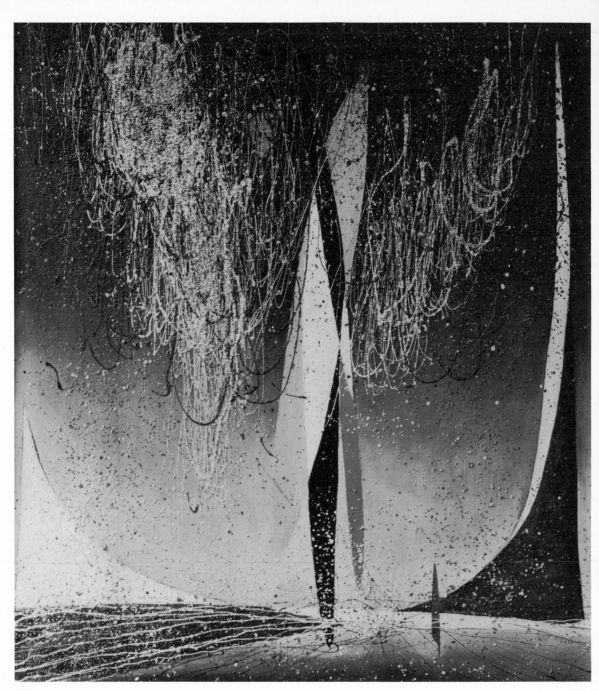

ROLOFF BENY *Prairie Lights* (oil on linen)

Boy Scouts, instead of staying in the studio, absorbed in the eternal problems and satisfactions of technique. To them, these new landscapes were no better than posters. And to politicians and other conventional patriots, they were not the kind of posters that would do Canada any good. These gaudy pictures of a raw wilderness presented a face to the world that any self-respecting nation would be ashamed to show. Still others, painters and laymen alike, resented the attention given to sticks and stones because, as they thought, man was left out. They wanted the Canadian scene, but they wanted the industrial scene—not the empty forest but the crowded city, not the pine but the logger; they wanted 'social consciousness'.

Starting somewhere about 1913 (although they did not exhibit under their group name until 1920) the Group of Seven survived ridicule and abuse and flourished for twenty years. Now, twenty-five years after they disbanded, with the formation of the larger Canadian Group of Painters, men who once were rebels and whose works were a scandal, are venerated—or taken for granted. They have had their retrospective exhibitions, they have their honorary degrees, books have been written about them, they are the subjects of motion pictures. They

were the rebels. They brought to Canada the shock of the Impressionists and the Fauves; they shot holes in the Dutch, as A. Y. Jackson said; they smashed windows to let in the strong Canadian sun. Now they are the classics, dated and put in their place.

A generation of painters followed their lead and landscapes in the tradition they created are still being painted. But these are seen less and less in the exhibitions. As the nation continued to exploit the north, shearing off its trees for pulpwood, boring into its heart for oil and ore, the impulse to delight in its pageantry flagged. Vaster excitements farther and farther afield reduced Algonquin to a mild suburb of Toronto. Lismer, when he is free of teaching, takes a holiday on Vancouver Island, goes to the Nova Scotia shore, or returns once again to Georgian Bay, to paint the jungle undergrowth, the details now, rather than the bigness of the country. Only Jackson, surely the last of the explorers, has continued to break trail, to contemplate once again the lonesome barren land before it is finally obliterated by the engineers. A new kind of nationalism which would celebrate, not the land but the men in it, the power lines rather than the pines, the dams rather than the rivers, has not taken

GHITTA CAISERMAN *Concert* 14" x 22" Dominion Gallery

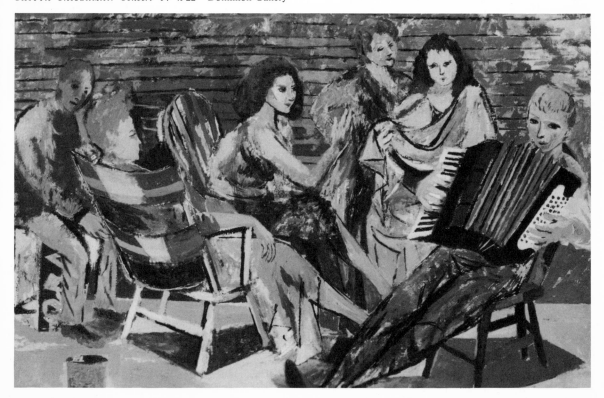

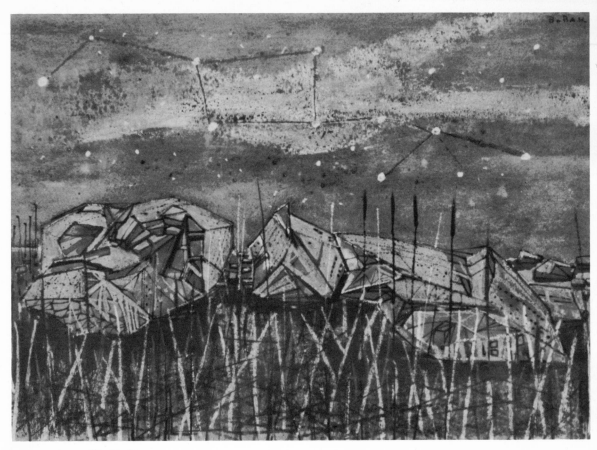

BRUNO BOBAK *The Big Dipper*

shape in our painting. Though it has been exploited in a few murals, the social art of the 'documentary' (to borrow a word from the films) is usually left to the camera man and the illustrator.

II

After the Second World War Canada, feeling herself mature, with greater dignity among the nations, was on the one hand proud of her physical strength and on the other, nervous about her cultural status. In spite of a Member of Parliament who protested that the National Gallery grant represented 650,000 bushels of wheat or 6,000 grain-fed steers, and another who voted to reduce the grant to $1, the Canadian people became more and more aware of the value of the arts and thus the creation of the Canada Council was a matter for widespread national self-congratulation.

And the image was changing. The painters on 'the growing edge' were no longer interested in the old regionalism. Canadianism in painting was superseded by new forces that were not even a reaction against the Group of Seven but as completely independent of it as if it had never existed.

'Many of us,' Joseph Plaskett has written, 'might still be hankering to paint the Canadian Shield if the war had not helped to put us more closely in touch with the contemporary thought of Europe.'

The Group of Seven, despite the excitement it generated, was a small, local phenomenon, concentrated in Toronto. The new movement, the greatest surge of adventure in Canadian painting since the Group's discovery of the north, is thoroughly national in its reach. The Painters Eleven group comprises only a few of the abstract painters in Ontario; the thirty members of *l'Association des Artistes Non-Figuratifs* do not represent the whole of the abstract movement in Quebec; the abstract is to be found in every Canadian centre where there is any painting at all, and in the work of Canadian expatriates in the United States, Mexico and Paris.

Canada first attracted the attention of Europe with the Group shows at Wembley in 1924 and 1925 and in Paris in 1927. Since the war, the recognition of Canadian art abroad has grown apace. When we made our first appearance at the Venice Biennale in 1952, we were represented by three painters of the Canadian scene, each an intensely personal interpreter—Emily Carr, David Milne and Goodridge Roberts. And with them was Alfred Pellan. The ascendancy of the abstract was clearly demonstrated in 1954, when the painters were Paul-Émile Borduas, Jean-Paul Riopelle and

TOM HODGSON *March Pond* 7' x 5'

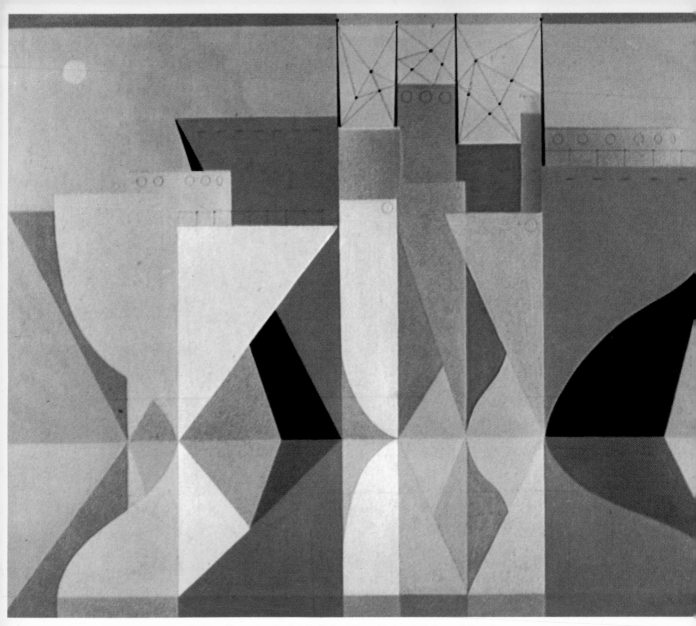

B. C. BINNING *Ships in Classical Calm* (1948) 32″ x 40½″ National Gallery of Canada

B. C. Binning, and again in 1956, when they were Harold Town and J. L. Shadbolt, accompanied by the sculptor Louis Archambault. It was in this year, too, that the National Gallery, at the request of the Smithsonian Institution, organized the first comprehensive exhibition of Canadian abstract painting for circulation in the United States. Alfred Pellan was honoured in a retrospective exhibition at the Musée de l'Art Moderne in Paris in 1955. Riopelle, who has lived abroad since 1948, is almost regarded as a French painter. Borduas, now living in Paris, and Roloff Beny, who has travelled widely in Europe and now lives in New York, also have gained international reputations.

Canadian government fellowships and other awards and scholarships have given European experience to many Canadians, from Humphrey in Saint John to Shadbolt in Vancouver. Others got it by going down to New York and Provincetown to work with Hans Hofmann, the great German force who has caused such an upheaval in American art. At one time, ten years ago, there were as many as seven of them submitting to the rigours of his inspiration—four of them originally from British Columbia: Joseph Plaskett, Takao Tanabe, Lionel Thomas and Jock Macdonald; Hortense Gordon from Hamilton, and Alexandra Luke and Ron Lambert from Oshawa. Some of these became members of Painters Eleven: 'the expression of a long repressed desire on the part of eleven painters to disagree harmoniously in terms visually indigenous to this age'. Other Canadian painters have got new perspectives by going to California and Mexico, as well as following the older routes to Chicago and New York. A strong infusion of teachers imported by the Winnipeg School of Art from Iowa produced a crop of vehement abstractionists, and, in Montreal and Toronto, newcomers from Europe, like the late Oscar Cahen, Marthe Rakine and Josef Iliu have brought new elements

14

and energies to Canadian painting.

But this new movement has roots here. The first Canadian abstract artist was Bertram Brooker. Thirty years ago, this man of many talents was endeavouring to make music visible, but his diversity of interests prevented him from making a major contribution in drawing and painting; he is to be honoured more for his eager, pioneering spirit as a writer and editor. Though not the complete abstractionist, Kathleen Munn, back in the twenties, was showing a greater awareness of advanced European painting than of the landscape at home. Her imaginative *Composition* of animals recalls the German *Blue Rider* Franz Marc. Jock Macdonald painted his first abstraction in 1935. Rupert Davidson Turnbull, one of the founders of the American Abstract Artists in 1936, was a Canadian, but he made his reputation in the United States and he is almost completely unknown north of the border.

At home the pioneer of greatest stature was Lawren Harris who, even as a member of the Group of Seven, in his own words, 'obsessed with the idea of an art expressive of our land', was moving toward the pure abstract, into realms of being far beyond any transcription of the visible world. He is a mystic and a philosopher. No one in Canada has written more profoundly about the abstract or demanded more of it in discipline and nobility. His painting is an intellectual integration of forms in just proportions. He seeks the radiance of space and the music of the spheres.

Harris left the north, went down to New Mexico, where he was a member of the Transcendental Painting Group and he settled in Vancouver when he returned to Canada in 1942. That was the year Borduas and Fernand Leduc began painting in the abstract. Meanwhile, in 1936, Fritz Brandtner had held his first one-man show in Montreal. He was not then painting pictures like *City from a Night Train* but, a German Expressionist who had come to Winnipeg from Danzig in 1928, he imported new themes and a violence unknown in Canadian painting. A powerful designer and a prodigious worker, he was soon making his presence felt.

It was possible, twenty years ago, to see not only Lord Leighton's *Bath of Psyche* in the Canadian National Exhibition in Toronto but such shockers as Max Ernst's *Burning Woman*, Picasso's *Woman Weeping* and Dali's *The Great Dreamer*. Art dealers in Montreal had been bringing over Odilon Redon, Modigliani, Lurçat, as well as the now safely established Utrillo, Vlaminck and Dufy. Montreal, the last pasture for contented Dutch cows, had let down the fences for strange blue horses. Not everybody who came to see them liked them, but at least they were made aware of the world outside Canada and of the great shakers and dislocators of the twentieth century.

When Alfred Pellan came home from Paris in

JACK SHADBOLT *Medieval Town (1957)* National Gallery of Canada

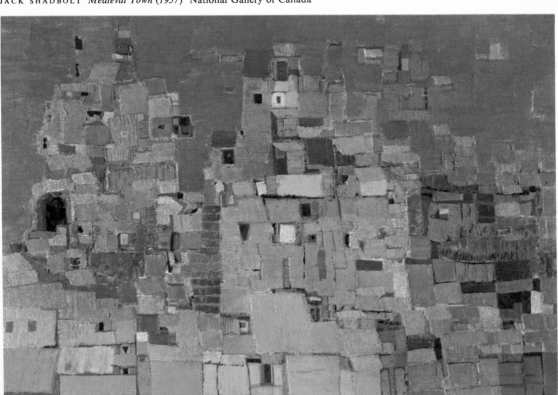

1940, many young painters were therefore ready for his stimulation and influence. The reverberations of his personality and his style are still felt, though Borduas has a greater following now. Not such a lone wolf as Pellan, further away from Surrealism, moved more by feeling than by intelligence and wit, a painter rather than a draughtsman, and so closer to the newer developments in the non-objective, Borduas was the father of several small insurgent groups, named *Prisme d'Yeux, Refus Global, Les Rebelles,* and others without name but coming under the general title of *Automatisme.* He eventually went to New York and thence to Paris, but he is still a power among the faithful, a sort of Prophet.

In the spring of 1954 he paid a flying visit to Montreal, to judge an exhibition, *La Matière Chante,* which proved that undisciplined emotional painting, spilled out of the unconscious without rhyme or reason, still had a powerful appeal. The invitation to the painters called for 'homogeneous works of a positively cosmic character, conceived and executed directly and simultaneously under the signs of the "accidental".' A 'bit of flair', it was explained, was required to find out 'whether or not it is cosmic, whether or not it sings the universal chaos of harmony.'

The exhibition demonstrated that there was room in the movement for both serious non-objective painting and nonsense. The dangers of ambiguity were pointed up when several practical jokes were submitted and accepted. The event also revealed, in addition to the high spirits of the young painters of Montreal (who made much of *l'affaire* in the weekly *Autorité*), the existence of a rebellion against the rebels, of a desire for consciousness and order.

European painting had got as far as Kandinsky when Canada was just becoming aware of the Impressionists and the Fauves. But the time lag has shortened astonishingly since the Second World War. Quickly, irresistibly, the new tide has swept into all but the most protected reaches of Canadian painting. Certainly, the abstract was prominent in the first Biennial Exhibition of Canadian Painting, organized by the National Gallery in 1955 to sum up current trends, and the winner of the first prize was the intricate *Structure with Red Sun* by Gordon Smith of Vancouver. The second Biennial, in 1957, was almost overwhelmingly abstract and the judges rejected twice as many abstractions as they chose. Donald W. Buchanan, in his foreword to the catalogue, observed that 'naturalism and realism, even in their decorative or romantic variations, are no longer the favourite paths to creation among Canadian artists. Abstraction, in all its aspects, is much more the practice of the day.'

Even without the Quebec painters, who have

MOLLY LAMB BOBAK *S.S. Beaumont* (1951) 17¾" x 32" PAUL V. BEAULIEU *L'Oiseleur* (1956) 40" x 29" Dominion Gallery

JEAN-PAUL RIOPELLE *Chevreuse* 10' x 13' Paris Museum of Modern Art (Ektachrome by Laniepce, Paris)

preferred to keep themselves apart from the so-called Canadian Group of Painters, the exhibitions of this and other national societies, such as that of the Water Colour Painters, have become more and more abstract. The 'heresy' has even invaded the Academy. And so it goes. Charles Comfort, noted for his grasp of the factual world, painted abstractions, because of a need to understand and cope with the complexities of his time. In one sudden flowering, Louis Muhlstock produced a series of thirty abstracts—albeit on a small scale. It was a self-contained experience, outside his normal preoccupations with humanity and domestic animals and the streets of Montreal, but he recaptured the inspiration several years later, in the summer of 1957. York Wilson long ago turned from a successful commercial career and abandoned his slick, accomplished style to put himself through the disciplines of the abstract and thus forge for himself a new formality. After his return from a year in France on a government fellowship, Jack Humphrey deserted his mature, well-established style and began to work in a new direction. LeMoine FitzGerald, in his last years, turned to pure abstraction, as the natural development of his pondering of form in still life and in his

drawings of trees, and, perhaps, partly because of his association with Lawren Harris during his visits to the Pacific Coast.

There was something in the air, some compulsion, that attracted these older men to the new language of painting—even if they afterwards realized that it was not their language.

This new visual Esperanto belongs to the young and the young have been quick to pick it up, rushing at it headlong, quick to utter its catch phrases and its slang without stopping to learn, many of them, its proper grammar and the traditional language out of which it grows.

Dismayed by these youngsters, the conservatives are inclined to believe that the abstract is nothing *but* slang. It will pass, because everything serves its time and passes, but this does not invalidate it, nor reduce it to a fad. These conservative critics seem to have a nostalgia for Paradise, a hope of returning to the innocence of Eden, unbiting the bite and hanging the apple once again on the bough of the Tree of Knowledge. They would have us unlearn all that has been learned, forget Cézanne, Braque and Picasso, the Bauhaus, Freud and Jung, chemistry, photography, electronics and nuclear physics.

17

Robert
Ayre

HAROLD TOWN
Deadboat Pond No. 2
96″ x 40½″

Abstract painting in Canada reflects all the complexities of the world today, its shifting values and uncertainties, its daring and impudence, its delight in new freedoms and discoveries. I am here using the term 'abstract' to denote the whole contemporary movement: non-figurative, non-objective, non-representational. It is unfortunate for the movement that it should be known for what it is not, rather than for what it is. Therefore in an attempt to avoid the negative (and for the sake of convenience) I am using the positive rather than the negative term, though *the abstract* is also inadequate and must be stretched to include varieties of expression that contradict each other: in Canadian painting, the use of pure colour in architecture by B. C. Binning and the diagrams of space and speed by Gordon Webber, the metaphysics of Lawren Harris, the sensuousness of Borduas' white flakes and Riopelle's jewelled rifts, the portentous structures of Fritz Brandtner and Rita Letendre's confectionery, the assault of William Ronald's 'block-busters' (I owe the word to Alan Jarvis), and the insinuations of Roland Giguère's calligraphy. We have in Canada and within the movement the measurers and the rhapsodists they rebuke because their automatic responses defy reason. And we have all the variations of these two main directions, running up and down the scale until at times they meet. For even the Automatists are capable of order—an explosion goes off according to law and there is logic in dreams. And even the purists may utter challenging proclamations in their colours.

To the uninitiated, the abstract seems to be more acceptable when it is used decoratively, as in textile design, or when it becomes an element in architecture (and here it may be noted that the integration of painting, as well as sculpture and ceramics, with the building is becoming more and more important in Canadian structural design). The difficulty comes when the abstract is made into pictures, identified only by numbers or with titles that are irrelevant and may even be jokes.

The uninitiated expect a picture to look like something, or to 'mean' something. When they cannot recognize a subject or fathom the meaning, they are likely to be annoyed, suspicious that they are being taken in, unless they simply pass by, with or without scorn. It is true that they are justified in dismissing much abstract painting as mere doodling, juggling with forms, a splurging of colour just for the fun of it, a pretence to 'self-expression' when there is no self to express. Never in history

SIDNEY WATSON *East-Coast Design*

GOODRIDGE ROBERTS *Pine Trees by the Sea* 24″ x 18″
Dominion Gallery

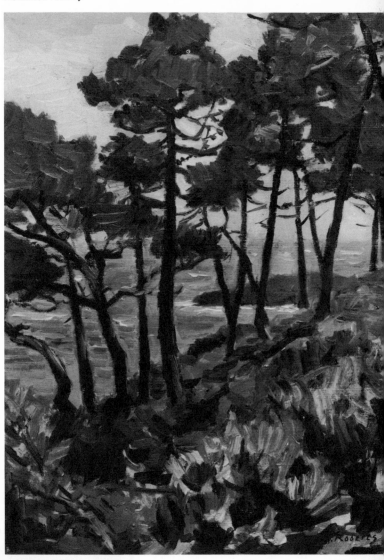

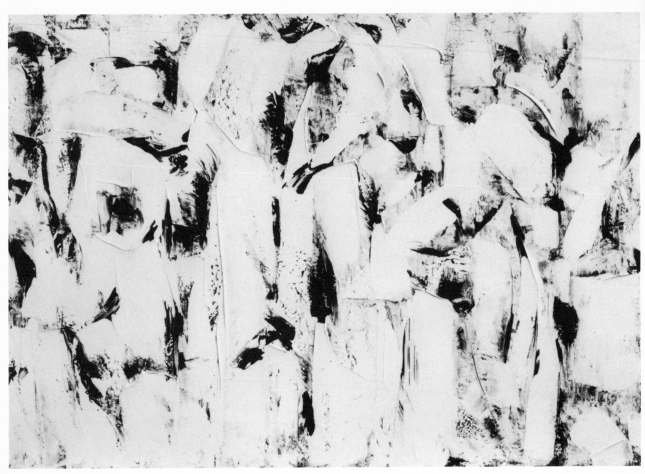

PAUL-EMILE BORDUAS *Epanouissement* 51″ x 76½″ Galerie Agnes Lefort

R. YORK WILSON *Mural* Imperial Oil Building, Toronto 21′ x 32′

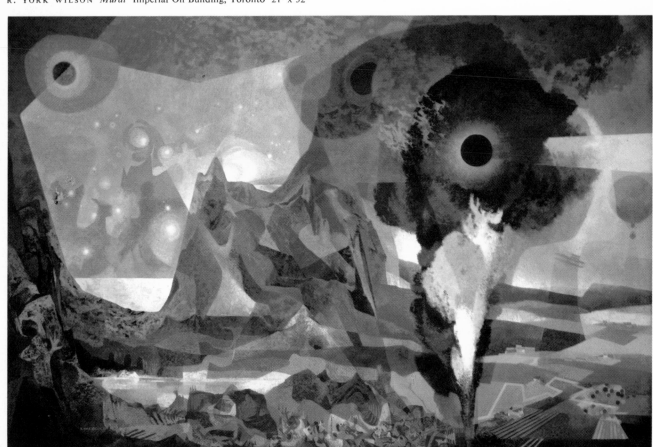

JACQUES DE TONNANCOUR *The Clearing*

JACK HUMPHREY *Black Sky* New Brunswick Museum

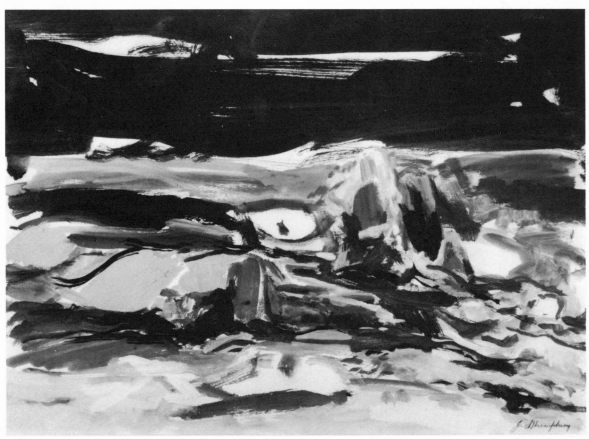

has the painter been freer than today. He need please no one but himself and the way is open to every kind of personal idiosyncrasy and licence. He is sometimes contemptuous of the public, sometimes indifferent to it. When he attempts to explain himself and his aims in words, as Fernand Leduc did in the manifesto of *Refus Global*, he only adds to the obscurity: 'Our justification—desire; our method—love; our state—dizziness. This alone has permitted and will permit the sister works of the atomic bomb, which call forth cataclysms, provoke panic and order revolutions . . .' And Leduc goes on to an apocalyptic vision of a quick end and the coming of a new civilization 'justified by wild desire, blossoming in vertigo'.

This kind of *dada,* so long out of date, has, to

the layman's ear, the ring of insincerity if not of downright insanity. Little is done to inspire understanding and confidence when the abstract, often through its apologists, pretends to a conceptual significance that is not in it, as when we are asked to look for the 'spiritual' qualities of Mondrian's right angles, or when the French critic Georges Duthuit reads into Riopelle's work 'the latent threat of a sudden lapsing into another excess—death' (instead of being satisfied with its 'display of agreeable splendours'). Riopelle is to be enjoyed for his magnificence. The question you are likely to ask is not *what does he mean?* but *how does he do it? where does he begin?*

It is easy to call a man a charlatan if you do not understand the art he practises, and especially

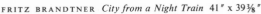
FRITZ BRANDTNER *City from a Night Train* 41″ x 39⅜″

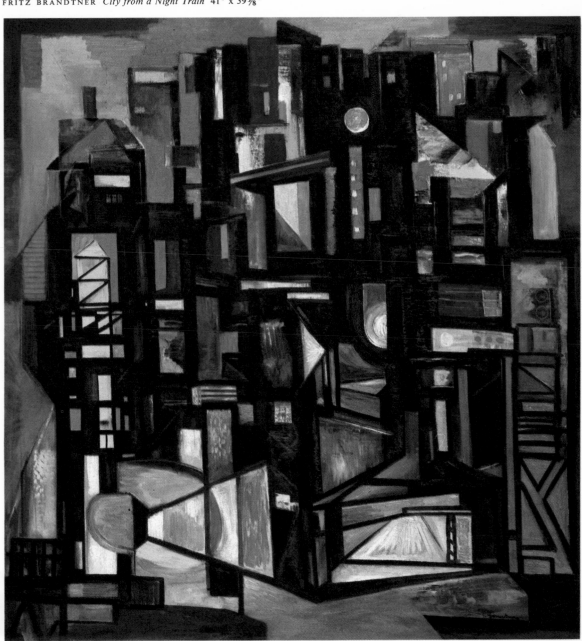

when, in his arrogance or his enthusiasm, the artist himself talks gibberish about it. (Perhaps with *Refus Global* it is only the French inebriation with words: the French drop manifestoes with every new quirk of style.) The hostile layman may find it hard to believe, but the abstract is serious art and while some of its practitioners may be self-deluded, we are not here much plagued by pseudo-mysticism nor are we victimized by cynics.

We have a few clever showmen. Roloff Beny is one of them: his virtuosity makes for an excitement that comes close to sensationalism, though it never reaches vulgarity. That prodigal of invention, Pellan, has room even for vulgarity. He has an amazingly fertile mind and an emotional capacity for pictorial invention. His forms proliferate, changing under his necromancy into breasts and wings, flowers and fingers (his work is a jungle of fetishes), then back again into the amorphous beginnings; lines stand rigid, coil into springs, whip across the canvas, break into shimmering northern lights or turn into flames or feathers; colours spread, blend, clash; paint thickens into sculptural relief and thins away to a wash; surfaces glitter with glass or are dulled by sand. Pellan's riches, and Beny's (at least in his big canvases) are all for the eye. They do not reach the deeper levels of experience, but they give us a wonderful show. Other painters, without this justification of splendid performance, succeed only in being pretentious. Some are so intent on exploring form (or playing with it) that they are betrayed into lapses of sensibility, or their eagerness for quick effects may result in a sleight-of-hand that is mere commercialism out of place.

The abstract, says Lawren Harris, 'makes possible an incalculable range of ideas that representative painting is closed to'. He did not convince

JOCK MACDONALD *The Iridescent Monarch* 42″ x 48″

ALFRED PELLAN *Jardin Mauve* 41¼″ x 73½″ Collection Mrs G. Elliot Trudeau, Montreal

ALEX COLVILLE *Two Pacers* (*1951*) (glazed tempera) Dominion Gallery

GERALD TROTTIER
Medieval Images
(gouache on paper) 19¼" x 33½"
National Gallery of Canada

KENNETH LOCHHEAD
The Dignitary
National Gallery of Canada

KAZUO NAKAMURA
Landscape 19" x 24"
National Gallery of Canada

CHARLES COMFORT *Timeless Fable*

GORDON A. SMITH *Pruned Trees* 29¾″ x 47¾″ National Gallery of Canada

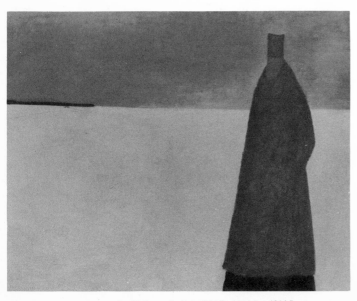

JEAN-PAUL LEMIEUX *Le Visiteur du Soir* (1955) 31½″ x 43¼″

Emily Carr that 'feeling can be as deep, as human, spiritual and resonant in abstract art as in representational work'. She said: 'I clung to earth and her dear shapes, her density, her herbage, her juice. I wanted her volume, and I wanted to hear her throb.'

Harris, even in his mountain pictures and in *North Shore, Lake Superior* (where the forms are known and recognized, stripped as they are to their essences), is already far from the warm earth, voyaging into the chill reaches of outer space. But the shapes of the earth Emily Carr loved, the density, the herbage, the juice, the volume, the throb, are all to be found in Canadian abstract painting, lifted from their context, it is true, singled out, seen in a new way, given a new importance.

To Emily Carr, as to many another, hungering for the familiar shapes and substances, it may be cold comfort to look into the secrets of earth through a microscope, but nothing can prevent our painters from pressing beyond the boundaries of the known and loved to new worlds. Leon Bellefleur, plunging deep into the water, by the transition of dream swims into the submarine gardens of the unconscious. Shadbolt, engrossed in rocks and plants and birds, brings in something of the magic and ritual of the West Coast Indians, unnoticed by most of our painters. Jean-Paul Mousseau finds massive drama in the bowels of the earth and Kazuo Nakamura reduces a forest to an ideograph. Kenneth Lochhead borrows stony figures from Salvatore Fiume of Italy to give a superhuman, half abstract, half Surrealist, impressiveness to human beings, and Gerald Trottier sends them forth bound in lead like figures from a stained glass window. Some painters start with the landscape, some with the still life, some with events. Fritz Brandtner compels us to feel the tensions and drives of the city. Hot from the smithy of that other German Expressionist, Hans Hofmann, come painters like William Ronald, with their dramas of smashing colour.

But those who make the most commotion are not necessarily the painters who have the most to say. The sound and fury of some Canadian engineers in paint corresponds to the passion of the hi-fi addicts for decibels: they are too interested in noise to hear music.

Size and striking power are not enough. Vitality, imagination and feeling can come quietly. To prefer the abstract in intimacy, as in Harold Town's autographic prints, the serigraphs of Gordon Smith and the drawings of Albert Dumouchel and Roland Giguère, may be the preference for the string quartette over the brass band.

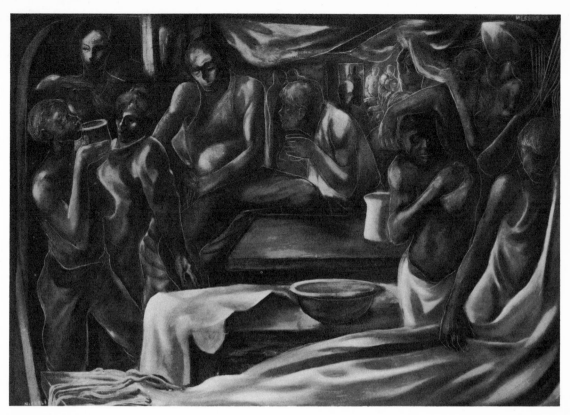

JACK NICHOLS *Mess Deck* (*1946*) 34″ x 50″ National Gallery of Ottawa

LEON BELLEFLEUR *Aigle-Feu* (*1956*)

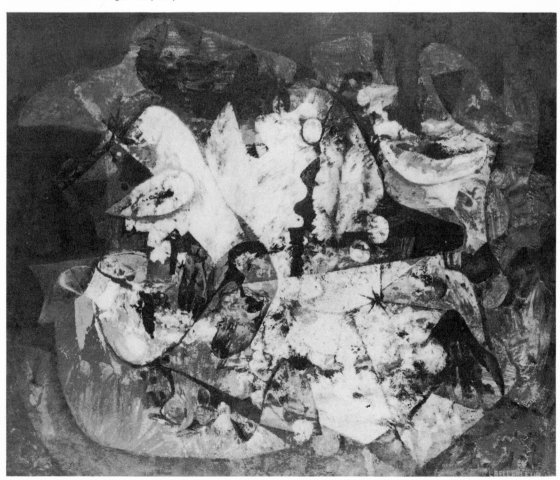

LAWREN HARRIS SR. *Abstraction* 60″ x 60″ National Gallery of Canada.

Hans Hofmann, a man once described as 'a perilous and liberating power', has had imitators among his Canadian students, but not all of them attempt to reproduce his earthquakes. As one of them, Joseph Plaskett, says: 'The dynamism of Hofmann's personality does not produce submissive disciples. His teaching is of such force that those who are strong pupils eventually rebel against it, but by then he has given them the power to go their own way'. Plaskett himself moved away from violence and back through the figurative to a more sensitive romanticism and Takao Tanabe, to name another Hofmann pupil, works with such delicacy in his shorthand travel notes and his flower writing that one wonders how he managed to survive the master's volcanic fire.

The abstract is a movement, continuously changing within itself. Fernand Leduc, who once painted the subtle, secret life of a dream world, is now working in interlocking flat shapes of clear colour, architectural patterns without overtones. Jean-Paul Mousseau has given up his introspective poetry in favour of the weaving, blending and contrasting of colours. Leon Bellefleur, whose forms

were once organic, even visceral, is developing a new, more geometrical style. Jack Shadbolt has abandoned his figurative drawing for colour suffusions. Riopelle's closely textured patterns have begun to give way to compositions with an airiness, depth and variety that suggest landscape.

It depends on your point of view whether you look on these changes as a sign of instability in the individual artists, in the movement, or in both —or whether you see them as proof of growth, or as the living, and inevitable, reflections of a world in flux.

There will be more changes. Any survey of Canadian painting today reminds us that the vitality and imagination of painters breaking new ground is not all being channelled through the abstract. We have the poets, intimate with the small life of the earth, like Bruno Bobak gazing at a bird nesting in the weeds, and Will Ogilvie watching the dragon flies hovering over the lily pads. There is Alexander Colville, looking at people steadily and realistically and holding them in an intensely revealing trance. There is Ghitta Caiserman with joyous extravagance letting her creatures loose in a

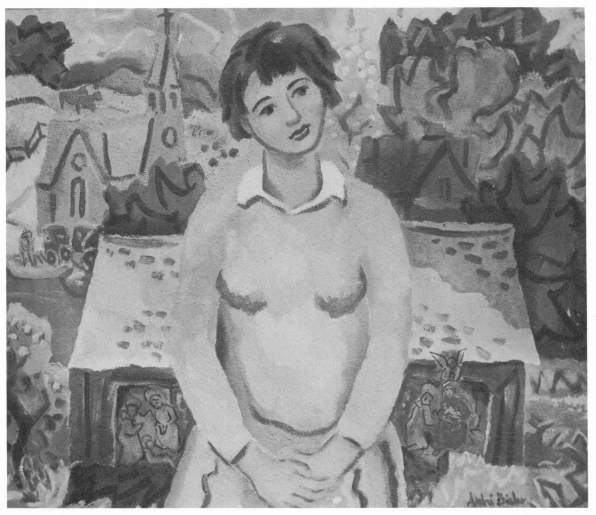

ANDRE BIELER *Nathalie*

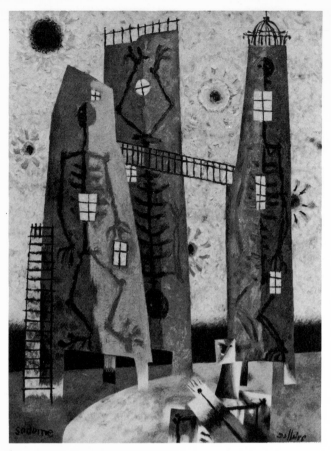

JEAN DALLAIRE *Sodome* 16″ x 12″ Dominion Gallery

JOSEPH PLASKETT *Le Peintre emérveillé devant le Monde*
National Gallery of Canada

luxuriant growing world, and John Fox painting quiet interiors with the understatement of the English school. There is Jack Nichols, casting off sentimentality, but retaining his deep humanity as he explores the art of the lithograph with greater and greater authority. There is Jean Dallaire, half abstractionist, touched with Surrealism, bizarre and good-humoured. And there is Norman McLaren and his film animations and an astonishingly rich flowering of the graphic arts under the heat of the television lamps.

And there will be *rapprochements*. Strongly subjective, Marian Scott has a deep inwardness which makes much of the so-called non-objective painting look superficial. Always absorbed in the exploration of form, she has gone through several phases, moving on from cells and fossils and cave drawings to the re-creation of figures from the mediaeval churches. In her *Iconics, Façades, Apostles* and *Translations,* she searches out and reveals in symbols the human spirit struggling to unburden itself. It may well be through such a religious synthesis as this of Marian Scott's that the abstract and the figurative modes will ultimately be fused.

Jean-Paul Lemieux, who has always found satisfaction in the life of Quebec, is making a deeper response to it than ever and he has inspired a number of students to look closely again at the Canadian landscape. But while Lemieux paints with a love that recalls Ozias Leduc and his tonal quality, the younger disciples are more open than he to what has been happening in the world and in Canadian painting in the past quarter of a century. There are strong abstract qualities in the organization of Suzanne Bergeron's wintry spars, in Elyane Roy's austere hills, in the squared compositions of Denys Matte and in Claude Picher's patterns of black trees and snow or the windswept spaces of the Terrace. Jacques de Tonnancour of Montreal, with his brusque and bristling trees, Franklin Palmer of Calgary, with his rocks and pools, and Tony Urquhart of Niagara Falls, with his wild, daringly imaginative landscapes (like *Nocturne* in the second Biennial), are others who are seeing Canada in a new way.

The Canada they look at is not the Canada the Group of Seven saw; their Quebec is not the Quebec of Clarence Gagnon, John Lyman or Goodridge Roberts. A Montreal painter, who has just come back to landscape after a long absence, has suddenly discovered Georgian Bay. In his excitement, he asked Arthur Lismer if he knew the place! But there is no question of coming full circle. There is no going back.

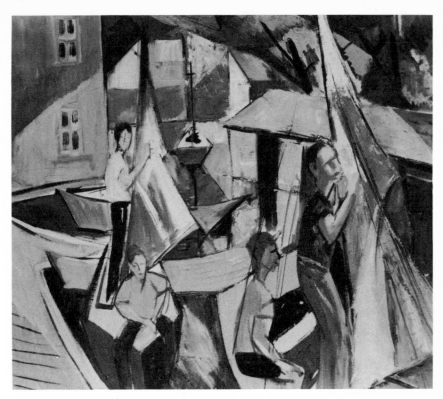

HENRI MASSON *Joys of Summer* National Gallery of Canada

MARIAN SCOTT *Field (1949)* Art Gallery of Toronto

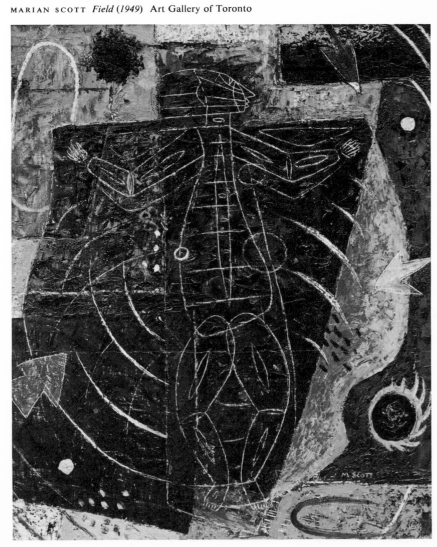

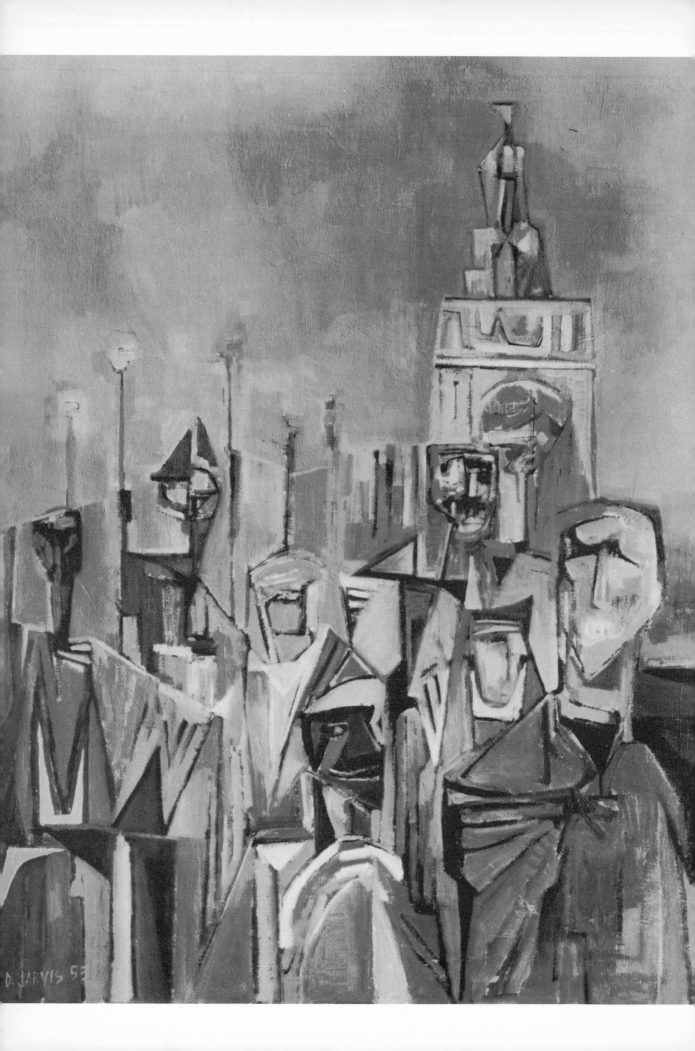

SCULPTURE

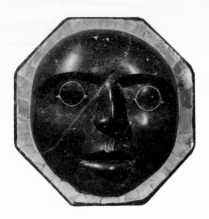

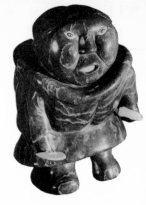

LOUIS ARCHAMBAULT
Night and Day, terra cotta and steel
Art Gallery of Toronto

ELFORD COX *Face of the Moon*
marble and abalone shell
Art Gallery of Toronto

JOHNNY INNUKPUK
Woman Holding a Fish, serpentine
Art Gallery of Toronto

SCULPT

FOR MANY YEARS it has been almost a ritual to preface any remarks on contemporary Canadian sculpture with the complaint that, ever since the decline of ecclesiastical wood-carving in the province of Quebec, sculpture has been the 'Cinderella of the Arts' in Canada. If there is still any justification for this gloomy view, the charge of neglect must be laid against patron and sculptor alike, and if there is any solution to be found, both must play their part in it.

No one could pretend that sculpture has ever been as popular as painting. Usually it lacks the immediate appeal of colour and demands a keener grasp of three-dimensional form for its fullest appreciation than most of us possess. In its more ambitious forms it is a deliberate art, allowing little room for mistakes or even experimentation on the final scale. At the same time, unfortunately, important works are almost invariably commissioned by public bodies, and sculptors are therefore much more at the mercy of public taste than are the painters. Until very recently 'public taste' and 'popular taste' were more or less synonymous, and even now the latter is apt to carry the vote of a committee. The steady, if sometimes sluggish, stream of commissions for war memorials, commemorative statues, fountains and architectural ornament throughout the first half of this century indicates at least a constant demand for the art of the sculptor, but what it seems to make up in quantity, in reality it lacks in quality. The truth is that we have not expected the best of our

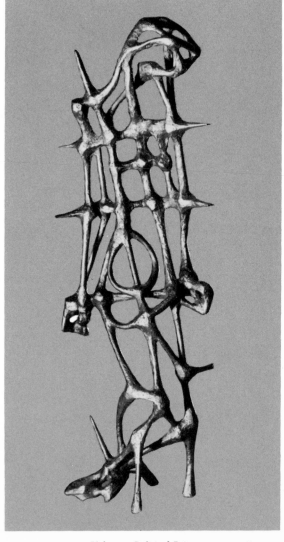

ANNE KAHANE *Unknown Political Prisoner*, maquette

WILLIAM S. A. DALE

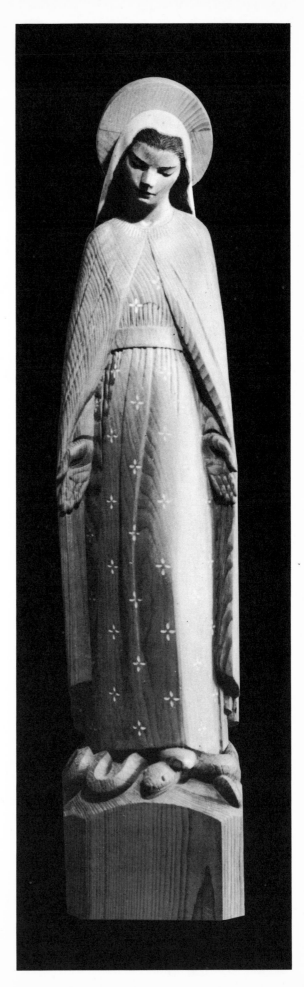

SYLVIA DAOUST *Madone*, pine carving

URE

sculptors, and have consequently received all too often the mediocrities of uninspired professionals and the crudities of untaught amateurs.

The present level of popular appreciation can perhaps be gauged by the continuing vogue for Eskimo carvings in soapstone and serpentine. Launched ten years ago by the Canadian Handicrafts Guild as a means of bettering the economic position of our Arctic population, the project has succeeded only too well in creating a market for these carvings. What was once a pastime for hunters of walrus, polar bear and seal has now become an industry, for which tons of raw material must be imported every year from Manitoba and New York State. It would be unfair to say that the authorities of the Handicrafts Guild are responsible for the destruction of one of our native crafts. What they have done is merely to bring its inevitable decline to a swifter, and in many ways more graceful, conclusion. There are, of course, exceptional pieces, but taken as a whole these Eskimo carvings show little understanding of design or material, and whatever charm and vitality they may once have had as naïve art has already given way to smooth sophistication. Perhaps we may still look forward to seeing such names as Akeeaktashook, Munamee and Tikketuk with the letters 'R.C.A.' after them, but not on the basis of their performance to date.

But there is another side to the coin. If the taste for good sculptors has been lacking, so has the talent. Sculptors in the period following the First

William
S. A. Dale

LOUIS ARCHAMBAULT
L'Oiseau de fer, steel
Musée de la
Province de Québec

World War still laboured under the unfortunate tradition of Louis-Philippe Hébert and Hamilton McCarthy, and even such leaders in the field as Walter Allward and Emanuel Hahn were rarely able to rise above it. Allward's Vimy Ridge Memorial will always be considered 'good theatre' on the strength of its architectural element, but his William Lyon Mackenzie monument in Toronto is pretty thin both in general plan and in detail, and, if Hahn's head of the explorer Stefansson has caught something of Rodin's breadth of design and vigour of modelling, his monument to Adam Beck has not. In spite of the fact that they too worked in bronze, M.A. Suzor-Coté and Alfred Laliberté are usually only one step ahead of the commercialized whittlers on the level of *genre* realism, and whatever monumental qualities the former's *Caughnawaga Women* may have are borrowed from a bronze by Carl Milles reproduced in the pages of *The Studio* a few years earlier.

Credit for the survival of the profession must go largely to the sculptors themselves, as represented by the Sculptors' Society of Canada. This body was founded in 1928 by Emanuel Hahn, Frances Loring and Henri Hébert in the latter's studio in Montreal, and received its federal charter in 1932. From the first it has kept a watchful eye on the quality of public monuments, and otherwise used its influence to improve the position of the sculptor in Canada. However, its public exhibitions have been few and far between, and, although its membership has broadened to include the modernists, the actual number of creative sculptors remains small.

An indication of the dearth of even passable sculptors in Canada was shown in two recent public competitions. Out of forty-one designs submitted for a monument to *The Unknown Political Prisoner* in 1952, three were chosen for the international competition in Britain. These were a thorny, lattice-like figure by the young Montreal sculptor Anne Kahane which won a prize of twenty-five pounds in the final judging, a reclining Moore-like abstraction by Julien Hébert of Montreal, and an Epstein-inspired *Samson* by Robert Norgate of Ottawa. Of the rest, one or two undoubtedly had some merit, but the bulk of them were mediocre and even grotesque both in conception and execution. Even cruder were some of the entries in a competition for a monument to Sir Robert Borden in 1953. The winning design was the work of Frances Loring, a veteran sculptor and still one of Canada's best. It showed the statesman standing solidly in front of a low wall,

but the thirty-two other models were for the most part stodgy variations on the familiar Parliament Hill theme, and at least one or two reverted to the Roman toga and parchment scroll.

The older sculptors still hold their own, both in design and execution, though outside the current stylistic trends and hampered by the lack of reliable stone-cutters and founders. Frances Loring numbers among her more recent works an impressive lion at the Toronto entrance to the Queen Elizabeth Way, the Borden monument, and a head of Sir Frederick Banting, which in varying degrees exemplify the broad planes, the flowing line and massive strength of her style. A gentler and more feminine approach is found in the sculpture of Florence Wyle, who has been turning in the last few years to small-scale wood sculpture, usually in sumac. Individually these have great

LOUIS ARCHAMBAULT Wall, Canadian Pavilion, Brussels World Fair, 1958

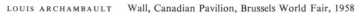

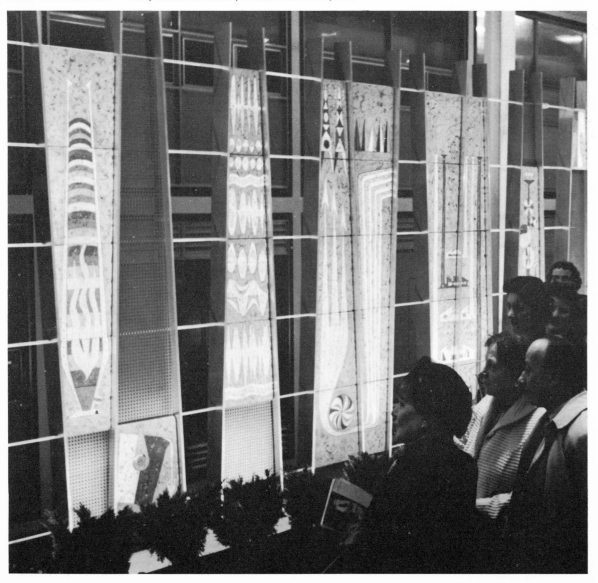

charm, but in a series, such as the female torsos symbolizing the Rivers of America, or the figures carved in 1953 as Calvert Trophies for the Dominion Drama Festival, they lose by their similarity of composition and the over-emphatic zebra pattern of the grain. Jacobine Jones is at her best in animal sculpture, which she often cuts herself in hard stone, but even her bronzes of horses and cattle, executed for the Ontario Agricultural College, have a stylized massiveness which recalls Egyptian art. On the other hand, Elizabeth Wyn Wood is more pictorial, and remains one of our few sculptors to attempt landscape themes. Her *Reef and Rainbow*, a free-standing abstraction in tin, and her *Passing Rain* relief, both done in the twenties, are as important landmarks in the history of Canadian sculpture as the canvases of the same date by members of the Group of Seven are in painting. By now, however, she represents with the others of her generation the more conservative tradition of Canadian sculpture.

FRANCES LORING *Lion*, Queen Elizabeth Way

THE QUEEN ELIZABETH WAY WAS OPENED BY THE KING AND QUEEN IN JUNE 1939 MARKING THE FIRST VISIT OF A REIGNING SOVEREIGN TO A SISTER DOMINION OF THE EMPIRE THE COURAGE AND RESOLUTION OF THEIR MAJESTIES IN UNDERTAKING THE ROYAL VISIT IN FACE OF IMMINENT WAR HAVE INSPIRED THE PEOPLE OF THIS PROVINCE TO COMPLETE THIS WORK IN THE EMPIRES DARKEST HOUR IN FULL CONFIDENCE OF VICTORY AND A LASTING PEACE

A younger group working in the traditional vein includes people like Donald Stewart and Sybil Kennedy, whose elongated scale of proportions and mannered gestures owe much to the German Lehmbruck. Sylvia Daoust's happiest productions are her appealing heads of children and her gentle statuettes of saints, carved in a somewhat streamlined version of the early French-Canadian style, but she also contributed with Florence Wyle and Frances Loring to the Calvert Trophies. Among the portraitists are Cleeve Horne, who has a vivid but superficial manner, and Leo Mol, who has a more intimate and sensitive style, while Pauline Redsell and Eugenia Berlin are better known for their lively, if rather trivial, *genre* pieces on a small scale.

The modern movement in Canadian sculpture has a longer history than most people realize. As long ago as the twenties Emanuel Hahn was making things like *Flight*, a highly stylized bird-form in the manner of Hans Arp. As far back as

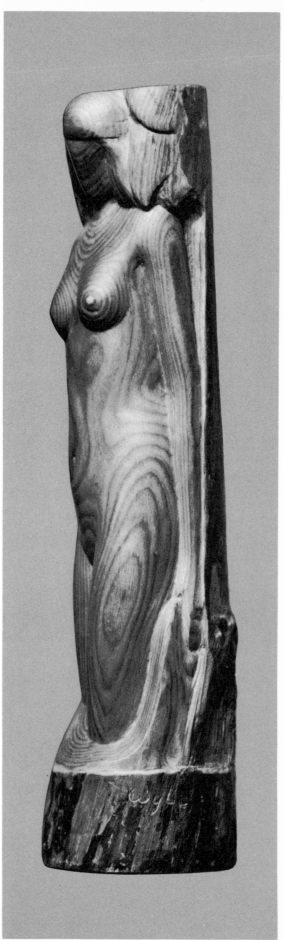

FLORENCE WYLE *Summer*, sumac carving

ELFORD COX *Groundhog*, marble
Collection: C. S. Noxon

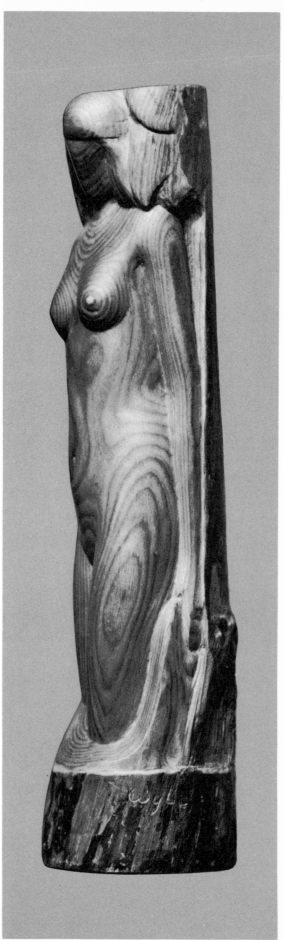

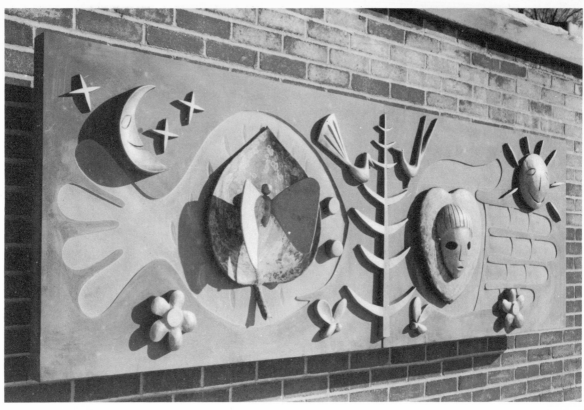

ARTHUR PRICE *Blackboard*, slate, bronze and aluminum Blackburn Corners Public School

ANNE KAHANE *Air Show*, wood

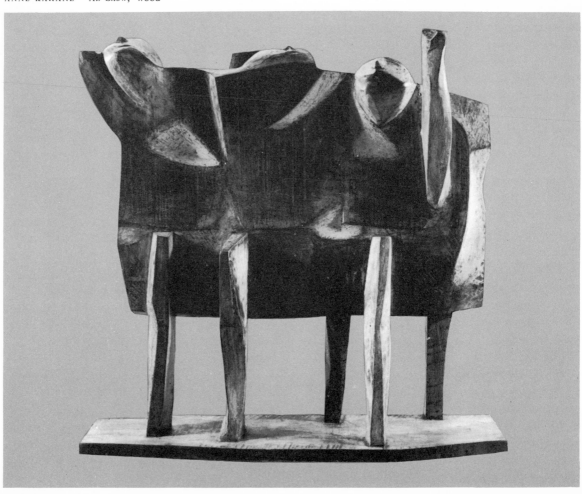

1939 Elford Cox was experimenting with the type of organic abstraction found in Brancusi and Henry Moore. In spite of these and similar attempts to absorb the lessons of modern European sculpture, the development as a whole has been sporadic and inconclusive, and the younger artists have been forced to learn their technique by trial and error, in the absence of a continuous tradition, and to beg, borrow and steal the elements of their style. This is particularly true in the case of those who have abandoned the mallet and chisel for the acetylene torch and the soldering iron.

The most promising source of inspiration in the last few years seems to have been primitive and folk art. Louis Archambault has captured much of the simple force of pre-Columbian Mexican art in his terra-cotta figures; he borrows his iconography from the prehistoric pantheon. His *Iron Bird*, a ten-foot high construction which was exhibited in the famous open-air show at Battersea Park in London in 1951, is a universal symbol of primitive force, more dinosaur than ostrich, and his terra-cotta mask in a steel framework entitled *Night and Day* has the direct and powerful approach of a romanesque gargoyle. In a similar way Elford Cox and Arthur Price have turned to the totem-poles of the West Coast and Indian masks of our eastern woodlands as sources of subject-matter and style. At first sight, one might feel that Cox's *Face of the Moon* and Price's essays in the Haida style were too close to the original, but they are essentially different in purpose, and the experience makes itself felt in their other work. The stylization of a child's head by Cox is essentially that of an Iroquois mask, and Price's *Blackboard*, a wall-decoration carried out in various metals on a slate background for a public school near Ottawa, makes use of the symbolic additive type of composition of the West Coast, but in both the format and detail of the design are completely independent. Even the decayed tradition of French-Canadian wood-carving has contributed to the formation of Anne Kahane's current style. Her subjects are usually *genre*, and include such titles as *Air Show* (a group of figures looking upwards), *Monday Wash* (a woman folding sheets), and *Revolving Door*. At times one is too conscious of the carpentry involved in their construction, but even these homely sculptures occasionally achieve an impressive monumentality through the skilful handling of masses and the sensitive simplification of contours.

Several of the more recent projects in contemporary sculpture have been in connection with architecture, although the results too often indicate that the debates initiated between sculptors and architects by the *Journal of the Royal Architectural Institute of Canada* have not yet resolved the problem of integrating the two arts. The boldly stylized figures in high relief designed in 1950 by Jacobine Jones for the Archives Building in Toronto, attractive as they are in themselves, give the impression of having been applied to the wall like animal crackers, and their colossal size plays havoc with the scale of the building itself, which is in a traditional style. Equally uneasy is the relationship of sculpture and wall in the stone bas-relief designed for a school at Danville, Quebec, by Armand Filion, although this won the Allied Arts Medal of the R.A.I.C. in 1953. The real answer seems to lie in separating the sculpture from the structure itself, as in the case of Elford Cox's fountain for the Park Plaza in Toronto, or in using it as an open screen, either inside or out.

By far the most encouraging example of the latter approach is Archambault's wall of ceramic tiles set in an aluminum framework which effectively adorns the Canadian pavilion at the 1958 World's Fair in Brussels. This screen measures a hundred and twenty-five feet long by ten feet high, and represents in bas-relief and incised design the people and resources of Canada. It took months of toil and experiment to complete, but its present form will permit it to be dismantled at the close of the fair for re-erection in the new building of the National Gallery of Canada in Ottawa, or on any future site. A prefabricated, portable design such as this is in keeping, not only with the temporary construction of an exhibition pavilion, but also with the open planning of the more adventurous forms of permanent building. It is to be hoped, then, that where traditional sculpture applied to traditional buildings may have failed, the more modern combination will succeed.

On the whole, the present state of Canadian sculpture is not entirely discouraging. Of our clay-modellers, wood-carvers, stone-cutters and metal-welders, many may be merely competent conservatives or untrained modernists, but we have in Loring a traditional sculptor of great power, and in Archambault at least one modernist who is rapidly gaining an international reputation through his showings at the Venice Biennale in 1956 and at the Brussels Fair this summer. Among younger artists, too, there are signs of an increasing interest in this medium, and from them we may hope for great sculpture in the future, if only we will demand it of them.

music

JOHN BECKWITH

music

THE FIRST thing to note about the present state of creative music in Canada is that there is a lot more of it than ever before. The *Catalogue of Orchestral Music* published by the Canadian League of Composers in 1957 gave some statistics which bear out this observation. Listed were 233 works for orchestra composed between 1918 and 1957. Of these 233 pieces, according to data supplied by the composers, all but 36 have been publicly performed—that is, approximately 85 per cent. By far the largest number of works were dated 1940 or later. This is partly because composers naturally excluded from the catalogue some of their earlier compositions. But aside from that, there is a noticeable increase in the number of works produced each year between 1940 and 1950, and the peak years of production seem to have been 1950 to 1953. These figures deal only with orchestral music, but they are indicative of a general state of productivity which probably could not have been predicted in Canada twenty years ago.

Description of the kinds of music being produced must, in view of the impracticability of extensive music-type quotations, deal in externals. One looks for similarities to known musical styles; one pin-points original traits adjectivally. Canadian works, it is found, often quickly call to mind internationally known styles of this century and the last, but more rarely each other's styles; and among the adjectives one is forced to draw on in describing typical compositions, there seems to be no single one of wide application. The complicated assortment of stylistic threads in Canadian music at present will call for comment later, under the topic: what is, is not, should be, should

not be, identifiably Canadian in our musical literature? Meanwhile, in embarking on a brief descriptive survey of the literature itself, I have taken my grouping from a third external: the convenient one of generation. Indeed, Stravinsky says that the evolution of styles in music is after all 'perhaps simply a question of generation'. (He means also the assimilation of such evolution by discriminating listeners; and this is a problem to be dealt with in this essay too.) In the review which follows, I shall refer to only a few characteristic recent works by living (or recently deceased) Canadian composers.

Taking first of all the composers of 65 and over, we find a group dominated by English born and trained musicians who came to Canada in the first and second decades of this century. Among them are Healey Willan, Alfred Whitehead, the late Leo Smith, and the late W. H. Anderson. They are men whose outlook was formed in the England of Hubert Parry and Charles Villiers Stanford. Although this means that their work has little about it that is North American, it is sometimes forgotten that this work is often of superior technical accomplishment.

Healey Willan, the best-known figure in the group, is also the most venturesome and productive. Some idea of his musical accents may be suggested by comparisons with other composers. His *Veni Sponsa Christi* for unaccompanied chorus (1953), a part of his *Coronation Suite*, is organized somewhat like the choral pieces of Parry, for example the latter's well known *a cappella* setting of *My Soul, There is a Country*. The vocal phrases imitate and overlap in an unobtrusive fashion, derived no doubt from sixteenth-century models; they then rise to impassioned and colourful moments that show the nineteenth-century romantic beneath the skin; the comparison would show that Willan is often Parry's equal in this vivid mixture of idioms. His knowledge and resourcefulness in the choral sphere are vast and admirable. His instrumental works echo Franck, Tchaikowsky, Elgar, and above all Wagner. One striking instance, a prominent motive of the *Second Symphony* (1950), consists of the root chords of C minor, G sharp minor, E minor, and C minor again—an extension of a harmonic progression familiar from Wagner's *Ring* dramas (see first two bars of example 1). Willan's style is often called 'academic': the term would hardly apply to these instrumental pieces or to the operas, where the unbridled expressiveness often reaches orgiastic proportions. A prolific composer of undeniable fluency, Willan

is a remarkably stout survivor of late romanticism.

When we come to the music of the composers now between 55 and 65, we note a marked reflection of the Canadian environment, such as is rare indeed in the work of the older group. Representative composers here would be Claude Champagne, Georges-Émile Tanguay, Hector Gratton, and Sir Ernest MacMillan. The folksong movement had just begun in Canada when these composers were coming to maturity, and in some cases they had direct associations with that movement. Champagne's *Suite canadienne*, and his *Symphonie gaspésienne*, Gratton's series of *Danses canadiennes*, and Sir Ernest MacMillan's concert settings of folk material are typical of the work of this generation. Even though attempts at national identification remain more prevalent among these men than anywhere, two observers, Marvin Duchow and Serge Garant, have recently noted defections from this tendency in the work of the most vigorous spirit of the group: Champagne's *String Quartet* (1955) is aligned more than any previous work of his with the main international styles of this century. Mr Garant compares its textures to those of early Schoenberg works such as *Verklaerte Nacht*; at the same time, the melodic content has a certain airiness in common with, say, the *Octet* of Milhaud.

Composers now between 35 and 55 strongly reflect the influence of twentieth-century masters such as Stravinsky and Schoenberg. We note a zealous concern for craft and, perhaps as a consequence, a trend toward the more abstract forms of music. John Weinzweig, Barbara Pentland, Jean Papineau-Couture, Alexander Brott, Murray Adaskin, and Jean Coulthard are perhaps the most prominent composers of this large and talented group. Though native-born, most of them went abroad for their training. Most of them are now teachers of music in Canadian universities. It was a struggle for them to achieve mastery of contemporary techniques. It was a struggle to gain a hearing. Almost belligerently they resisted the artistic influence of the older Canadian com-

posers—although at present the younger and older generations are on fairly cordial terms. The Canadian League of Composers was founded in 1951 by Weinzweig and some of his colleagues, largely as a result of the struggle I have mentioned. The organization now numbers approximately forty composers, including virtually all of the country's serious creative talents; significantly, in 1955 Willan and Champagne were made honorary members. (Incidentally, it was to the advantage of Canada's first musical modernists that their coming of age coincided with the formation of the Canadian Broadcasting Corporation and the National Film Board: these agencies were and are important in the newer musical developments of the contemporary period.)

The music of these men is eclectically modern, revealing an amalgamation of modern techniques, with often a close resemblance to contemporary American music. For instance, Weinzweig's ballet score *The Red Ear of Corn* (1949) recalled to one American dance critic the music of Aaron Copland's *Rodeo*. Other stylistic and technical strains discernible in recent Canadian composition are the primitivism of Stravinsky's *The Rite of Spring*, the rhythmic vocabulary of jazz, the neoclassicism of Hindemith and the later Stravinsky, and of course, the twelve-note serialism of Arnold Schoenberg. Some details of the situation may be filled in by taking a closer look at the work of three leading members of this group.

Barbara Pentland's *Second Quartet* (1953) is a long rhapsodic piece in five main sections, framed by an elegiac largo of elaborately-drawn long melodies (see example 2). The occasional oppressiveness of the textures is relieved in a very original *pizzicato* movement. The technical devices appear to stem largely from the quartets of Bartok, but the expressive feeling is quite distinctive and original. Her two *Sonatinas* for piano (1951) show melodic character of a different sort —intimate, lyrical, often reminiscent of the boulevards, but never mere paste. The sense of fitness in the material assigned to these instrumental

EXAMPLE 1. Opening of the second movement from *Healey Willan's Symphony No. 2*. The first two bars form a 'motto' which recurs many times in the Symphony. Permission, BMI Canada Limited.

EXAMPLE 2. Phrase from the first movement of *Barbara Pentland's String Quartet No. 2*. Permission, the composer.

EXAMPLE 3. Passage from the second movement of *Otto Joachim's Concertante* for violin, strings, and percussion. Permission, the composer.

EXAMPLE 4. Violin phrase from 'development' section of *Harry Somers' Symphony No. 1*. The accompaniment, not quoted, is a brass ostinato in eighth-notes; there is also a counter-theme in the bass instruments. Permission, BMI Canada Limited.

media, string quartet on the one hand and piano on the other, epitomizes one remarkable feature of Miss Pentland's talent.

John Weinzweig's music ranges from Hebraic intensities such as those of his Sonata *Israel* for cello and piano (1949) to a very personal kind of satiric rhythmicality, witness the opening movement of his *Divertimento for Oboe and Strings* (1947), which one critic described as a series of pokes in the midriff. The twelve-note method is used in many of his works, though rarely with the idea of a total exclusion of tonality. Tonal resolutions of tensions in the music, though often un-

expected, nearly always occur, and especially in the more recent pieces such as the *Violin Concerto* (1954). This complex work, one of the most substantial creative achievements of recent years in Canada, bears comparison with the Prokoviev Concertos, and occasionally resembles them in spirit, although Weinzweig tends, if anything, to ramble less than Prokoviev.

Representative major works of Jean Papineau-Couture are the *Concerto Grosso* (1943), the *First Symphony* (1948), the violin-and-piano *Sonata* (1944, revised 1952), and the *Psaume CL* (1955). The Symphony is a rare instance of a

possible link with the folkloristic style of older Canadians such as Champagne. The *Concerto Grosso* and *Sonata* both follow international and neoclassicist models (especially Stravinsky) and they present difficulties to the performer by the very clarity and precision of their ideas. The *Sonata* is the more rigorously disciplined score of the two: its melodic and textural attractiveness is always refreshing. The *Psaume CL*, a work scored for choir, soloists, wind ensemble, and organ obbligato, is a carefully evolved pattern of variations on a pregnant scalic theme.

Concurrently with the rise to prominence of these notable native talents, a number of gifted European born and trained composers have joined us here and are becoming valuable and influential on the Canadian musical scene. Some are conservative moderns—Oskar Morawetz and Talivaldis Kenins are examples. Others are modern in a more partisan way than any of the native Canadians—one would cite István Anhalt, Udo Kasemets, and Otto Joachim. The presence here of such men is of interest, if only because it shows that Brott, Weinzweig, Adaskin, *et al*, although considered radical by their Canadian public, have never been as extreme as some European composers of the same generation. (They could not afford to be.) Men such as Anhalt and Kasemets left Europe late enough to have been touched by the influences of Olivier Messiaen and Anton Webern—influences hitherto unreflected in Canadian music. It is perhaps surprising to discover that in the work of some of these recent émigré composers, Canada has produced her first strict or orthodox twelve-note-serial writing. Beyond question it is valuable and enriching for Canadian music to receive an infusion from continental countries at this time. Previous infusions have been almost entirely from England.

Works of Morawetz and Joachim may be taken to stand for the two contrasted aspects of this new continental influence. Morawetz's themes are freely conceived and often employ strongly dissonant intervals, though rarely in an atonal context. While often surprisingly original in detail, they are conventional in their general impulse: hence the over-all impression of conservatism. Morawetz's dirge is *the* dirge; when he writes a *grazioso* or a *scherzo macabre*, the result is the accepted prototype of these things. His *Piano Fantasy* (1948) is an enlarged latter-day Brahmsian rhapsody. His *Second Quartet* (1955) is personally felt music of strong developmental urge, with some suggestions of the Czech tendency towards pictorialism. If fluency and a sort of expressive

conformity to type (not devoid of vigour) are Morawetz's trademarks, Joachim is recognizable by the high polish of sonorous detail in his music. Joachim is strictly schematic in ordering materials and stating ideas. His *Music for violin and viola* (1954) proceeds on an inexorable and evenly regulated rhythmic plan, and creates a very special sound-world, comparable perhaps to certain things in Webern. His *Concertante* (1956) for string orchestra, solo violin, and a percussion section consisting of bongo drums and gongs, is a *tour de force* of rhythmic development in which virtuosity and strangeness are justified by essential simplicity, economy, consistency, and drive (see example 3).

The youngest generation of composers (those at present between 25 and 35) contains some striking talents, among whom are Harry Somers, Harry Freedman, Pierre Mercure, François Morel, and Roger Matton. Most of these composers received the bulk of their training in Canada. It must be noted that John Weinzweig's influence on younger composers was one of the remarkable features of Canada's music in the years 1947 to 1951: most of the emergent talent of that period came from his classes.

The younger Montrealers, who in a sense form a group by themselves, none the less reveal a variety rather than a unity of style. This may be illustrated by mentioning and describing briefly four important works performed in Montreal in recent seasons. *Le rite du soleil noir* is an orchestral tone-poem by Clermont Pepin with an elemental percussiveness derived from Stravinsky and a harmonic palette similar to that of Scriabin. *Cantate pour une joie*, a choral-orchestral piece by Pierre Mercure, stems from the pageant-like musical-dramatic works of Honegger. The *Trois poèmes de Saint Jean-de-la-Croix*, set for chamber ensemble and voice by Gabriel Charpentier, have a sort of endless melodic flow and a lack of tension in the phrasing which link them with medieval music on the one hand and with Messiaen on the other. The *Piano Variations* of Serge Garant are an essay in a sort of rarefied twelve-note idiom, based largely on the discoveries of Webern, though rather more explosive in content than this might imply. These are all fine mature works: but hearing them one after the other a listener would scarcely guess that the four composers knew each other.

By far the most prolific of the younger composers, Harry Somers also possesses the most distinctive personal voice. His one-movement *Symphony No. 1* (1952) is cumulative in design and

in physical impact, and epitomizes some central features of his creative thinking. It begins slowly and monodically, with a single timbre, progresses by gradually increased momentum, colour, and complexity of devices, until capped by a fugue; a brief epilogue serves to subside and relax the musical energies after this 25-minute climb. The language is atonal, polytonal, sometimes carelessly modal, again for some stretches serially chromatic. The slow melodies are open, broad, and wayward; the faster passages primitivistic in impulse (see example 4). A curious ironic combination of the classical and the primitivistic is attempted in various recent works of Somers, a most successful example being a scene in his ballet score *The Fisherman and His Soul* (1956), where trumpets blare out little staccato comments of savage rudeness against serene tonal progressions in the strings. Repetitive forms such as rondos, fugues, or passacaglias, are favoured by this composer in his most recent works, some striking instances being the chorale movement of his *First Sonata for Violin and Piano* (1953), the passacaglia in *The Fisherman*, and the continuous and thematically unified *Five Songs for Dark Voice* (1956). The rigidity of the forms used increases, rather than curbs, the effect of physical intensity produced by the themes.

Having reviewed the field thus cursorily, from the oldest to the youngest generation, we arrive at a question which everyone in the arts seems to want to ask nowadays: is there a pattern of relationships in all this? I am tempted to answer 'No' and leave it at that. If there is a pattern it must be a very complicated one, made up of assorted squares, ellipses, triangles, and oblongs, only very occasionally converging. As consolation we may remind ourselves that this pattern differs little from the current creative-music patterns in other countries. At the same time it differs in two distinct ways from the creative-music patterns of previous eras in Canada: it is both more complicated and more vigorous.

And what about the Emergence of a Canadian Identity in music? Side-stepping the question of whether seeking such an identity is a valuable or necessary pursuit for our composers, I would like to discuss briefly the ways in which national or regional features can make themselves felt in music.

First of all, obviously, music can associate itself with literature. Canadian music shows many instances of this: Nelligan, Pratt, Birney, Livesay, have all been set by composers in recent years.

Secondly, music can associate itself with some-

thing visual, for example landscape. Not every composer has the right sort of temperament for such writing, but some beautiful examples of depictive or evocative scores exist in Canadian music, such as *Tableau* by Harry Freedman and *North Country* by Somers.

Thirdly, music can adopt folkloric content. In the above summary of composers and their works it was found that those between 55 and 65 seem to be the most frequent users of folk-song. This particular possibility seems to attract the younger men less strongly. The question is worth discussing for a moment.

Canada has a rich musical folk-lore—or rather, several different rich musical folk-lores: French-Canadian, Maritime, Indian, Eskimo, Western-settler, and so on. The collecting and editing of folk music, in which Canada has an internationally known authority in Marius Barbeau, continues; and a Canadian Folk Music Society has recently been formed. One of the Society's stated aims is to foster the use of folk-song material by serious composers. Personally I foresee two problems in this. First of all, the folk music itself, with the possible exception of the Indian material, which is, in any case, ours by adoption only, is not musically distinct. There are no recognizably Canadian cadence-inflections, intervals, or scales, comparable to the marked features of, say, Hungarian or Spanish folk music. Secondly, there are limits to what a composer can do with a folk-tune. He can harmonize it, or surround it with evocative harmonies or special instrumental colouring. When he starts to work with it in a creative way, he usually finds he can either repeat it, alternating it with original material in the manner of a rondo, or he can write variations on it. If he wants to develop it or get solemn about it, the charm and simplicity of the material is going to be destroyed, and the effect is going to be hollow. Though favouring the use of folk-song by composers, I believe it is wrong to expect the most profound artistic results from such use. A warning is contained in one of the most vacuous musical works of the twentieth century, the *String Quartet* of Sibelius, where again and again three instruments hold or waver on interminable chords while a fourth pronounces the phrases of a most innocent folk melody, and the cadences fade off into long diminuendos of 'Nordic mist'. That sort of pretension in handling folk music is surely to be avoided.

At the same time the music adopted as model or as source-material must be really good in a musical way, and not just because it happens to

Passage from the first movement of *John Weinzweig's Violin Concerto*, in the composer's manuscript. Permission, the composer.

be indigenous. I personally enjoy hearing the recordings, now being made in abundance, of aged farmers' wives singing songs they knew sixty years ago. I think, however, that I enjoy them for the richness of character and memory that comes through the microphone, and not for any intrinsic musical values. The tunes are mostly quite mediocre and derivative. More rewarding to the Canadian composer than resurrecting such crude home-made pieces from the rural past would be to gain closer acquaintance with the music produced by the musically trained people of nineteenth-century Canada. Most of this is bad, too, but not bad in a crude way. We have to respect the musical correctness of it. This literature comprises the dance music, the salon pieces, and particularly the early hymnals produced in Canada in

the last century. At a slightly higher level we have also the band music and pianistic extravaganzas of men like Calixa Lavallée. The early hymnals are fascinating. Compiled, and sometimes also engraved, by small-town émigré musicians, they usually consist of a preface setting forth the rudiments of musical notation, for people to teach themselves, and then continue with a series of hymns and religious songs, some new and rousing, others traditional, still others adapted from reflective instrumental pieces by the classical masters. American composers of today have found unique forms and inflections in the study of their eighteenth- and nineteenth-century musical publications, humble though these may be: they have proved an important impetus to new writing in the United States, and possibly Canadian compo-

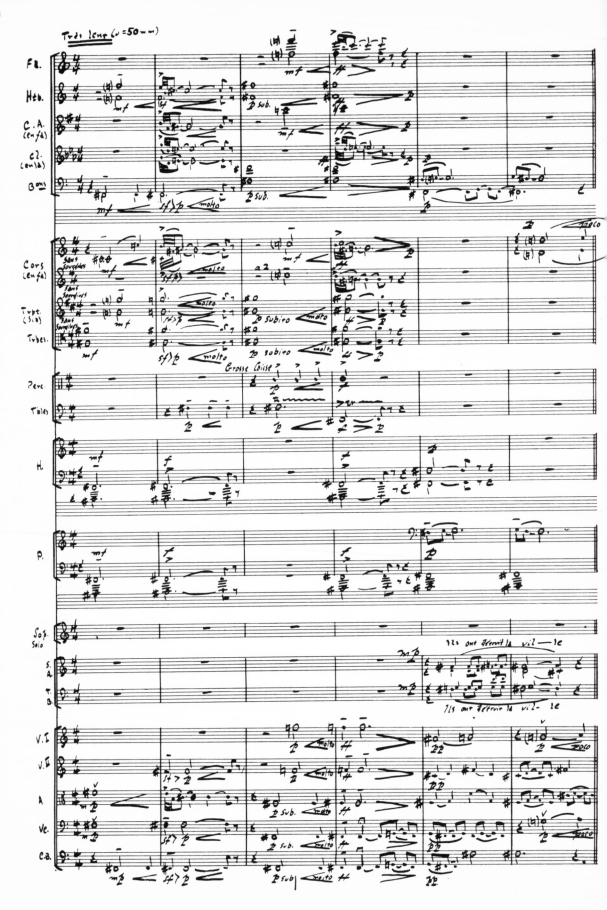

Opening of the third movement of *Pierre Mercure's Cantate pour une joie*, in the composer's manuscript. Permission, G. Ricordi and

Company, Toronto, Ltd.

sition may yet have the same sort of experience.

These then are some ways in which the Canadian composer *might* become perhaps more closely related to contemporary Canadian life: through concern for our literature or our landscape, through closer study of our native musical tradition—both in folk music and in composed music. However, if music is to form a strong part of Canadian culture, all the effort cannot be from the composers' side. It is, I think, possible to point out certain general conditions which would benefit the growth of the country's music and help to effect its integration in the pattern of our cultural life.

First of all, something can be done in the concert sphere. Performers and conductors can assist by playing, often, and well, more of the great masterworks of the twentieth century, the epochal pieces on which the musical developments of our time—in Canada as much as elsewhere—have been based. This will help to make clear the relationship of Canadian composers to current international idioms. They can assist in another way, too. When they are asked to programme a Canadian work, or when their conscience (artistic or patriotic) moves them to programme a Canadian work, occasionally, at least, they might choose a major one! A five-minute orchestral piece by, say, Jean Coulthard, sandwiched between Bach and Dvorak in a symphony programme looks and sounds like a mere gesture. Now and then risks might profitably be taken on larger works such as symphonies and concertos.

Something can be done in the fields of scholarship and criticism. It is an encouraging thing that two ambitious new music journals have been started up in Canada since 1955: the *Journal Musical Canadien* in Montreal, and the *Canadian Music Journal* in Toronto. Moreover, the country's existing scholarly journals seem to be turning their attention to music more frequently than in the past. There are, however, still no published monographs or books on the works of Canadian composers, and in several cases these are clearly overdue.

Something can be done by the music publishers: but perhaps not much. Most of the Canadian publishers deal in instructional piano pieces and church anthems, the sort of material they can sell in large quantities and on which they can expect sure returns. Publishing anything of more serious scope is just impractical. People, even professional musicians, no longer buy printed music for casual enjoyment in the way they do books. Under the circumstances it is often surprising how much the publishers do manage to bring out, in the realm of more substantial musical fare.

But there remains one sphere in which perhaps a great deal can be done. The Canadian record business is large and rapidly expanding. There is a big market for long-playing records, and the records themselves are relatively cheap to produce. One looks in vain for a Canadian parallel to the Deutsche Grammaphon Gesellschaft's *Musica Nova* series or the Modern American Composers series put out by Columbia in the United States. These are both ventures by commercial companies which are very helpful to the musical community and which surely reflect much prestige on the companies themselves. Without entertaining hopes of governmental subsidies (although these would be very useful too!), I am inclined to think that the single event which would most effectively advance the state of Canada's music at present would be the conversion of just one Canadian recording executive to a sympathy and zeal for the work of Canadian composers.

But the most important question of all is this: is our music worth fostering? Is it worth the attention of the intellectual community in the way Canadian art and poetry are? In short, is it good? Professor Graham George of Queen's University, in an article in *Culture* devoted to a survey of certain Canadian composers' styles, concludes that there are six composers in the country 'whose technique is', as he puts it, 'potentially adequate for the expression of serious musical thought', though he mentions that 'at least three composers important to the development of Canada's music' are omitted from his survey. The composers, by the way, are not named. The phrase 'potential adequacy of technique' seems to me both pessimistic and over-cautious; so does the estimate given. It is perhaps a question of artistic criteria; but, if asked how many composers in Canada today are writing music of interesting and serious enough content to make me, personally, anxious to hear their next composition, I should say about thirty. If we have no one composer of undeniable genius, we have several composers who write with vigour, individuality and correctness—and who have produced individual works of genius. A true cause for pessimism, perhaps, is that our chief composers do not yet loom large on Canada's intellectual and artistic scene. This is a reflection or recurrence of a world-wide problem in contemporary music. Its solution would seem to lie partly with the intellectual and artistic sector of Canadian society, and not altogether with the composers themselves.

BALLET

KEN JOHNSTONE

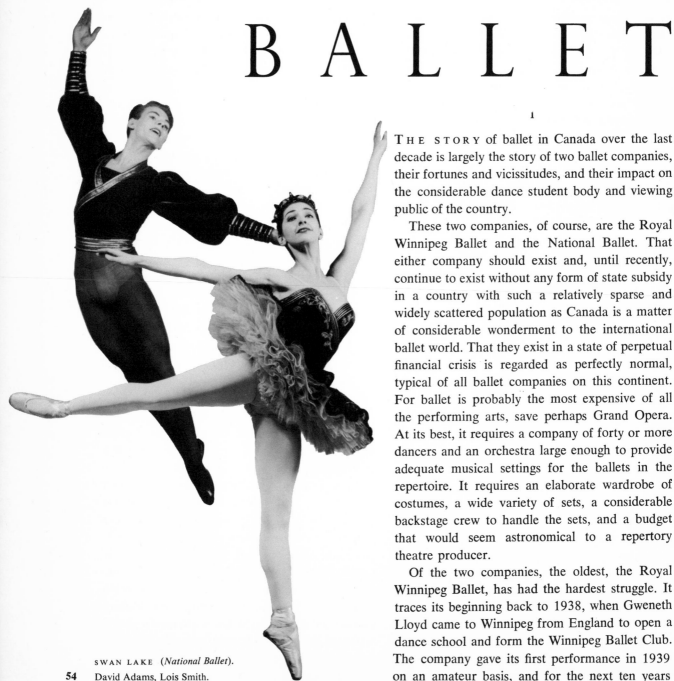

BALLET

1

THE STORY of ballet in Canada over the last decade is largely the story of two ballet companies, their fortunes and vicissitudes, and their impact on the considerable dance student body and viewing public of the country.

These two companies, of course, are the Royal Winnipeg Ballet and the National Ballet. That either company should exist and, until recently, continue to exist without any form of state subsidy in a country with such a relatively sparse and widely scattered population as Canada is a matter of considerable wonderment to the international ballet world. That they exist in a state of perpetual financial crisis is regarded as perfectly normal, typical of all ballet companies on this continent. For ballet is probably the most expensive of all the performing arts, save perhaps Grand Opera. At its best, it requires a company of forty or more dancers and an orchestra large enough to provide adequate musical settings for the ballets in the repertoire. It requires an elaborate wardrobe of costumes, a wide variety of sets, a considerable backstage crew to handle the sets, and a budget that would seem astronomical to a repertory theatre producer.

Of the two companies, the oldest, the Royal Winnipeg Ballet, has had the hardest struggle. It traces its beginning back to 1938, when Gweneth Lloyd came to Winnipeg from England to open a dance school and form the Winnipeg Ballet Club. The company gave its first performance in 1939 on an amateur basis, and for the next ten years

SWAN LAKE (*National Ballet*).
54 David Adams, Lois Smith.

gradually built up its repertoire and reputation until in 1949, backed by a citizens' committee, it became professional. But with the transition from an amateur to a professional basis, the company's difficulties really began. To provide a long enough season for the dancers, a ballet company must travel, and travelling in Western Canada, particularly for a ballet company, is prohibitively expensive. The long jump to Eastern Canada, where audiences are more concentrated, presents similar problems. The logical solution has always appeared to be the United States, where there is a large ballet audience and where a great number of cities can be covered in a relatively short time. But an unknown company venturing into the United States must expect lean years before it can build up a reputation sufficient to justify profitable houses. This was the experience of the Winnipeg Ballet, as it was to be that of the National Ballet later. To make matters worse, Gweneth Lloyd moved to Toronto, and the company lost its most forceful personality and leading choreographer. Between 1938 and 1949 Gweneth Lloyd created a total of 32 ballets. In 1950 she produced her celebrated *Shooting of Dan McGrew,* for which the company became best known. But in the next seven years the company added only three Lloyd ballets to its repertoire, of which the 1952 *Shadow on the Prairie* is probably the finest she has yet done. In this same period the company went through some violent ups and downs.

A peak was reached in 1951, when the company was called upon to give a Command Performance to the then Princess Elizabeth and the Duke of Edinburgh. Two years later it was able to change its name from the Winnipeg Ballet to the Royal Winnipeg Ballet. It added some classical ballets to its repertoire and in 1954 enjoyed a short American tour with Alicia Markova which was an artistic success but a financial disaster. Then, in the same year, a fire destroyed the company's physical assets—sets, costumes, props, musical scores, lighting equipment as well as the home base. There were few who thought the company could survive. But ballet companies, though chronically ailing, are hard to kill. By the following year a financial campaign that was centred in Winnipeg but extended to supporters throughout Canada assured the group's reappearance on a more modest scale with Betty Farrally as artistic director and Carlu Carter and Bill McGrath as leading dancers.

Meanwhile, in 1951, the National Ballet had been formed, headed by the talented Celia Franca. Although both groups disclaimed any rivalry, rivalry was inevitable both in competition for dancers and for the widely scattered but growing public. And in such a rivalry, all the advantage lay with the company closest to the largest potential public, the National Ballet in Toronto.

A ballet company depends very much for its growth and quality upon its artistic director, and the departure to Toronto of the hard-driving and prolific Gweneth Lloyd was a crushing blow for the Royal Winnipeg Ballet. Betty Farrally, an admirable ballet mistress, could not hope as artistic director to match the experience and background of Celia Franca in her effort to maintain the Royal Winnipeg Ballet on a comparable level with the National Ballet any more than the company itself could match the salaries, however modest, that the National Ballet was able to pay its dancers. Realizing this, Betty Farrally enlisted the support of two talented American dancer-choreographers, Ruthanna Boris and Frank Hobi. The size of the company was sharply scaled down to meet the small, available budget, and Boris and Hobi did a brilliant job of creating the nucleus for a well-trained, balanced and versatile company. The only opportunity that Eastern Canada was offered of seeing the new Winnipeg Ballet was on a CBC television programme, but this was enough to prove that the Royal Winnipeg Ballet had reached a higher performing level than ever before — despite the absence of such former stars as Jean Stoneham, Arnold Spohr, Eva Von Gencsy, Carlu Carter and Bill McGrath. The company performed in Winnipeg and had a short Western tour in Canada and the United States, but difficulties developed between the two American stars and the backers of the company—difficulties over the requirements of a professional company and the budget available to support such requirements. Boris and Hobi did not return last year and another American, Benjamin Harkarvey, was engaged as artistic director and ballet master. At this stage it is difficult to predict exactly what the future will be for the Royal Winnipeg Ballet. The basic problem that confronts this company is still the same: how to build a professional company on an amateur budget. The competition of television and the National Ballet makes it impossible for Winnipeg to secure first-class dancers at the salaries formerly paid, and Winnipeg and Western Canada alone cannot provide a sufficiently long season to maintain these dancers in employment for any length of time. If the company ventures into Eastern Canada and the United States, it will need a greatly increased budget, and it must maintain a level of performance far surpassing the semi-amateur work of the forties.

Possibly the greatest achievement of the Royal Winnipeg Ballet to date has been the revelation that Canadian themes and settings (such as those for Gweneth Lloyd's *The Shooting of Dan McGrew* and *Shadow on the Prairie*) offer appropriate and exciting possibilities for ballet treatment. Then, too, in Arnold Spohr the company developed another choreographer of considerable promise. But Spohr, like so many other talented Canadians, has gone abroad. Indeed, most of the other dancers who were with the Royal Winnipeg Ballet in its most successful days are now in Eastern Canada or on the West Coast, where year-round employment for dancers is available. Subsidy is needed desperately, and the support of the Canada Council, if continued, may yet save the day.

II

The National Ballet is of more recent birth, but in its brief seven years it has had a tremendous impact upon the development of the dance in Canada. It is a wry fact that the founders of the Royal Winnipeg Ballet were the initiators of a movement which led directly to the founding of the company which was soon to become Canada's chief representative in the ballet world. For it was in 1948 that the first Canadian Ballet Festival was held in Winnipeg, initiated and organized by the then Winnipeg Ballet. From that and subsequent Canadian Ballet Festivals held in Toronto and Montreal, a group of interested Torontonians (with the support of the T. Eaton Company) conceived the idea of building a professional ballet group in Eastern Canada, taking advantage of the wealth of dance talent and choreographic promise revealed by the Festivals.

Undoubtedly Gweneth Lloyd, Toronto's Boris Volkoff and other Canadian artistic directors were considered as possible personalities around which to build the new company, but it was finally decided to secure someone from abroad, probably in the hope of surmounting local rivalries. The advice of Sadler's Wells' Ninette de Valois was sought, and she recommended Celia Franca, an English dancer-choreographer and artistic director who had already made a reputation for herself in England as a company organizer. That the decision was a sound one has now amply been proved, but for the first few years Celia Franca had a hard uphill battle to gain acceptance from Canada's many dance teachers. Her single-minded dedication to the task of building a company of the highest possible artistic and performing level (and her considerable success in working towards this still unattained goal) has finally won them over. Today most Canadian dance teachers, who formerly looked towards the United States or Britain, now groom their most talented pupils for the National Ballet and they find in Franca an eager collaborator who grants numerous scholarships each year to the National Ballet's summer school for promising students from all over Canada.

While the Royal Winnipeg Ballet based its repertoire on the ballets of Gweneth Lloyd, who dis-

INTERMEDE (*Royal Winnipeg Balle*

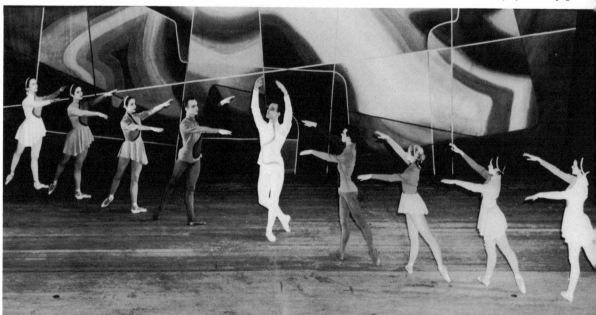

played a tremendous range of inventiveness, Franca chose to start her company with the classics, later adding to them from the hitherto neglected ballets of one of the greatest of modern choreographers, Anthony Tudor. Thus, the first performance of the National Ballet on November 12, 1951, consisted of *Coppelia* (Act 2), *Les Sylphides*, the 'Polovetsian Dances' from *Prince Igor* and the 'Pas de Deux' from *Don Quixote*—all established classics. The first Tudor ballet, *Lilac Garden,* was given in 1953, but Franca did not neglect Canadian choreographers. *Ballet Composite*, by David Adams, *Etude,* by Kay Armstrong and *Ballet Behind Us,* also by Adams, were added in 1952, along with two ballets by Franca herself, as well as several classical ballets.

At this writing, the National Ballet has some thirty-three ballets in its repertoire, including full-length versions of *Swan Lake* and *The Nutcracker* (heroic accomplishments for any company), four Tudor ballets, one ballet by that other great present-day choreographer, Frederick Ashton, and ten ballets by Canadian choreographers. These latter include *Dark of the Moon,* by Joey Harris, *Lady from the Sea*, by Elizabeth Leese, *The Fisherman and His Soul by* Grant Strate, *La Llamada* by Ray Moller, *Post-Script* by Brian Macdonald, *Pas de Chance* by David Adams, and *Jeune Pas de Deux* by Grant Strate. Thus, in recent years, Franca has leavened her repertoire of classical ballets (and the modern classics of Tudor) with much new work by Canadian choreographers. These works,

it must be admitted, still fall considerably short, in choreographic quality, of the well-performed classics, and the beautifully interpreted Tudor ballets which have brought the company its highest praise.

And, too, the National Ballet has welcomed Canadian composers. Hector Gratton, Louis Applebaum, Saul Honigman, Harry Somers, Arthur Morrow have written the music for various of the original Canadian ballets. Kay Ambrose has designed by far the majority of the sets and costumes. Her versatility and ability at improvisation have been invaluable in making a modest budget go as far as possible, and this has undoubtedly been a factor in giving her a near monopoly of the sets and costume designing.

A glance at the box-office record of the National Ballet in its six seasons to date tells a story of remarkable growth and at the same time emphasizes the uneconomical nature of ballet production. In its first season, 1951-2, the company gave 19 performances to 12,513 spectators, with a gross box office of $44,674. This together with donations of $43,057 resulted in a deficit of only $24.18! The second season was considerably expanded: 42 performances to 62,435 spectators with a box office gross of $117,400 and donations of $39,200 and a still relatively modest deficit of $1,053. Then the company made its first cross-Canada tour and ventured into the United States. It gave 121 performances to 80,770 spectators, collected $150,075 at the box office and $57,316 in donations and saw its deficit swell to $28,212. This resulted in a

sic by Cimarosa, Setting and Costumes by John Graham, Choreography by Arnold Spohr.

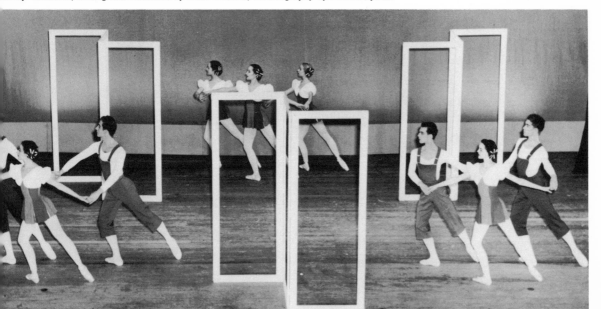

sharply-restricted itinerary for 1954-5. In this year 53 performances before 69,831 people yielded $128,973 at the box office. Though $56,167 was collected in donations, the deficit jumped to $48,727. The following season saw an expanded tour, with 70 performances before 89,183 people, yielding $161,559 at the box office. And although a record $102,124 was collected in donations, the deficit nearly doubled to $83,878. In the season 1956-7, the National Ballet clearly established that it was playing to a growing audience. Though it gave 97 performances, 24 less than its record of 121 in 1953, it played to nearly twice as many patrons, 147,595, and collected $282,800 at the box office. Final figures for the season are not available at this writing, but it is probable that despite this great increase in audience, the deficit was correspondingly greater. Ballet is not a 'paying proposition' anywhere. The American Ballet Theatre has cost its chief 'angel', Lucia Chase, over three million dollars to date. Clearly, the continuing support of the Canada Council is necessary to the survival of both our leading ballet companies.

But the value of the National Ballet cannot be measured in terms of its annual deficit. The company is now at last keeping the finest of the country's dancers in Canada, and it is raising the dance to standards never attained before the existence of the National Ballet. Similarly, it is offering a Canadian stage for Canadian choreographers, composers and designers. No mean achievement in these few years.

And Celia Franca and ballet mistress Betty Oliphant have had a tremendous effect upon the teaching standards of Canadian ballet schools. When they emerged on the scene, ballet was generally taught by one of two methods (when there was a method at all). There was the Russian method, used by Boris Volkoff in Toronto and others trained in the old Russian tradition. And there was the Royal Academy method, developed in England as a guide to teachers in communities where professional standards were not available. The second method worked well. It still works, and it was employed by Gweneth Lloyd and her teachers at Winnipeg and later at the Banff School of Fine Arts. In the case of the Russian method, the level was set by the individual ability of the teacher and that teacher's memory of what had been taught him. With Volkoff it produced some brilliant results. Melissa Hayden received her first training from him. But with less-talented teachers it produced pupils erratically trained in only a rough approximation of what was correct Russian practice, for there was no central point of reference or

rule by which teachers could be governed. The Royal Academy method, useful in maintaining a minimum standard, did not pitch standards high enough to meet the technical requirements demanded by Franca. She therefore proceeded to introduce the Cecchetti method, developed by the famed ballet master Enrico Cecchetti and organized into a system of teaching by his disciples of the old Diaghileff Ballet. This system has rapidly spread through the most advanced ballet schools in Eastern Canada and is supported by regular and strict examinations conducted by Franca, Oliphant, and examiners from England. By this system, Franca is able to assure her company of a constant flow of young ballet blood trained in a uniform method that is practised not only at the school of the National Ballet but also by other major ballet companies abroad. And since the method is carefully worked out to develop fully professional dancers, the level of the dance now achieved by Canadian studios has been raised considerably.

III

Apart from the existence of the Royal Winnipeg Ballet and the National Ballet, dance in Canada in an organizational sense has had a very episodic

THE FISHERMAN AND HIS SOUL (*National Ballet*). Harold da Silva, Earl Kraul, Lilian Jarvis.

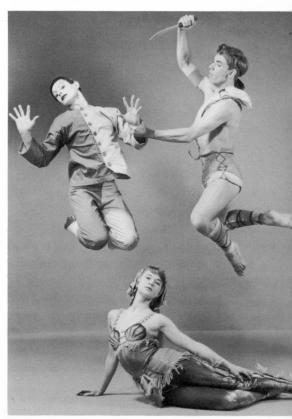

character. Two talented Latvian dancers, Jury Gotshalks and Irene Apine, settled briefly in Halifax when they first came to Canada in the late forties and formed the nucleus of an amateur company there. Then they came to Toronto and danced several seasons with the National Ballet. However, they were unable to fit into Franca's long-range plan for a homogeneous company, and they moved to Montreal where they are frequent performers on television.

To Montreal, too, gravitated Eva Von Gencsy and Eric Hyrst, the latter a brilliant if erratic English dancer who was briefly and violently with the Winnipeg Ballet. They joined the company of Ludmilla Chiriaeff, which performs almost exclusively on television. Civic grants by the theatre-minded administration of the City of Montreal have kept two Montreal ballet companies alive. The Montreal Theatre Ballet, founded by Brian Macdonald in co-operation with choreographers Joey Harris and Elizabeth Leese, put on two seasons of performances, accumulated a sizeable debt and lost its founding artistic director, Macdonald, when he had differences both with the dancers and the Board of Directors. However, a grant of $7,000 from the city put the company back in business again. Guy Glover, Ken Withers and Don McGill were appointed as the board of artistic advisers and Elizabeth Leese was persuaded to become dance director and ballet mistress of the company. First important addition to the strength of the company came with Irene Apine and Jury Gotshalks. With the new artistic direction definitely turned towards contemporary ballet, it would seem that this company has a definite role to play in the Canadian ballet world.

Les Grands Ballets Canadiens of Ludmilla Chiriaeff have not offered as many public performances as the Montreal Theatre Ballet, but are often seen on television and may possibly rank as the first television ballet company in Canada. However, an arrangement with Gratien Gélinas has made his new theatre, Comédie Canadienne, available to this company for Saturday afternoon performances. It was also made available to the Montreal Theatre Ballet for specific performances. Since the emphasis in Les Grands Ballets Canadiens has been on the classical tradition, in a sense the two companies complement each other and keep the local scene busy between visits of the National Ballet.

In both Toronto and Montreal, television has

DARK OF THE MOON (*National Ballet*).
Celia Franca, David Adams.

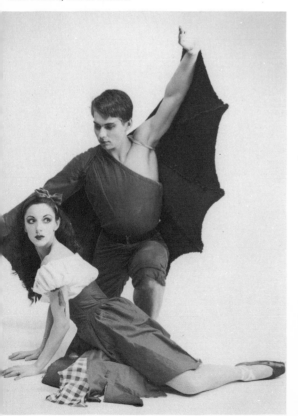

ROUNDELAY (*Royal Winnipeg Ballet*).
Beverley Barkley, Virginia Wakelyn, Richard Rutherford.

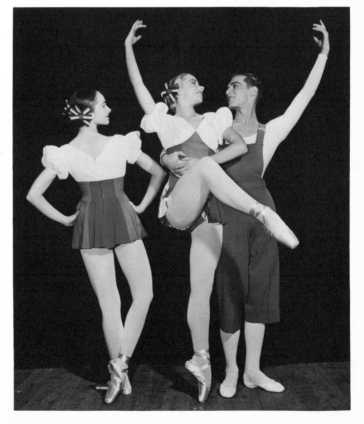

opened up lucrative careers for many dancers, but the absence of adequate dance knowledge on the part of television producers has sometimes resulted in performances that have done more to hurt dance with the general public than to win converts. However, a few scintillating performances by the National Ballet and the Royal Winnipeg Ballet have helped to remedy the situation. Both 'Folio' in Toronto and 'Concert Hour' in Montreal have displayed some fine dancing on the part of New York companies, but the regular Canadian dance productions that appear on television have with rare exception revealed either a dismal lack of imagination or too much haste on the part of the choreographers responsible. Only exceptionally gifted choreographers can hope to produce a regular weekly show without running out of ideas half-way through the season. And the speed essential to television production does not lend itself to serious dance creation in that medium. Faking and repetition become automatic.

Vancouver, which has probably given the dance world more talent per capita than any other city in Canada, still does not support a professional company. Yet its sons and daughters fill the rosters of the National Ballet, the Royal Winnipeg Ballet, CBC television groups, and dance companies in New York and London. It has always proven a warm host to visiting companies, and its Ballet Club is unique in Canada.

Modern Dance which, ten years ago, showed promise of taking root in this country, has languished in recent years. One of its most serious exponents, Yone Kvietys of Montreal, went to Chicago, and Cynthia Barrett of Toronto has expressed herself almost exclusively in television shows. Elizabeth Leese, of Montreal, who continues to teach modern dance at her studio, along with classical ballet, frequently makes use of its range of movement in her own ballets, and Juliette Fischer of the same studio has kept closely in touch with recent American developments in this *genre*. José Limon has been seen several times in Harvey Hart productions of 'Folio', notably in *The Moor's Pavane* and *Emperor Jones*, but the decline of interest in modern dance, except in the universities, may be attributed to the rise of the National Ballet with its emphasis on the classical tradition. Modern classical choreographers have not hesitated to borrow from the vocabulary of modern dance for their own purposes, but in so doing have robbed it of its previous novelty. In Canada, modern dance tends more and more to be absorbed into ballet as the latter reaches out creatively in all directions for nourishment and enrichment.

opera

BOYD NEEL

opera

DON GIOVANNI by Mozart (*Vancouver Festival, 1958*).
Set by Ita Maximovna.

OPERA IS a convention with a tradition always attached to it. Part of the tradition is the acceptance of the convention. Opera is essentially a growth and is a form of art which cannot possibly appear in a short space of time in any civilized community. The difficulty with young countries is that they do not possess any tradition, so that the growth must be a slow and tedious process. The roots of opera came from Italy in the seventeenth century. The operatic art gradually spread across Europe and established itself in other countries, the tradition, however, always being that of the original Italian opera. Even the greater German composers of the eighteenth century were enormously influenced by Italy; in fact, it could be said that a composer such as Handel was a German who wrote Italian operas. It was nearly two hundred years before any Nationalism could be discerned in the world of opera, and it was only towards the end of the nineteenth century that the great distinctive National schools appeared in their full strength. Yet even then we can find traces of the original Italian beginnings. One would think that in such an essentially Germanic work as Wagner's *Ring* there would be little trace of it, yet constantly during that colossal masterpiece we find the singers breaking into florid vocal melodies which could have had their origin nowhere else but in the early Italian operas of the eighteenth century. With the founding of the great National Schools such as the German Romantic, the Russian Group and the French works of the nineteenth century, we find traditions evolving in connection with these movements. Traditions of performance, style of production and constitution of repertoire have become very powerful, and when breaks

occur in this cast-iron formula, the operatic world is rocked to its foundations. Acceptance of operatic convention is regarded as inseparably bound up with tradition and it is this stylized art with its long history that makes it so difficult for a young country to establish any operatic school of its own.

If we look at history we will see that the mere importation of foreign operatic influences does not by any means ensure that a local tradition will be founded. Great Britain has imported opera from Italy, France, Germany and Russia for the last three hundred years, and yet has never been able to form an English operatic tradition of a national variety. English operas have been written and will continue to be written and produced, but we cannot say that there is any distinctively English operatic style, either in composition, singing or production. The only possible National school, if one can call it such, that England has ever produced, has been that of the Savoy Operas, of which Gilbert and Sullivan were the most famous creators. A kind of tradition has been established here and this type of opera is probably nearer the typical English genius than any other.

The United States has not been able to evolve, as yet, a national style, although it did appear that Gershwin's *Porgy and Bess* was going to found an American operatic tradition. It never came to anything, however, and that masterpiece remains as a solitary case of a truly nationalist American opera. In the case of Canada, it is, of course, even harder to find traces of anything approaching a national opera. As far as operatic performance goes, I think that Canada, in relation to its age and size, has a very notable record, but developments here are limited by factors which no other

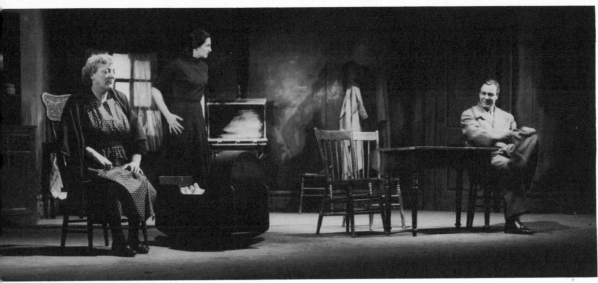

THE CONSUL by Gian Carlo Menotti (*Opera Festival Association of Toronto*). Nellie Smith, Theresa Gray, Andrew MacMillan.

countries have to contend with. First and foremost is, of course, the enormous distances between large centres. It is almost impossible for operatic productions to be taken across the Dominion at anything but crippling cost. The consequence is that the only hope of founding an opera in Canada lies in each cultural centre creating its own independent unit. This might be done on a provincial basis and things seem to be tending in that direction.

The outstanding achievement so far in Canadian opera is the Toronto company which had its beginnings in the Opera School of the Royal Conservatory of Music, formed by Dr Arnold Walter in 1946, and this has now grown into a full-fledged professional organization. During its career it has become known by various names and at present bears the title of the Opera Festival Association of Toronto. There are many who feel that this is not a satisfactory title, but it is very hard to find just the right name. It has certainly started in the right way and has, even during its short life, begun to evolve some kind of tradition of performance. Mr Herman Geiger-Torel has been the life and soul of this company from its beginning and it is due to him, more than anybody else, that a distinctive style of production is already making itself apparent. Many singers have appeared with this company who have later found fame in some of the world's great opera houses. It is to be devoutly hoped, however, that it will not merely form a training ground for Canadian talent which will vanish overseas and never return. This tragic story is all too common in the history of many artistic enterprises in the Dominion. Canada must, by every means in its power, retain its finest talents

if it is to be found and maintain a great Canadian singing theatre. At present it looks as though the Toronto company may be able to achieve this.

One of the greatest stumbling-blocks to opera in Canada is the lack of suitable theatres where it can be performed. The central nerve cell which imparts life to every opera house is the orchestral pit. If this is inadequate, then the whole structure is bound to suffer. When we consider that there is no theatre in Canada at the present time which has an adequate orchestral pit, we can only wonder that there has been any progress at all.* It has been said very truthfully that at one time in Canada every county town had an opera house, but no opera. Now there is opera, but no opera houses. When the Metropolitan Opera visits Toronto each year the performances have to be given in the Maple Leaf Gardens, a building totally inadequate in every possible way for the presentation of opera. At the time of writing, however, a ray of hope has appeared on the horizon, with the news that, in two years' time, Toronto will possess one of the best opera houses in the world.

Apart from the Toronto opera company, other brave efforts have been made in many parts of Canada and it is quite astonishing to read that in a season such as 1953-4, about two hundred public performances of some fifty operatic works of all types were given, employing about 1,200 performers. The activity in subsequent years is probably greater. Some of these performing groups are of fully professional stature, such as the Toronto Opera Festival, Melody Fair and Vancouver's

*Since this was written, Calgary and Edmonton have both built such theatres.

Theatre Under the Stars. Others might be styled semi-professional, with performances given on a student level, while some are wholly amateur.

In Montreal, the Opera Guild, founded in 1941 by Madame Pauline Donalda, has been working along the lines of the Toronto Festival Company and has now a repertoire of fifteen operas, many of which had never been heard in Canada before. Ottawa also has its Grand Opera Company and has given some eight operas since 1948.

As for opera by Canadian composers, there is not a great deal to be chronicled, and until a permanent opera theatre is established in the Dominion, it is doubtful if composers will be stimulated to write for the stage. Recently in Toronto two interesting works were performed, one by Harry Somers and the other by Maurice Blackburn. The Somers' work, *The Fool*, with libretto by Michael Fram, somewhat mystified the first-night audience, which was nevertheless impressed by its obvious originality and sincerity. Blackburn's *A Measure of Silence* was easier of comprehension, and it is hoped that both works will eventually be absorbed into the Canadian national opera when it appears. Healey Willan's operas *Transit through Fire* and *Deirdre of the Sorrows* were commissioned by the Canadian Broadcasting Corporation for radio performance. Other

operas which have had performances since the war include Graham George's *Evangeline*, Keith MacMillan's *Saints Alive*, and *The Prodigal Son* by the American composer, Jacobi, which had Herman Voaden for librettist.

In 1950 there was a production on Vancouver Island of an opera called *Tzinguaw*. This was given by a cast of Cowichan native Indians and consisted almost entirely of native songs and dances. It was written by Frank Morrison and had a great success, being repeated several times. Here again we have the glimmerings of the evolution of a national style.

Nova Scotia has not lagged behind on the operatic scene and the Nova Scotia Opera Association has been active for many years. The movement here is extremely important, in that provincial and civic grants have been given to help towards these performances—one of the first instances of governmental support of any kind for the arts in this country.

At present it would seem that the great mass of the people has not been lured into attending operatic performances in Canada. The average operatic performance still tends to be a 'social event' and it is felt in some quarters that the larger public has been frightened away because of this. Just how much truth there is in this, it is impossible to say.

SCHOOL FOR FATHERS by Wolf-Ferrari
(*Opera Festival Association of Toronto, 1954*). Joanne Ivey, Evelyn Gould, Andrew MacMillan. Set by Hans Berends.

The social aspect of opera-going was very strong in the nineteenth and early twentieth centuries, but has gradually disappeared in European countries, opera now being regarded as a 'popular' entertainment, on a level with football and horse-racing. A performance in, say, the great open-air arena in Verona, is a revelation of opera as a popular form of entertainment, but such popularity is possible only after the tradition is established. That the tradition will eventually come in Canada is just as sure as the fact that it has taken root in so many other countries.

The reader may be wondering about the type of opera which has been performed in Canada up to this time. The standard repertoire has been adhered to almost exclusively. To take the Toronto company as an example—they have, during different seasons, performed: *Orpheus, Hansel and Gretel, Gianni Schicchi, Rigoletto, Don Giovanni, La Bohème, Madame Butterfly, Faust, The Marriage of Figaro, The Magic Flute, Manon, The Bartered Bride, Cosi fan tutte, Tosca.* Great successes were scored with the Menotti operas: *The Consul, The Medium, The Old Maid and the Thief, Amahl,* and *The Telephone,* all of which have been performed many times by this company. Off the beaten track have been Wolf-Ferrari's *School for Fathers,* Puccini's *Suor Angelica* and Mozart's *Il*

Seraglio. As the work of the company expands, we hope to see it performing operas which are not in the general repertoire of companies such as the Metropolitan. In this way Canadian audiences will get a wider picture of the enormous number of works which are available to the average opera company.

There is one operatic venture in Canada which surpasses all others in its adventurous policies. I refer to the Canadian Broadcasting Corporation Opera Company, which was formed some ten years ago in the Toronto studios of the Corporation. Largely owing to the untiring efforts and enthusiasm of Terence Gibbs, the producer, this company has given superb performances of many operas which would otherwise have never been heard by Canadian music lovers. Britten's *Peter Grimes*, Janacek's *Jenufa*, Benjamin's *Tale of Two Cities*, Walton's *Troilus and Cressida* and Stravinsky's *Rake's Progress* are among the works which have been heard in this series.

In Montreal the repertoire is also extremely interesting and operas such as *Otello, Louise, Coq d'or* and Prokofiev's *Love for Three Oranges* have had performances there.

It cannot be said that Canadian operatic ventures have been timid in their artistic ambitions and it will be an exciting day when a completely Cana-

THE ABDUCTION FROM THE SERAGLIO by Mozart (*Opera Festival Association of Toronto, 1957*). Set by Hans Berends.

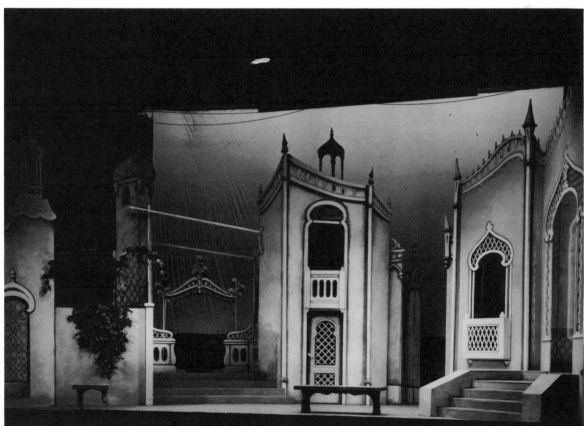

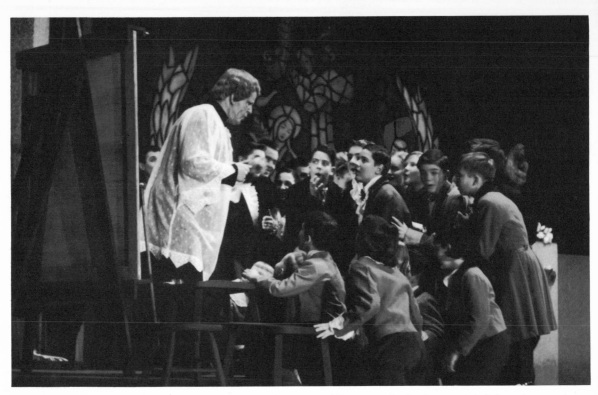

TOSCA by Puccini (*Opera Festival Association of Toronto, 1957*). Bernard Turgeon as the Sacristan, and choir boys.

dian opera is sung by a completely Canadian cast in a new Canadian opera house. In order to keep our singers in this country it is essential that they be given opportunities to practise their art, and the establishment of a great Canadian singing theatre is one of the prime essentials in the musical development of the Dominion. Not only would the establishment of such an institution help Canadian singers, but it would be a focal point round which every musical activity could revolve. As in Europe, young conductors could be trained here, orchestral players would find permanent employment, scenic designers and ballet dancers would be on the permanent payroll, not to mention the dozens of coaches, stage mechanics, costume makers and scene painters, who are always attached to every great opera house the world over. That this may come quite soon is no idle dream. It is merely a matter of co-ordinating all the musical forces that Canada possesses today.

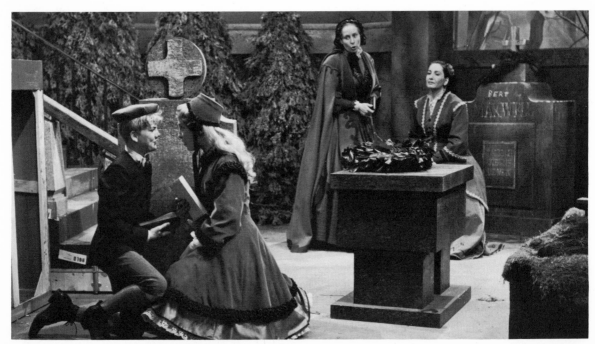

THE TURN OF THE SCREW by Benjamin Britten (*C.B.C. 'Folio', May 1st, 1958*).
Billy Potten, Shirley Martin, Judith Pierce, Theresa Gray.

Theatre in English-speaking Canada

MAVOR MOORE

Theatre in English-speaking Canada

I

THE 1957 edition of the *Oxford Companion to the Theatre* furnishes the following information under 'Canada':

'This vast Dominion (*sic*) with its scattered population and its division into French- and English-speaking groups, offers the paradox of a country which combines *the complete lack of a professional theatre* with an immense theatrical activity. *Forced by the conditions of their life to depend very much upon themselves for amusement,* Canadians in town and country have been enthusiastic advocates of the Little, Amateur or Community Theatre movement. The infrequent (*sic*) visits of American and English touring companies have been welcomed in the larger towns . . . and have no doubt done much to encourage the local amateur groups. But it is on these groups that the main burden of theatrical entertainment falls. . . . In conclusion it may be said that Canada, a young country, has a young theatre, which cannot as yet claim professional status. Yet it is probably no more amateur than were *the first plays of medieval Europe* . . .' [Italics mine]

In an attempt to explain our precipitous emergence from these Dark Ages, the *Companion* adds a supplement noting that 'A professional theatre has now come into being in Canada, with the opening in 1952 of the Shakespeare Playhouse at Stratford, Ontario', and goes on to mention other recent activities with staggering inexactitude: eight factual errors in fifteen lines—surely a record for a reference work.

Nothing spreads like misinformation; a short time ago I was approached by one of the telegraph companies in need of assistance in the delivery of a cable addressed to 'The Amateur Theatre. Toronto'. I was undecided as to whether the message should go to one of the three current professional houses, one of the half-dozen professional managements or one of the two dozen amateur groups. Canada has had professional theatre for a century.

The *Companion*'s estimate, however, does reflect the success with which Canadians have presented to the world, over the same period, a singularly blank face. It is true that the expression on the face is not easy to detect; partly because when viewed through the spectacles of European tradition it is unfamiliar (as when Occidentals, looking at Orientals, find their faces blankly similar); partly because the expression itself is both diverse and volatile.*

Far from being 'forced by the conditions of their life to depend very much upon themselves' for entertainment, Canadians have always had it thrust upon them from the outside. Klondike Mike, in 1898, was only following an already hallowed tradition when he carried a piano on his back over the Chilkoot Pass, to bring to his fellow-miners in the Yukon the delights of a girl sextet from Seattle. Throughout our history we have turned back American armies and Fenian raiders, we have rebelled against British tyranny and kept Orientals out by immigration laws; but we have welcomed with open arms any and every theatrical ploughman who ever

*Mavor Moore: 'A Theatre for Canada', *University of Toronto Quarterly*, October, 1956.

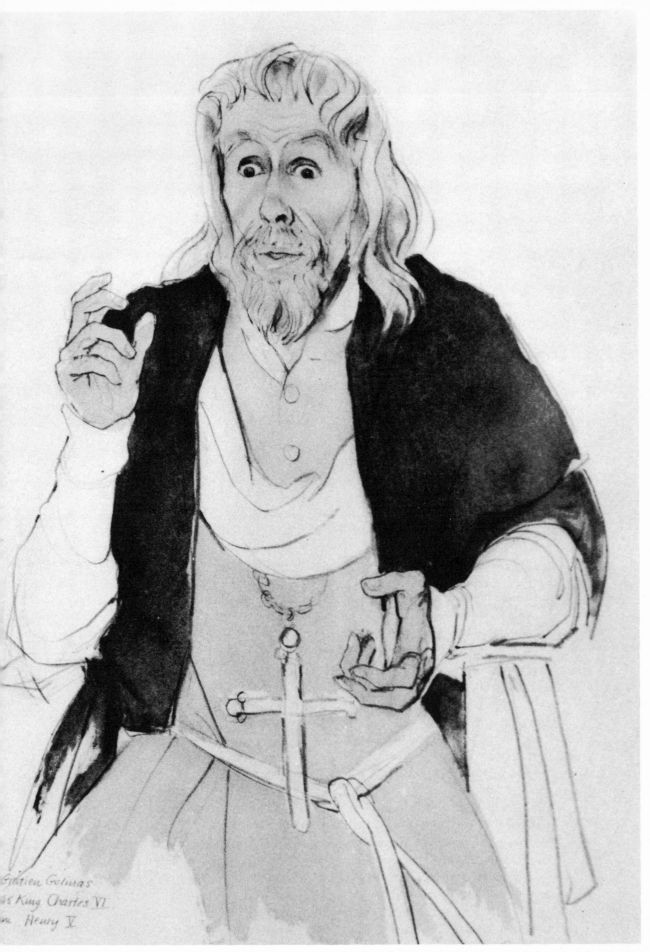

Portrait by Grant Macdonald of Gratien Gélinas as King Charles VI in HENRY V (*Stratford Festival, 1956*). From the Globe and Mail Collection.

came to dig our fertile land. (There is surely no better argument for the superiority of cultural over military conquest than the 'Canadian' theatre.) The result, inevitably, was that native performers who stayed in the country to share in its mongrel theatre, performing mainly in English or American plays, were for long unidentifiable even to their fellow-Canadians. Anonymity is the price of versatility.

Moreover, when they went abroad, either as performers or playwrights, Canadians had few obvious distinguishing marks to take with them. Charles Heavysege (glorious name) as early as 1857 wrote in *Saul* a play which became world-famous. One of the most prolific melodramatists of the American nineties was W. A. Tremayne of Montreal. A Hamilton lawyer pseudonymously penned some of Broadway's raciest farces of the twenties. Two Ottawa ladies, disguised as a single male, provided Martin Harvey with *The Breed of the Treshams*, one of his greatest romantic successes. But none of these bore Canadian birthmarks.

Later on, while Bea Lillie went to England to become, so far as most people were aware, English, and while Walter Huston and after him Raymond Massey became America's best known portrayers of Lincoln, the only show that publicly carried a Canadian label at home and abroad was 'The Dumbells', a boisterous soldier entertainment engagingly unashamed of its amateur beginnings. Only now are Canadian performers in Britain and America beginning to be regarded as foreigners, even by the jealous performers' unions. In the United States they have been considered Americans with a happy facility for speaking 'English' when required, and in Britain it has been the custom to teach them to speak English 'properly', except when their ability to play American roles without offending immigration officers and tourists has proved valuable. Recent years have brought a kind of revenge: nowadays shameless Canadians like Bernard Braden and Barbara Kelly in England, or Christopher Plummer, Donald Harron and Lorne Greene in the United States, find their native wood-notes in demand since they are (a) classless, (b) intelligible to all parties.

Our playwrights of more recent vintage, in so far as they have been represented abroad at all, have scarcely caught up with the actors. Mazo de la Roche's *Whiteoaks*, though technically set in Ontario, had not a trace of any flavour but Merry England's when I saw it in London in 1936. Robert Fontaine's *The Happy Time*, supposedly laid in Ottawa, seemed Mitteleuropan in New York.

Brian Doherty's *Father Malachy's Miracle* was a Broadway hit but an Irish one. John Coulter, an Ulsterman transplanted to Toronto, has had several plays performed abroad, but *Riel*, the only play derived from his experiences in this country, has regrettably been seen nowhere else. Patricia Joudry's *Teach Me How to Cry*, a success off-Broadway, was in no obvious way anything but American. J. B. Priestley's *Glass Cage* (although it scarcely belongs in this roster) was superficially Canadian in both setting and character, but in every way that mattered it was just tired Priestley. Ted Allen (*Double Image*) and Stanley Mann (*The Egg*) have not yet allowed native hues to colour their expatriate works, and Mary Jukes's *Every Bed is Narrow* was translated into a London comedy called *Be My Guest*: a pity, since its finest quality was its delicate capture of our speech and mores.

No wonder our face looks blank to others. Even in films a Canadian to date has been either a half-breed trapper or a Mountie, or a contrivance for casting an Englishman in a Hollywood picture or an American in an English one.

II

Is it then the case that the Canadian is indistinguishable: so North American he blends with the American landscape, so English under the skin he can become every inch an Englishman with a touch of make-up? The one patently Canadian drama to appear on Broadway since the Dumbells, the English version of Gratien Gélinas' *Tit-Coq*, was an instant flop; the critics, looking hard to find in it expected echoes of American or French theatre, failed to see or appreciate what was in fact there. The ending—a realistic and authentic resolution in the Canadian context—was found by them to be artificially theatrical. What was it that escaped them?

Under and behind and around the superficial lack of a definable Canadian personality, there has always been a stubborn streak of indigenous creativity. In the nineteenth century it was best observable in the crazy-quilt adaptation of popular melodramas to local setting, costume and dialect; in the widely read but unstaged verse plays of Wilfred Campbell and others on Canadian themes; in the occasional take-off on British or American theatrical fashions (*H.M.S. Parliament, The Big Boom*); in political 'rags'. In the twenties it found expression in the amateur movement, in the self-consciously Canadian plays performed at Hart House in the halcyon days of Roy Mitchell: of

these, Merrill Denison's *Brothers in Arms*, a one-act joke about a stuffy, anglophile business man stuck in the northern bush, has become a genuine classic. The Dominion Drama Festival, with its annual awards for the best presentation of Canadian plays, has maintained this tradition.

Then in the thirties, while the professional theatre shared in the general economic drought, radio—which overcame the geographical problems with ease—provided us with our national theatre.

The CBC 'Stage' series—anomalously but aptly named—allowed us to speak to each other as ourselves, about ourselves, in a simultaneous national union.* The federal government, until then unwilling to give direct support to the theatre, had now not only the chance but the mandate to develop Canadian talent; thus was born a typical Canadian compromise, the close co-operation of

*MAVOR MOORE: 'Radio and Television' (page 116)

the living and mechanical theatres. Television is now performing the same competitive-co-operative function, making possible far more theatrical activity than it destroys.

In this space of time since radio grew up and television began to grow, there has been a notable increase in all our theatrical activity, and a corresponding improvement in both manner and matter. Within two years of the end of World War II a dozen new professional and semi-professional groups appeared, and older organizations took on new life: Vancouver's Theatre Under the Stars, Toronto's New Play Society, Ottawa's Canadian Repertory Theatre, the Montreal Repertory Theatre, the west's valiantly touring Everyman Players and others. Summer 'stock' had a renascence across the land, a few universities launched appropriate training courses, Canadians began to 'come home' from everywhere, and from everywhere

HUNTING STUART by Robertson Davies (*Crest Theatre, 1955*). Max Helpmann, Donald Davis, Barbara Chilcott.

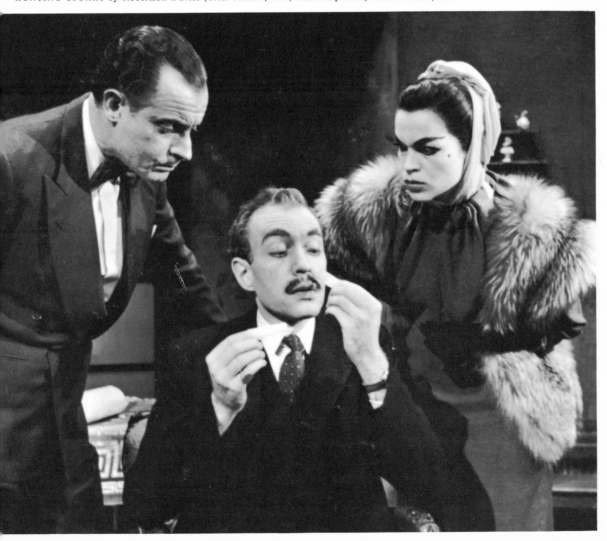

came artists who wanted to become Canadians.

Our playwrights—often, like our actors, making a living from radio and television while they worked for the stage—could speak in their own idiom and hope to see their works produced. In the season 1948-9, the New Play Society presented (in addition to some classics) plays by the Canadians Morley Callaghan, Lister Sinclair, Andrew Allan, John Coulter, Harry Boyle and myself, and in subsequent seasons plays by de la Roche, Donald Harron and others. Toronto's lamentably short-lived Jupiter Theatre produced works by Sinclair, Ted Allen, and the critic Nathan Cohen. Robertson Davies has had his plays performed by many groups, both amateur and professional. Stephen Leacock's *Sunshine Sketches* (once dramatized by the author) was the basis for a native musical comedy, and other musicals on Canadian themes such as Vancouver's *Timber* and Halifax's *Bonanza* have been successfully presented. And in Ontario, satirical revue, as it had previously in Quebec with the great comedian Gélinas, became the biggest commercial success of all with the annual *Spring Thaw*. The recent Cinderella-hit *My Fur Lady*, launched first as a McGill undergraduate show, is another example of successful home-brew.

Now while it would be a serious mistake to over-estimate this activity, no analysis of our present situation can properly be made without acknowledging that Canadian professional theatre has a B.C. as well as an A.D.

To seek a pattern in all this, to identify the stubborn native streak, is not easy, but neither is it impossible. One thing that becomes clear is that satire has been our strongest vein: Sinclair and Davies, our two most prolific and popular playwrights, are both essentially satirists; like the writers of revue they have given Canadian audiences *something they could not get elsewhere*—neither at the films (nearly all American or British) nor from the visiting theatrical companies. I do not mean that they have narrowed their purview to the Canadian scene, but rather that they have looked at the world from this time and this place.

That we have developed a penchant for what is often considered the most sophisticated of dramatic styles, should surprise only those who are unacquainted with our past. For satire has all along been our most effective form of self-defence against the very British and American culture we borrowed and were sometimes swamped by. Davies' *Fortune My Foe* is about a Canadian professor who is being wooed south by American money, and its mockery of the Canadian scene is rooted in the assumption that with all its faults it is preferable to the Ameri-

can. Ted Allen's *The Moneymakers* is about an idealistic Canadian screen-writer at loose in the psychotic Hollywood of McCarthy's heyday. Sinclair's *The Blood is Strong* is about Scots settlers in the Maritimes, and the elders who cling to old-country traditions get the brickbats. The lofty Englishman and the foxy American were, of course, stock figures of North American farce in the last century; in our topical revues they have been replaced by more modern stereotypes, and we joke about more timely matters, but the grist of our mills is basically the same. We know our neighbours better than each does the other. Almost any competent Canadian dramatist, for instance, can reproduce American speech better than the ablest of his English colleagues, and vice versa. Moreover, we are ourselves not yet so great that offence is taken at our cheek.

This love-hate, then, this borrowing-while-we-spit-in-your-eye, seems to me the most insistent theme in our theatre. And if it smacks a little of adolescence, if we see ourselves bringing up father and mother, the office is none the less important and peculiarly suited to us as members of both families. It is as necessary for Britain and America as it is for us. For only by insisting on our own fresh viewpoint and acting upon our own judgment can we earn whatever recognition others may afford us, and whatever thanks they will owe us, in the theatre as in politics or elsewhere.

The interesting thing is that all the elements of this pattern were there before the Stratford Festival in Ontario sprang an apparently new theatre on a world too ready to believe romantically that flowers arise overnight in a desert, or goddesses fully-armed burst from the brow of Guthrie.

III

With the opening of the Stratford Festival in 1953, Canada suddenly found its theatre a world concern. There were many contributing causes to this success (even including the geographical location and almost uncanny suitability of the town), but most remarkable was the confluence of auspicious stars at that time and place and the arrival of an astronomer who saw it.

Tyrone Guthrie had, among the world's leading directors, a rare knowledge of the Canadian situation. He had previously spent some months here producing a radio series, had made many friends who continued to keep him conversant with our developing theatrical life, and had at least once before contemplated coming to Canada to launch a major theatrical enterprise. When at length he

THE WORLD OF THE WONDERFUL DARK
by Lister Sinclair
(*Vancouver International Festival, 1958*).

HAMLET (*Stratford Festival, 1957*).
Frances Hyland, Christopher Plummer.
Directed by Michael Langham,
Costumes by Tanya Moiseiwitsch.

came to reconnoitre Stratford, he made a shrewd and realistic appraisal: we had the horse, ready— in Leacock's native phrase—to ride off in all directions, but with inadequate harness and no rider. A lesser horseman, a less inventive harness-maker, would have imported his harness from Britain or the United States and forced it on the wild horse; Guthrie seized the chance to fashion a new one to fit the nag. Building on our British and American traditions, but—equally important—bringing to bear all his Irish scorn for things English and his Ulster suspicion of the 'American Way', and his respect for our own ingenuous vitality, he produced an historic fusion. Call it Canadian or call it Guthrie: the elements were at once his and ours.

I believe that the future of Stratford and the future of our theatre as a whole must be measured by Guthrie's yardstick. The aim of the great director at first was to build up a corps of Canadian performers and technicians who would master the mechanics of such unfamiliarly spectacular productions and eventually (within five years, he said then) carry on themselves. This hope has not been fulfilled. In many ways it is even further from fulfilment than ever; and I fear that this is less because the Canadians have defaulted than because the fundamental elements that went to form the movement in the first place are now being slighted. Or rather let us say that the Festival continues to be successful in so far as it heeds these elements and their characteristic fusion, and will fail to the degree it ignores them.

The production of *Henry V* by Michael Langham, Guthrie's successor, was an inspired implementation of the principle of making capital out of the Canadian situation, with its two languages, two cultures and bi-national military and political history. But last year's productions of *Hamlet* and *Twelfth Night*, good as they were, bore few such marks of identity. Here were cockney gravediggers, for whose accent there is no authority other than modern English fashion; and indeed there was little

MUCH ADO ABOUT NOTHING (*Stratford Festival, 1958*). Deborah Turnbull, Anna Reiser, Sydney Sturgess, Conrad Bain, Roberta Maxwell, Eric Christmas, Christopher Plummer, John Horton, Joyce Kirkpatrick, Eileen Herlie, Diana Maddox, William Hutt. Directed by Michael Langham, Costumes by Desmond Heeley.

to distinguish the productions from those of England's Stratford except the physical difference of the stages. There is nothing inherently wrong with this, except that by merely copying our elders we shall be throwing away our dearest advantage, and inevitably ending up second best. The increasing use of non-Canadians and very new Canadians in the company can be an asset in so far (and only in so far) as it helps to maintain a high standard of performance; but in so far as it tends to minimize the difference between what we can do and what is already done well elsewhere, to negate the freshness of the Canadian approach and to drive those with stronger roots to other activity, it works against the long-range interest of the Festival.

I do not believe this view is chauvinistic. If there is a pattern in the history of the Canadian theatre, and especially if the Stratford Festival found its initial success precisely because of that pattern, it would seem sensible to continue following it. The stake is more than national: can we make a greater contribution to the theatre of the world by furnishing it with a new and vivid creature, as Tyrone Guthrie had begun to, or by multiplying copies, however skilful, of what comes naturally to others? If we are not ourselves, we shall be less than others.

In terms of skill, of theatrical know-how, the Stratford Festival has already transformed the Canadian theatre, by precept if nothing else. From its various activities have stemmed, indirectly, the Canadian Players, who splendidly revived the custom of touring into towns across the continent. Toronto's Crest Theatre, although actually an outgrowth of the prior summer Straw Hat Players, owes much to Stratford in terms of personnel and finish. And Stratford's success has bred other festivals, most notably the Vancouver Festival. Certainly the appearances of the Stratford company in New York and Edinburgh have been the most important single factor in the rise of our cultural prestige abroad; and the architecture of the Strat-

A New Canadian Flag designed by Gordon Webber for McGill University's MY FUR LADY, 1957.

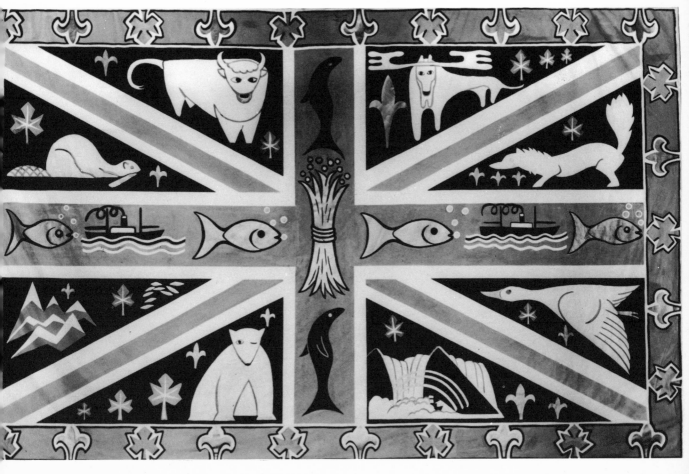

ford Theatre has stimulated new staging methods all over the world.

The Stratford Festival has now dropped the 'Shakespeare', and in its winter season of 1957-8 given us an earnest of its intent to become Canadian with a handsome production of Donald Harron's *The Broken Jug*, adapted from the German classic. But how far we can expect this unique company to play the role of a national theatre, without radically altering course, is an open question. Perhaps we can expect the by-products to be more important, in the long run, than the productions themselves. Whatever else, Stratford has challenged our native theatre to show its mettle. In Toronto the Crest has presented in fine style plays by Davies, Jukes, Mann and John Gray. The New Play Society has devoted at least one season entirely to Canadian plays. In Montreal, Gélinas has opened his new Comédie Canadienne for the presentation of plays, mainly original, in both languages; and at least two other English-language theatres are active there. Major playwriting competitions have been established, with substantial prizes, and above all the new Canada Council—with, at long last, public funds at its disposal—is subsidizing both organizations and individual workers in the theatrical arts. Our performers' unions already contain the thousands of artists the *Oxford Companion* hoped they one day might, and a Canadian Theatre Centre has been formed to facilitate the exchange of information and activity in the professional theatre in Canada, and to assist in its representation abroad.

What is represented abroad is now in the balance. If our playwrights and our performers continue to take advantage of our ambivalent position, we may well become to the English-speaking world what the Irish have long been to Britain: its favourite critic, clown and conscience. And when one adds that the future must bring an increasing awareness of our other neighbours, China, Japan and Soviet Russia, it will be seen that we are in a situation so unique in world history that merely to repeat here the patterns of other places and other times would be unforgivably stupid.

Consciences speak best from within; and the secret of our success, if we attain it, will be that we can look closely and clearly at these other peoples because there is a little of each of them in us. (It is this, I think, that makes it difficult for them to see us as we are.) We carry their traditions, but we stand slightly to the cock-eyed side of each: a perfect position from which to observe—even to observe oneself. And that, surely, is the point of having a theatre.

Le Théâtre au Canada Français

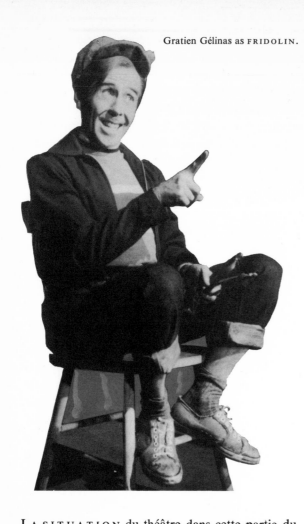

Gratien Gélinas as FRIDOLIN.

JEAN BÉRAUD

Le Théâtre
au
Canada Français

English translation, page 160

LA SITUATION du théâtre dans cette partie du Canada que l'on désigne couramment comme le Canada français, et qui se confine presque à la province de Québec, est assez singulière. Géographiquement, à cause des vastes espaces qui séparent le Québec de la plupart des autres provinces, ethniquement, parce que la langue anglaise est celle de la majorité dans l'ensemble du pays, cette situation se singularise par l'isolement auquel elle est condamnée envers le reste de la population. C'est là un état de choses déplorable, de par la force des circonstances mais aussi à cause du mauvais vouloir, apparemment peu raisonné, de tant de Canadiens de langue anglaise.

Si l'on remonte un peu loin dans l'histoire du théâtre au Canada, l'on constate que lors de la conquête de la Nouvelle-France par l'Angleterre en 1760, les premiers spectacles donnés à Montréal par les officiers de la garnison anglaise étaient joués en français, que Molière, et non Shakespeare, était leur auteur de prédilection. Ces officiers, leurs soldats, ainsi que les premiers gouverneurs de la colonie, parlaient le français couramment. Les générations suivantes de Canadiens de langue anglaise, sans doute influencées par les événements politiques, notamment par la lutte en faveur du bilinguisme d'État, crurent bon de répudier la langue française, se privant ainsi des avantages incontestables d'une double culture.

Or, il se trouve qu'aujourd'hui on éprouve une admiration parfois irraisonnée, à travers tout le pays, pour le théâtre de langue française comme il se pratique à Montréal et pour ses principaux animateurs. La situation, pourtant, reste bien complexe; elle est tout au plus satisfaisante. Elle me rappelle cette malice d'un caricaturiste montrant Maurice Rostand, fils de l'auteur de *L'Aiglon* et de *Cyrano de Bergerac*, à genoux devant la Gloire et la priant de lui accorder ses faveurs, pour recevoir cette réponse apitoyée: 'Passez, jeune homme, j'ai donné déjà à votre Père!' C'est-à-dire qu'il est des héritages très lourds à porter. On peut invoquer un témoignage plus sérieux, celui de Lucien Dubech dans son *Histoire générale du théâtre,* au chapitre qu'il consacre aux tragiques latins: 'Nous sommes fondés à supposer que l'enveloppe seule, si on peut dire, de ce théâtre était latine et que des souvenirs grecs le dirigeaient. On ne pouvait forger de toutes pièces un théâtre national alors qu'on avait la tête pleine des chefs-d'oeuvre athéniens.'

Quelle est la situation du dramaturge et du comédien canadiens-français devant la tâche d'écrire et de jouer des pièces d'inspiration

nationale? N'est-elle pas précisément celle de ces Latins qui avaient la tête pleine des chefs-d'oeuvre étrangers? Nos dramaturges peuvent-ils se garder d'imiter la façon de voir et le tour d'esprit des dramaturges français? Nos comédiens ne sont-ils pas tout naturellement séduits par le prestige des dramaturges étrangers? Si l'on retient, par ailleurs, que pour les Canadiens français du moins le Canada est un pays à double culture, pour ne pas dire trois en tenant compte du voisinage américain, on peut aisément comprendre comme il devient difficile de faire naître et croître une dramaturgie distinctement canadienne. Il est évidemment avantageux d'avoir à sa disposition un héritage culturel, mais d'en avoir deux et même trois, et d'être tenu de les faire fructifier en deux camps qui s'entendent bien mais se comprennent moins bien, porte à croire qu'abondance de biens peut devenir nuisible. Si cet héritage culturel qu'a légué la France au Canada français constitue un atout, il constitue aussi un danger. On ne peut se passer de modèles, mais il ne faudrait pas croire que l'on puisse vivre éternellement à même un héritage. Celui-là, qui est fort beau, doit porter des fruits mûris en terre canadienne. C'est à quoi se sont employés depuis une dizaine d'années quelques dramaturges canadiens de langue française, ainsi que quelques troupes qui ont réussi à donner un accent particulier, une tenue originale à de grandes oeuvres du répertoire français.

Ces nouveaux venus ont d'autant plus de mérite qu'ils se sont attaqués à un terrain laissé en friche. Chez les dramaturges, leurs prédécesseurs s'étaient complus surtout à évoquer en des sortes de pageants les figures héroïques de l'histoire de la Nouvelle-France, ou à combiner des situations de mélos ou de comédies de salon, pour la plupart imités du répertoire en vogue dans certains théâtres parisiens. Chez les acteurs, les pionniers avaient parfois tiré un étonnant parti d'un métier acquis par la pratique du plateau, mais qu'aucune étude de Conservatoire n'avait mise au point. La somme de travail fournie par ces comédiens abandonnés à leurs propres ressources, sans jamais la moindre subvention des pouvoirs publics, ne devait pas tarder à les épuiser; aussi l'avènement de la radio, puis de la télévision, devait-il susciter chez eux la débandade générale. De tous ces efforts, il ne subsistait aucune valeur durable; il fallait tout recommencer à pied d'oeuvre. La guerre, le cinéma (français, anglais, américain, italien, etc.), la radio, la télévision avaient fait renoncer à la construction de salles de spectacles, pendant que les pouvoirs publics (gouvernement fédéral, gouvernements provinciaux, administrations municipales)

trouvaient dans l'abandon du théâtre un prétexte facile à leur magnifique apathie.

Cet aboutissement à un cul-de-sac était d'autant plus imprévisible et injustifiable que Montréal, à titre de métropole du Canada, a été de tout temps un carrefour où se sont donné rendez-vous les plus grands artistes du monde: les Sarah Bernhardt, Coquelin, Mounet-Sully, Réjane, de Féraudy, Albert Lambert, Cécile Sorel, Louis Jouvet, aussi bien que les Irving, Mansfield, Terry, Kean, Arliss, Barrymore, Hayes, dans les répertoires les plus divers. Mais le théâtre de ce temps-là avait fait . . . son temps. Il fallait trouver de nouvelles formules pour reconquérir le public. C'est tout directement du collège à la scène qu'allait venir la nouvelle relève. . . .

Le R. P. Émile Legault, C.S.C., fonde en 1937 la troupe des Compagnons (de Saint-Laurent), et c'est de là, comme du Montreal Repertory Theatre (section française), de l'Équipe, du Rideau Vert, précédemment du Stella, que prennent leur essor la plupart des comédiens aujourd'hui en vedette sur nos scènes et à l'écran de télévision. L'objectif du directeur: 'l'établissement au Canada d'un théâtre culturel, poétique et spirituel, populaire enfin, dans un climat chrétien', exigeait aussi un style nouveau, qui se manifesta aussi bien dans le choix du répertoire que dans sa présentation stylisée, avec en honneur Molière et Shakespeare, Anouilh et Edmond Rostand, Racine et Giraudoux, Claudel et Wilder. Ce beau mouvement dura quinze ans. Les Compagnons étaient tenus en haute estime à travers tout le pays; ils avaient deux fois remporté le trophée Bessborough, donné plus de 1,500 représentations, et puis un jour, faute de moyens d'action suffisants pour tenir tête à la télévision et à ses cachets si enviables, la troupe dut se disperser.

En mars 1938, sur la scène du Monument National, un revuiste du nom de Gratien Gélinas, se présentant sous le nom de Fridolin, s'affirmait d'emblée comme un homme de théâtre complet: auteur, metteur en scène, acteur, administrateur, dans une veine comique qui n'empruntait rien à personne. Son accent est du cru, il diffère de celui de tous ses prédécesseurs dans le genre; il apportera de plus à sa série de 'Fridolinons' un style de présentation où s'avèrera un goût dans le choix du matériel scénique qui est aussi neuf que son ton d'impertinence et son sens du comique spontané. En bref, la Revue devient avec lui un grand genre, de portée nationale, car non seulement réussit-il à abattre la fameuse barrière Est-Ouest qui, au moins symboliquement, sépare les Montréalais de langue anglaise de ceux de langue

FONTAINE DE PARIS by Eloi de Grandmont (Théâtre du Nouveau Monde).
Guy Hoffman, Denise Pelletier.

française, mais aussi à attirer à ses spectacles des Canadiens de toutes les provinces. Bien avant la création de sa pièce en trois actes *Tit-Coq,* en mai 1948, le nom de Gratien Gélinas devient ainsi celui de la plus grande personnalité du théâtre au Canada. Cette pièce, comme ses revues, aura des centaines de représentations, en vertu d'une théorie chère à Gratien Gélinas: présenter au public canadien des personnages canadiens, avec qui il soit en communion d'idées et de sentiments. Ce sera la tendance nouvelle de l'art dramatique essentiellement canadien, dont on trouvera un autre porte-parole chez l'auteur de *Zone,* Marcel Dubé, tandis que d'autres jeunes dramaturges, tel Paul Toupin, choisiront de rester fidèles à l'ancienne esthétique classique de sujet et de style.

Gratien Gélinas demeure encore seul de son espèce, en ce sens que tous les autres dramaturges doivent compter sur un hasard heureux pour avoir la chance d'être joués. Mais conscient de ses responsabilités, tout à fait conquis à l'idée qu'un théâtre national ne s'édifie pas seulement avec des acteurs mais aussi, et surtout, avec des auteurs, Gratien Gélinas ouvre toutes grandes les portes du théâtre dont il vient d'assumer la direction, et qu'il

a nommé La Comédie-Canadienne, à tous les dramaturges canadiens, de langue anglaise comme de langue française, qui ont quelque chose à dire et qui savent le dire dans le langage du théâtre. Disposant d'une forte commandite de la part du gouvernement de la province de Québec ainsi que de la part d'une importante brasserie, le nouveau directeur de théâtre se rend bien compte que le temps n'est plus des succès d'estime que l'on faisait pour un soir ou une semaine à des auteurs en mal d'être joués, et que la sécurité financière ne peut davantage justifier le slogan qui a si longtemps eu cours: 'Encourageons les nôtres!'

Mais il faut mentionner une autre troupe disparue, dont il était permis de tirer de grands espoirs: celle de l'Équipe, fondée par le jeune metteur en scène Pierre Dagenais en 1941 et qui ne dura que cinq ans. Ce fut encore là une pépinière d'acteurs qui n'est pas négligeable dans le contexte du théâtre de langue française, d'autant que Pierre Dagenais fut à maintes reprises invité par des groupes de langue anglaise à diriger leurs spectacles et qu'il assura la création d'une première pièce d'auteur canadien, le *Brutus* de Paul Toupin.

D'autres troupes se sont formées depuis: le

Théâtre du Nouveau Monde, qui eut l'honneur de représenter le Canada au Festival international d'Art Dramatique à Paris en 1955, le Théâtre-Club et le Rideau Vert. Toutes ces troupes ont leur importance, car c'est d'elles que dépend actuellement le sort d'une dramaturgie qui nous soit propre.

Se dégage-t-il de toutes ces tentatives, même de ces réussites isolées, une sorte d'unité, une ligne définie qui permet de dire vers quelle tendance s'oriente le théâtre canadien? Hélas! non. Pour le moment, on en est à l'apprentissage et, l'art dramatique n'ayant pas encore droit de cité dans les universités du Canada français comme il l'a obtenu depuis longtemps dans les universités américaines et canadiennes-anglaises, c'est encore à son instinct, en autodidacte, que doit se fier l'auteur débutant pour approfondir les lois si spéciales de la composition dramatique.

Des noms sont pourtant à retenir: celui de Lomer Gouin, disparu prématurément, qui avait donné un *Polichinelle* charmant et émouvant dans l'esprit de *La Princesse Turandot* de Gozzi; d'Yves

Thériault, un romancier qui avec *Le Marcheur* a manifesté des dons dramatiques dans le ton folkloriste; de Félix Leclerc, chansonnier en grande vogue, qui a réussi à obtenir un succès populaire avec un sketch allongé sur trois actes, *Sonnez les matines*; d'Éloi de Grandmont et de Paul Toupin dont le style de qualité peut faire excuser les manquements aux exigences dramaturgiques; de Marcel Dubé, qui a su traduire dans un moule véritablement dramatique les velléités sociales de ses personnages de *Zone*; de Gratien Gélinas, encore, qui est loin d'avoir dit son dernier mot.

La télévision, grâce à ses émissions de théâtre, peut jouer un grand rôle dans la formation de dramaturges, en leur permettant de se faire la main, d'assister aux répétitions, d'étudier les moyens dont se sert le metteur en ondes pour transposer son texte en images correspondant, en quelque sort, à la présence que pourraient avoir ses personnages en scène. Mais il reste que les deux moyens d'expression sont différents, et qu'une réadaptation à la scène demeure nécessaire,

TIT-COQ (1948) Gratien Gélinas, Fred Barry, Huguette Oligny.

Jean
Béraud

comme elle l'est pour les acteurs chez qui l'habitude du micro altère parfois la portée vocale et réduit la diversité d'inflexions. La télévision crée par ailleurs de graves problèmes aux directeurs de troupes, incapables d'offrir des cachets aussi munificents aux auteurs et aux acteurs.

Il est bien un domaine où l'art scénique au Canada français s'est décisivement enrichi ces dernières années: celui de la mise en scène. Une étude plus attentive des textes; une collaboration suivie de metteurs en scène comme Gratien Gélinas, Jean Gascon, Jacques Létourneau, Yvette Brind'Amour, de la direction des Festivals de Montréal, avec les décorateurs Robert Prévost, Jacques Pelletier, Michel Ambrogi; le souci soit de recréer une atmosphère d'époque en la stylisant soit de créer un cadre moderne avec goût ont même permis à la critique, parfois en tenant compte aussi de l'interprétation, de comparer sans hésitation certains spectacles locaux à ceux de troupes réputées venues de France. Ce fut le cas, notamment pour le Théâtre du Nouveau Monde, lorsque la troupe reçut même à Paris le témoignage d'avoir 'dépoussiéré Molière' et lorsqu'à Montréal on la mit en parallèle avec le Théâtre National Populaire de Jean Vilar.

L'un des signes les plus réconfortants de cet essor nouveau fort prometteur, de la littérature dramatique canadienne-française, c'est l'intérêt intense que lui portent les Canadiens de langue anglaise. J'ai dit que cette admiration pouvait paraître irraisonnée. En ce sens qu'impressionnés par l'animation, le don de conviction dont les acteurs de langue française font preuve en scène et à l'écran de télévision, ils se trouvent tout naturellement portés à croire que tout ce que nos dramaturges écrivent procède vraiment d'un art créateur dans le contexte de la vie canadienne. Cela est juste dans le domaine du sketch ou même de la pièce de radio et de télévision. Mais seuls encore à la scène, Gratien Gélinas et Marcel Dubé ont su se dégager des influences, voir autour d'eux, composer des études de caractère qui puissent être comparées, pour la vérité d'observation, à celles que présente, par exemple, Roger Lemelin, dans ses *Plouffe*. D'autres y ont réussi partiellement, comme Félix Leclerc et Yves Thériault, mais sans connaître aussi bien les lois de la dramaturgie.

Si cet essai peut paraître un peu pessimiste, c'est qu'il faut bien admettre qu'un art dramatique qui soit à la fois distinctif et susceptible d'intéresser le public européen, par exemple, est encore à naître chez nous. Si l'on veut s'en tenir aux réussites locales, dans le répertoire français (Anouilh, Musset, Molière, Guitry, etc.), il n'y a aucune contestation possible: le théâtre au Canada français est fort avancé et de qualité supérieure. Des conditions nouvelles, heureusement, vont permettre à nos propres dramaturges de subir un apprentissage continu et de développer leurs dons indéniables selon le concept que l'on se fait généralement d'un art national. Si bien que l'on peut espérer, grâce au concours indispensable du Conseil des Arts de la région métropolitaine de Montréal et du Conseil national des Arts, voir surgir en peu d'années un mouvement dramatique continu et significatif qui, au-dessus des conflits politiques, créera vraiment, dans les esprits et à la lettre, l'unité nationale que l'on souhaite sans bien savoir par quels moyens y parvenir. La participation d'acteurs canadiens-français aux représentations du *Henry V* de Shakespeare, au Festival de Stratford, doit être citée comme un exemple de cette bonne entente et de cette meilleure compréhension sur le plan culturel comme sur le plan national.

POETRY

poetry

LITERARY DATES coincide only approximately with political ones, and the date which marks the political appearance of the entity we know as 'Canada', 1867, precedes by several years the development of a poetry in which the sense of 'Canada' as a genuine imaginative environment can be discerned. The new literary age is signalized by the appearance of Charles G. D. Roberts' *Orion and Other Poems* in 1880, when the poet was twenty. Lampman's first volume, *Among the Millet*, partly inspired by the example of Roberts, appeared in 1888; Carman's *Low Tide on Grand Pré* and Duncan Campbell Scott's *The Magic House* in 1893. The work of these four poets is the cornerstone of Canadian poetry, and many readers of Canadian anthologies feel that only with Roberts does the quality of writing leap from clumsy amateurishness into professional competence. All four are romantic and subjective poets, at best when confronting nature in solitude, in moods of nostalgia, reverie, observation or extra-sensory awareness. Their sensibility is emotional in origin, and they attain conceptual precision by means of emotional precision. Lampman, who had the keenest mind of the group, often does this; Carman and Roberts, trying with emotional sensibility to reach something beyond it, are apt to let their sensibility go out of focus into a woozy inspirationalism. This subjective and lyrical sensibility, sharp and clear in its emotional foreground but inclined to get vague around its conceptual fringes, is deeply rooted in the Canadian tradition. Most of its characteristics reappear in the Group of Seven painters, in Tom Thomson and Emily Carr, with their odd mixture of *art nouveau* and cosmic consciousness.

The Canadianism of Canadian poetry is of course not a merit in it, but only a quality in it: it

may be revealed as clearly in false notes as in true ones, and may be a source of bad taste as well as of inspiration. The Canadian reader of Canadian poetry, however, may legitimately be concerned not only with poetic merit but with the imaginative articulateness of his own country. If so, he may find much to interest him in poetry of less limited objectives than the romantic lyric, poetry which attempts more and has greater flaws, or is more impressive in conception and theme than in achievement. Some literary values may emerge from an intense struggle between a poetic imagination and the Canadian environment even if the former is defeated. It is a somewhat narrow view of criticism, and in Canada an impossibly pedantic one, that excludes all sympathy for poets who have tried something big with only a little success.

Romanticism was almost incidentally a lyrical development: the bulk of it consisted of narrative, didactic or dramatic poems, the last group seldom intended for acting. As the exotic is, so to speak, indigenous to romanticism, a North American setting is not uncommon even in European romantic poems, as in Chateaubriand. This largely neglected, almost forgotten romantic tradition produced Longfellow's *Hiawatha* and *Evangeline,* and it flourished in Canada side by side with the lyrical poetry. Isabella Crawford's *Malcolm's Katie* appeared in 1884, Mair's *Tecumseh* in 1886, Duvar's *De Roberval* in 1888. The four lyrical poets attempted longer forms too, and D. C. Scott has a narrative poem on Dominique de Gourges, a subject also considered by Wordsworth as a possible epic theme.

If we look back at the pre-Confederation poets, we see at once that this narrative tradition is more deeply rooted than the lyrical one. There are very few good pre-Confederation lyrics, but there are several quite interesting longer poems: Sangster's *The St. Lawrence and the Saguenay* (1856), a Canadian echo of Tom Moore's series of poems on his travels in North America; O'Grady's *The Emigrant* (1842); Heavysege's *Jephthah's Daughter* (1869), which is Canadian in feeling if not in theme; Howe's *Acadia.* It looks as though Canadian poets have always felt that a longer form than a lyric was needed to convey the central imaginative impact of a huge, primitive and sparsely settled country. Such poems can hardly be exported: they are primarily for sympathetic and historically-minded Canadian readers. Perhaps it could also be said that such poems are evidence of a healthier public attitude to poetry than we now have, when stories or disquisitions in verse could be read without the feeling that a poem must justify itself

by being strikingly poetic in every line. Certainly we must abandon, in reading them, our modern prejudice that density of poetic texture is always a primary virtue. It is in certain forms, but a narrative often achieves its emotional climax with the driest and baldest of statements. Here is the martyrdom of Père Lalemant in the lyrical context of Marjorie Pickthall, where the texture is appropriately elusive and indirect:

> My hour of rest is done;
> On the smooth ripple lifts the long canoe;
> The hemlocks murmur sadly as the sun
> Slants his dim arrows through.
> Whither I go I know not, nor the way,
> Dark with strange passions, vexed with
> heathen charms,
> Holding I know not what of life or death . . .

and here it is in Pratt's *Brébeuf,* where the virtues are the very different virtues of narrative:

> The wheel had come full circle with the visions
> In France of Brébeuf poured through the
> mould of St. Ignace.
> Lalemant died in the morning at nine, in
> the flame
>
> Of the pitch belts. Flushed with the sight
> of the bodies, the foes
> Gathered their clans and moved back to
> the north and west
> To join in the fight against the tribes of
> the Petuns.

This prelude is necessary to explain why certain phenomena of contemporary Canadian poetry are as they are, and in particular why Pratt is still its dominating figure. Pratt's poetic instincts took him back to the narrative rather than the lyrical tradition, although he has written some fine lyrics. One can no more get him into anthologies than one could get his whales and dinosaurs into a circus parade: he has to be read by himself or not at all. There is much in his work that recalls the earlier narrative poems mentioned above, with their sense of the loneliness of man facing the huge untamed Canadian landscape and pitting his forlorn moral and civilized standards against nature's vast indifference to them. But in striking contrast to the earlier romantics, Pratt's poetry is intensely social, even gregarious: there are no wanderers in his poems, only hunters, fighters, builders and missionaries. He has written of railways and shipping with a genuine love of technological language: his poetry rings with the noise of the machinery that has grappled with the country, and he makes himself and his reader par-

ticipators rather than spectators of the heroic actions he celebrates. In relation to what has gone before him, he has clarified and brought into focus a distinctively Canadian kind of imaginative consciousness. As a result he has achieved a popularity in his own country which is a genuine and healthy popularity, not the false popularity of the Service school, with its lurking anti-intellectual bias. As part of the same result, he has had a very limited recognition in Great Britain and the United States. Pratt's achievement has been too individual to leave an integrated tradition behind, but indirectly he has influenced Canadian poetry a great deal by loosening and informalizing it, encouraging poets to think in less introverted and page-bound categories. Here his influence has partly coincided with that of the CBC, which has also done a great deal to make poets realize the importance of oral reading and a listening audience.

We may take 1943-4 as the year marking the beginning of contemporary Canadian poetry. Pratt's collected poems appeared in 1944, and though he has written some of his best poetry since (*Behind the Log*, 1947; *Towards the Last Spike*, 1952), the collection indicates the general range and tone of his work. At almost the same time (1943) there appeared E. K. Brown's *On Canadian Poetry*, a rather casual historical survey with a more detailed consideration of Pratt, Lampman and D. C. Scott. Its opening pages, however, clearly state, in its contemporary context, the perennial dilemma of the English-Canadian poet: the fact that he is involved in a unique problem of self-identification, torn between a centrifugal impulse to ignore his environment and compete on equal terms with his British and American contemporaries, and a centripetal impulse to give an imaginative voice to his own surroundings. The centrifugal poet lacks a community, and if we look at the proportion of recent poetry in Britain, for instance, that has been produced by Irishmen, Welshmen and home-rule Scotsmen, we can see how important a restricted community is. Besides, Canada is not a bad arena for poets as such things go: a few Canadian publishers are generous to them; a surprising proportion of the poetry bought in Canada is Canadian poetry; Canadian journals give space for reviews and discussion which enable the poet in Canada to achieve an amount of recognition that he could hardly attain in the larger countries; Canadian radio and television disseminate his work and exhibit his personality. But of course there is the opposite danger of being too easily satisfied with povincial standards, when today the real standards of poetry are set in the world as a whole. Some of our best poets have been confused by a tendency, conscious or unconscious, to develop either the centripetal or the centrifugal impulse into a moral principle.

The first edition of A. J. M. Smith's *A Book of Canadian Poetry*, the most impressive piece of historical and critical stock-taking yet made in Canadian poetry, also appeared in 1943. This anthology represented a thorough first-hand revaluation of Canadian poetry up to that time, in the light of liberal and intelligently applied critical canons. The picture of Canadian literary history presented by it has remained in the foreground of Canadian criticism ever since. Those poets who did not appear in Mr Smith's book, such as Wilson MacDonald, were, whether their omission was deliberate or involuntary, almost obliterated from the serious discussions of Canadian poetry that followed it. Mr Smith discovered or re-emphasized neglected merits in the pre-Confederation poets; he gave the next or romantic generation a more modest rating, indicating that in all of them except Lampman the proportion of chaff to grain was high. He then dramatized the conflict of centripetal and centrifugal impulses by dividing his 'modern' poets into a 'native' and a 'cosmopolitan' group, with Pratt at the head of one and Frank R. Scott at the head of the other. This division was dropped in the second edition of 1948, and probably should have been, as it represents a division of mind within each poet, not a division between two groups of poets. Nevertheless, the older scheme does correspond, if accidentally, to the facts of the contemporary situation in Canadian poetry, where Pratt and F. R. Scott are certainly the chief personal influences.

A survey of Canadian poetry since 1943 has certain inherent difficulties. It is only where there is great genius that the critic is provided with a ready-made construct, for the life of a great genius is, as Keats said, a continuous allegory, however tragic or truncated his life. In Canada the critic must set up a more or less plausible construct of his own, made out of trends and schools and groupings, which every poet of unusual talent bursts out of. Further, Canada naturally has no full-time poets: every poet writes in what time he can spare from some exacting profession, usually the academic one. Hence many poets have to be slow and thrifty writers, eking out every volume of new poems with reprinted older ones. Canadian anthologies are even more confined to stock repertory than anthologies elsewhere. Again, a cultural lag of approximately a decade keeps dogging publication dates. Death-and-resurrection poems with

Waste-Land overtones were being written during the twenties, but did not reach the public until Leo Kennedy's *The Shrouding* (1933) and the collection *New Provinces* (1936), of which more in a moment. A glance at some of the books that appeared at the end of the war, such as Dorothy Livesay's *Day and Night* (1944), F. R. Scott's *Overture* (1945), and Louis Dudek's *East of the City* (1946) would convince one that the country was in a state of social ferment, but the main inspiration is of the previous depression decade. Finally, some poets, notably George Johnston and Margaret Avison, are in too unpublished a state as yet to be dealt with here, although they may well be of greater interest to posterity than many who are mentioned.

The primary channels for the publication of Canadian poetry are of course precarious 'little magazines', which, in Canada as elsewhere, bloom and vanish like a display of fireworks. Most important of these is the indomitable *Canadian Forum,* founded in 1920 and still going on, which, though never primarily a literary magazine, has done more than any other single periodical for Canadian poetry. *Contemporary Verse*, in British Columbia, edited by Alan Crawley, survived for over ten years, and *Fiddlehead,* in New Brunswick, is still active. *Preview* (1942) in Montreal expired when the group that founded it disintegrated; *First Statement* (1945) was reborn as the *Northern Review,* edited by John Sutherland, which, though it eventually tended to become something of a catechist's manual, represented great editorial energy and devotion. In the last year or so some of the best current poetry has appeared in the *Tamarack Review,* but of the subsidized magazines only *Queen's Quarterly* pays much serious attention to poetry. The Contact Press in Toronto, under the management of Raymond Souster, has sponsored an extraordinary variety of poetic ventures, many of them mimeographed. The Ryerson Press, besides publishing several books of verse every year, also issues a series of 'chapbooks' in paper covers, in which a great number of both permanent and transient talents have appeared. McClelland and Stewart's 'Indian File' series, as its name indicates, averages one volume a year. Readings of poetry are featured by the CBC, chiefly on its 'Anthology' programme. This list is not intended to be exhaustive, but apart from it the catalogue of accessible Canadian poetry would be, like some Anglo-Saxon elegies, simple, brief, and bleak.

A little book called *New Provinces* (1936) contained poems by Pratt and by a group of younger poets born between 1900 and 1910, all of whom except Leo Kennedy have continued productive. A. J. M. Smith's *News of the Phoenix* appeared in 1943 and *A Sort of Ecstasy* in 1955. Along with Kennedy, though in a much solider way, he shows the increasing influence of metaphysical poets and the contemporary impact of Eliot and the later Yeats. In this and in his critical and scholarly approach to poetry—he is a professor of English —he is typical of what we may call the academic tradition in Canadian poetry, which was largely established by the poets of his generation. In Robert Finch (*Poem*, 1946; *The Strength of the Hills,* 1948), who also appeared in *New Provinces,* in Roy Daniells (*Deeper into the Forest,* 1948), in Alfred Bailey (*Border River,* 1952), in Louis MacKay (*The Ill-Tempered Lover,* 1948), professors respectively of French, English, History and Classics, we find a great variety and range of the normal characteristics of academic poetry. Echoes abound from the great tradition of poetry, from Virgil in MacKay to Mallarmé in Finch; shadows of Frazer, Jung, Freud, Spengler and Toynbee lurk around the margins; the symbols and rites of religion inform the themes.

As long as these influences were new to Canada, an impression grew up that this 'difficult, lonely music' was an intellectual reaction to the emotional facility of the earlier romantics, or, with the hazier-minded, that some erudite and esoteric group was seizing control of Canadian poetry, taking it away from the people, and retreating from direct experience. The causes of the fact that nearly all the best Canadian poetry today is academic poetry, and will be in the foreseeable future, lie deep in the nature of poetry itself and of twentieth-century society: it is not its causes but its effects that concern us here. With the passing of time it has become more apparent that much of the poetry of the academic generation shows the tradition of the romantic lyric continuing with a slight change of idiom and literary taste. The path is direct from Bliss Carman's 'Resurgam' to Leo Kennedy's 'Words for a Resurrection', and from Lampman's 'City of the End of Things' to Smith's 'The Bridegroom'. But there is another element in academic poetry that needs more careful analysis.

If we look back at the narrative poems of the nineteenth century with twentieth-century eyes, we find ourselves less interested in the story being told than in what seem the imaginative reasons for telling it: the attempt to dramatize certain themes or situations that have for the poet a symbolic or mythical importance. Poe's 'poetic principle' that long poems are actually fragments of vision stuck together with prose is a principle that works

Poetry

87

fairly well for Canadian narrative poetry. What we remember of *Malcolm's Katie* or *Jephthah's Daughter* are the bits like the 'south wind' passage from the former or Jephthah calling to his blind god for release from his vow and hearing only the hill wolf and the bittern. Here something looms out of the poet's environment with the mysterious urgency of a myth, a symbol, an epiphanic moment, an evocative mood, or whatever we like to call the sudden fusing of subject and object. These moments of fusion seem to us the *raison d'être* of such poems. And if we look at John Sutherland's study of Pratt, we can see what younger poets mainly read Pratt for: they read him less for the story than for the mythical or symbolic significance of his characters and themes. The poetry of what we have called the academic school is overwhelmingly mythopoeic. The hills and forest and river of Finch and Daniells and Bailey are partly landscape and partly the landscape of the more mysterious parts of the mind. Hence what the academic tradition represents in Canadian poetry is a fragmenting of the narrative tradition, a concentrating on the significant moods and symbols in which poet and environment are identified. The romantic lyrical poets are normally detached from their environment: they observe and describe what they see, and they observe and describe the emotions with which they see it. Thus Lampman:

> And yet to me not this or that
> Is always sharp or always sweet;
> In the sloped shadow of my hat
> I lean at rest, and drain the heat;
> Nay more, I think some blessed power
> Hath brought me wandering idly here:
> In the full furnace of this hour
> My thoughts grow keen and clear.

The 'modern' poet strives to break down this mutually aggressive barrier between the mind and its environment; he seeks some enveloping myth in which mind and nature become the same thing. Thus Irving Layton:

> But the furies clear a path for me to the worm
> who sang for an hour in the throat of a robin,
> and misled by the cries of young boys
> I am again
> a breathless swimmer in that cold green element.

And when Layton so writes he is writing in the mythopoeic tradition of Isabella Crawford when she comes to an imaginative focus in her narrative:

> The pulseless forest, lock'd and interlock'd
> So closely, bough with bough, and leaf with leaf,

> So serf'd by its own wealth, that while from high
> The moons of summer kiss'd its green-gloss'd locks;
> And round its knees the merry West Wind danc'd;
> And round its ring, compacted emerald;
> The south wind crept on moccasins of flame.

Further, poetry is a world of its own: it does not reflect life but contains it in its own form, and hence what is most profoundly evocative in poetry is, nine times out of ten, not an evocation of life but of other parts of one's literary experience. When Louis MacKay calls one of his poems 'Nunc Scio, Quid Sit Amor', he is not echoing Virgil because he is lazy or lacking in originality, but because his mood evokes specifically this echo, not a general series of associations. The erudition in academic poetry is neither ostentation nor an accident of the poet's profession, but a precise guidance of the reader's emotional reactions.

Earle Birney belongs, chronologically and by profession, to the academic group. His scholarly competence in Old and Middle English is reflected in 'Anglo-Saxon Street' and elsewhere. But *David* (1942), the poem that established his reputation, is an admirable, and unfragmented, later product of the narrative tradition. The impact of the war on Birney diversified a talent for satire with a sense of comradeship, perhaps more genuine in feeling than successful as poetry. In *Trial of a City* (1952) there is a theme (a proposed destruction of Vancouver) fitted to bring out the best of his powers: erudition, satire, parody and a sense of the irresistible power of ordinary humanity as against pedantic officialdom. The relation of this radio play to the Canadian tradition of narrative and dramatic poetry is clear enough, and indicates that that tradition, even in its continuous form, may still have a long development ahead of it.

Abraham M. Klein, also one of the *New Provinces* group, is perhaps the most distinguished single poet of the generation following Pratt, though none of his poetry equals the passion and fire of his prose romance *The Second Scroll,* which for sheer intensity has little if anything to rival it in Canadian fiction. Klein's earlier poetry (*Hath Not a Jew*, 1940) is steeped in Jewish life and culture, and reminds us that of all groups in English-speaking Canada, the Jews are in a most favourable position to deal with the environmental dilemma mentioned above. They form a close Canadian community which is immediately linked to other parts of the world, and the advantages of belonging to such a community have been exploited

by both Jewish poets and novelists, especially novelists. Klein however was not content merely to exploit the special knowledge and sensitivity which his religious and ethnical affinities gave him. In *The Rocking Chair* (1948) there are brilliant vignettes of French-Canadian life that show how understanding of one community may develop an understanding of another; there are lively linguistic experiments stimulated by a profound study of Joyce; and, in 'Portrait of the Poet as Landscape' there is one of the most searching studies of the modern poet in Canadian literature.

The last of the *New Provinces* group is F. R. Scott, whose *Overture* appeared in 1945 and *Events and Signals* in 1955. A penchant for political and social satire is more conspicuous in him than in most of his contemporaries, but by no means peculiar to him: a recent anthology of light verse compiled by him and A. J. M. Smith, *The Blasted Pine*, shows how deep-rooted the sense of irreverence in Canadian poets is, and has been from the beginning. His satires, however, are not shots at random targets, but part of a consistent social attitude, intensely Canadian in reference. We notice that he is not at all a mythopoeic or symbolic poet, but a poet of detached comment: the romantic duality of mind and environment reappears in him. He is in fact a neo-romantic, a product of an age in which the centre of Canadian social gravity has finally shifted to the urban, the industrial and the political.

Scott has been a major personal influence in encouraging a neo-romantic movement in Canadian poetry, a descriptive and nostalgic commentary on the *fourmillante cité*. This movement is, of course, often rationalized as a rediscovery of reality. Thus the magazine *Preview*, founded mainly by Patrick Anderson, P. K. Page and Scott himself in 1942, wished to 'look forward, perhaps optimistically, to a possible fusion between the lyric and didactic elements in modern verse, a combination of vivid, arresting imagery and the capacity to "sing" with social content and criticism.' Patrick Anderson's *The White Centre* and P. K. Page's *As Ten, As Twenty* (1946) are full of sharp glances at landladies, stenographers, hospitals, and of course the war. As in the previous romantic movement, the emotional reaction is clear and the intellectual one fuzzy: whenever lyric and didactic impulses fail to fuse, this is usually the reason for it. In their second volumes these poets have moved over into the academic camp. Anderson's *The Color as Naked* (1953) is, at its best, pastoral poetry, and Miss Page's *The Metal and the Flower* (1954) has absorbed its sharpness of perception into an elaborate and quite recognizably mythical framework of expression.

The romantic tradition is now carried on by Raymond Souster and Louis Dudek. The former, whose *Selected Poems* appeared in 1956, has finally developed a form of epigram, the theme almost invariably urban life, which at its rare best is a type of poetic experience as immediate and sharply pointed as anything in Canadian poetry. Louis Dudek has never quite fulfilled the promise of his earlier *East of the City* (1946), but he has produced a great deal of original and striking poetry, which appears to be forceful by conviction and delicate and haunting by instinct. His retrospective collection *The Transparent Sea* (1956) gives a good idea of the range of his powers.

Irving Layton has been closely associated with this group, and much at least of his earlier poetry is indistinguishable from it. But beginning with *In the Midst of My Fever* (1954) he began to turn his enormously prolific talents in other directions. One aspect of him, represented by *The Long Pea-Shooter* (1954) and *The Blue Propeller* (1955), is the dramatizing of a poetic personality not unlike that favoured by the 'jam session' schools of New York City and California. The other aspect is consolidated in *The Improved Binoculars* (1956), a collection of his work which is perhaps the most important single volume of Canadian poetry since the Pratt collection of 1944.

It is difficult to do justice in a sentence or two to the variety and exuberance of Layton's best work. The sensuality which seems its most obvious characteristic is rather an intense awareness of physical and bodily reality, which imposes its own laws on the intellect even when the intellect is trying to snub and despise it. The mind continually feels betrayed by the body, and its resulting embarrassments are a rich source of ribald humour. Yet the body in the long run is closer to spirit than the intellect is: it suffers where the intellect is cruel; it experiences where the intellect excludes. Hence a poetry which at first glance looks anti-intellectual is actually trying to express a gentler and subtler kind of cultivation than the intellect alone can reach. Thus Layton is, in the expanded sense in which the term is used in this article, an academic rather than a romantic poet, though one of his own highly individual kind.

Out of the great number of contemporary Canadian poets who have some valid claims on our attention, we may make a more or less arbitrary choice of six: Douglas LePan (*The Wounded Prince*, 1948; *The Net and the Sword*, 1953); Wilfred Watson (*Friday's Child*, 1955); Anne

Wilkinson (*The Hangman Ties the Holly*, 1955); James Reaney (*The Red Heart*, 1949); Jay Macpherson (*The Boatman*, 1957), and (perhaps as yet more potentially than actually) Daryl Hine (*The Carnal and the Crane*, 1957). All of these represent the academic tradition in its second generation. In them the use of myth and metaphor has become instinctive, and allusions to other poems, including nursery rhymes, are unforced and unself-conscious. Such characteristics are, as we have tried to show, not superficial, but signs of a habit of poetic thought. LePan is the most conspicuous figure of this group: *The Net and the Sword* deals with the poet's experiences in the Italian campaign, and shows very clearly how what in the previous century would probably have been a continuous narrative has become fragmented into brief moments of intense apprehension. Wilfred Watson, whose book was published by Faber and Faber, uses a good deal of sacramental religious language, but his central vision, a kind of Sartor-Resartus contrast between the world as we see it and the same world in its naked apocalyptic form, does not depend on such language. Anne Wilkinson has some curious accidental resemblances to Watson, though in her the religious language turns into sardonic parody. James Reaney showed in *The Red Heart* (1949) a puckish humour and a gift for disconcerting fantasy that has developed into the extraordinary and erudite satire of *A Suit of Nettles* (1958). Daryl Hine has also shown very little of the full range of his developing abilities as yet, though one feels that his power will be considerable when it turns from self-communing into direct communication. At present (1957), the Canadian poetic scene is dominated by Jay Macpherson's *The Boatman*, a book of very lovely lyrics ranging in tone from light verse to elegy, and which is not simply a collection of poems, but one of the most carefully and exquisitely constructed books in Canadian poetry.

In the best contemporary Canadian poets one senses an extraordinary sureness of direction. They work in the midst of a society which is largely indifferent to them, not because it is stupid or vulgar or materialistic, but because it is obsessed by the importance of putting ideas into words, and cannot bring itself to understand that putting words into patterns is a much more profound and fundamental reshaping of thought. They give little sign of wanting either to fight this indifference or to compromise with it, and hence they are not simply an indication of the quality of Canadian civilization today, but one of the few guarantees of its permanence.

THE NOVEL

C. T. BISSELL

THE NOVEL

IT IS ONLY since the end of the second great World War that the Canadian novel has aroused anything like the interest and attention that, for many decades now, has been given to Canadian poetry. Throughout the nineteenth, and during the first three decades of this century, fiction was in Canada a minor literary activity to be mentioned casually and with some embarrassment by the critics before they hastened on to pay their respects to the poets. The recent emergence of the Canadian novel from the Colonial shadows has been accelerated by a happy cultural development—the breaking down of the barrier between the novel written in English and the novel written in French, a barrier that, in the other literary forms, shows no sign of weakening. Many of the good novels written in French are now translated into English, and there has as a result emerged a body of Canadian fiction that is independent of language. The two outstanding contemporary French-Canadian novelists, Roger Lemelin and Gabrielle Roy, are almost as well known in English-speaking as in French-speaking Canada. Although this *entente cordiale* has brought about a new and exhilarating sense of a single Canadian literature, it has not, of course, eliminated the two traditions, which, in fiction as elsewhere, are separate and distinct. In what I have to say I shall be concerned primarily with the English-Canadian tradition.

The beginnings of the distinctively contemporary Canadian novel go back considerably beyond the Second World War. They are to be found in the works of two men, Frederick Philip Grove and Morley Callaghan, whose novels first appeared in the twenties. At that time Canadian fiction was dominated by two traditions. The first, the oldest, and the most respected, was the tradition of historical romance. In the hands of the Canadian novelist, the historical romance was largely a means of avoiding any detailed consideration of the contemporary scene, and of finding a refuge in the romantic and exotic past. Moreover, it satisfied the needs of a predominantly puritan and practical-minded civilization by emphasizing strong moral values expressed in terms of simple opposites. The other dominant tradition could be described as decorous realism; it encouraged the novelist to look at the society in which he lived, but warned him that he must avoid the trivial, the base and the degrading and emphasize only those qualities that bring out the nobility of human nature. The weakness of this kind of novel is that it lent itself to exploitation by writers with a calling for sentimentalism and didacticism. Such a writer, for instance, was Charles William Gordon (1860-1937) or 'Ralph Connor', who captivated thousands of readers throughout the world with his melodramatic stories of sin and salvation in the Canadian backwoods.

Callaghan and Grove were not interested in developing the historical romance. Their eyes were fastened upon the society around them, and their few faint predecessors were to be found in the second tradition. As early as 1904, Sarah Jeanette Duncan Cotes in her novel *The Imperialist*, about a small Ontario town, demonstrated a Jamesian skill in analysing a restricted human society. In his one venture into fiction, Stephen Leacock (1869-1944), in *Sunshine Sketches of a Little Town* (1912), cleansed a small Canadian town of the impurities deposited by the sentimentalists and revealed it as a place capable of gaiety, wit and robust humour. Miss Mazo de la Roche, who is still by far the most widely read of all Canadian novelists, must also be looked upon as a precursor of the new novel. It is true that she has worked

mainly in the tradition of decorous realism and that she has never permitted herself to stray outside of a cosy self-contained domestic world. But Miss de la Roche's romantic attitude did not becloud her observation of details of human speech and action, and the Jalna saga, the first volume of which appeared in 1927, has a sprightliness and verve rarely present in the novel of decorous realism.

Both Grove and Callaghan realized that the Canadian novel needed a realism that would be more comprehensive and enquiring than anything that Miss de la Roche could afford, although the two men had completely different backgrounds and worked independently from each other. Grove was an immigrant from Sweden who spent most of his adult life in the pioneer west. Callaghan was a Canadian by birth, educated at the University of Toronto, who had spent some time in Paris on the periphery of the Stein-Hemingway circle. Grove wrote in painfully correct English about the trials of pioneer life and the conflicts in a young rural economy. Callaghan, in a prose that has the repetitious rhythms and spare directness of his Paris mentors, recited the mean tragedies of little men and women in a big city. Yet despite these differences, they had a similar concept of the novel. They thought of it as a serious art form that should strive to present a tragic vision of man in a realistic social environment.

Grove's tragic vision is best embodied in the four novels he wrote about settlement in the west: *Settlers of the Marsh* (1925), *Our Daily Bread* (1928), *The Yoke of Life* (1930) and *Fruits of the Earth* (1933). All these novels are illustrations of his own dictum that 'man is trapped, defending himself on all fronts against a cosmic attack'—against the cruel sorties of nature, the blind urges of sex, and the dark acquisitive instinct that permeates society. Callaghan's early novels *Strange Fugitive* (1928), *It's Never Over* (1930) and *A Broken Journey* (1932) exude a similar atmosphere of dull hopelessness. This was strong meat for the delicate Canadian appetite, especially when both novelists clearly wrote about a recognizable Canadian scene. Callaghan's Toronto was, it is true, stripped of identifying detail, but to the Torontonian at least, the picture was recognizable. Grove paid particular attention to his backgrounds, for he believed that the Canadian west by the power of environmental influences was creating a distinctive national type.

Grove and Callaghan did not, by themselves, create a distinctive Canadian school of writers; neither was a sufficiently powerful or command-ing artist to inspire followers. Indeed, two of our best contemporary novelists are more susceptible to nineteenth-century influences than they are to those that helped Grove and Callaghan to formulate their concepts of the novelist. Thomas Raddall, for instance, first worked in the tradition of the historical romance, bringing to it, however, a detailed knowledge of his sources and a compelling power to render time and place that raises a novel like *His Majesty's Yankee* (1942) far above the level of previous Canadian historical fiction; when he moved into novels of the contemporary scene, as he did in 1950 with *The Nymph and the Lamp*, it was natural that he should still use the methods of the historical romancers: a sweeping, rhetorical style and a heavier concentration on place than on person. Mr Hugh MacLennan, who in many ways may be said to have made the greatest popular impact of our contemporary novelists, is a Victorian in his methods—in his fondness for elaborate plot, and, above all, in his readiness to indulge in direct comment. His mind constantly leaps to generalizations and abstractions and his characters and plots are subsumed by ideas. Indeed one could say that frequently his characters and plots seem to have been devised to illustrate ideas. Occasionally ideas, character and plot interlock effectively so that the novel moves forward smoothly both as a human drama and as a political thesis. This is what happens in the first part of *Two Solitudes* (1945), Mr MacLennan's best novel, in which the story of Athanase Tallard's struggles to achieve a reconciliation between his ancestral heritage and his acceptance of the new age of technology and secularism is both a moving personal tragedy and a piece of keen social analysis. But more often than not the sprightly essayist and the writer of fiction are at odds with each other.

Even those novelists who have espoused the realism first introduced by Grove and Callaghan move cautiously and conservatively within the tradition. There has not yet appeared in Canada, nor is there likely to appear, the kind of naturalistic novel so popular in the United States during the last few decades in which man is seen simply as an animal with a curious and interesting pattern of sexual and political behaviour. Most of our good novelists see a meaning in experience over and above the naturalistic; they are frankly moralists. Mr Callaghan himself illustrates this development. His early novels were written simply and directly so as to achieve a flat matter-of-fact effect with a minimum of moral and philosophical implication. Then his interest in human beings deepened and widened and his theme shifted from

a social to a moral context. The novels of the thirties, *Such Is My Beloved* (1934), *They Shall Inherit the Earth* (1935), and *More Joy in Heaven* (1939), are no longer flat studies in social injustice but are warm allegories that illuminate the contrast between the judgments of a materialistic and insensitive society and the judgments of a moral society. *The Loved and the Lost* (1951) affords us the best illustration of Callaghan's new emphasis. His problem is to take a moral paradox, the fatal tendency of innocence and goodness to unleash forces of evil and destruction, to see the paradox, first of all, in simple human terms and then to expand it in terms of the social and physical background. Sometimes this is done by symbols that are rather obviously planted, more often by a subtle interplay between fixed symbol, the reflections of his character, and the physical background. In various ways, usually with less explicit religious emphasis, many of the best Canadian novelists of today follow in this tradition of contemplative realism in which a detailed realistic background is united with a concern for human values. These novelists give form to the writing through the implicit statement of a moral problem, which is usually some variant on the conflict between moral obligation and individual instinct. Rarely, however, do they indulge in a direct moralizing. They are more concerned with creating an ironic tension, and their aim is to illuminate the human predicament rather than to resolve any specific issue.

What I have called contemplative realism is the strongest tradition in the modern Canadian novel. Many of the good novels of the last fifteen years belong to this tradition. In *As For Me and My House* (1941), Sinclair Ross looks at the society of a small prairie town, with its dullness and cruel prejudices, through the eyes of a sensitive onlooker. This is certainly one of the most vivid recreations of a society in our literature, but what gives it a special poignancy is the central human situation of the clergyman-hero condemned to a self-destroying hypocrisy by his own weakness and the tricks of circumstance. Henry Kreisel's novel *The Rich Man* (1948) begins as a sympathetic and detailed picture of the life of the poor Jewish German immigrant in Toronto in the years preceding the First World War, but develops into a human parable of wide ramification. The hero, on returning to his family in Nazi-shadowed Austria, accepts the role of the rich man providentially arrived from across the seas and tragically loses distinction between illusion and reality. Philip Child's *Mr Ames Against Time* (1948) is, on one

level, a novel about a slum underworld, about a sordid murder, a false accusation and detection and apprehension. It is also a novel of Dostoyevskian concern with the nature of confession and redemption. Ernest Buckler's *The Mountain and the Valley* (1952) is the most unflinchingly naturalistic of the numerous studies of rural regions. It is a portrait of the artist as a young man, but without the conventional treatment; for Buckler is interested not simply in the heroics of revolt but rather in the ironic complexities of family life. This is a study in the power of the group and of the way in which human beings living in separate worlds are yet made one with each other. Buckler shows us how human affection and love are delicately poised and how, if the balance is disturbed, the result is often violence and tragedy. Adele Wiseman's *The Sacrifice* (1956) is, in its exploration of orthodox Jewish life, the prose counterpart of Abraham Klein's early volumes of Jewish poetry. The old man at the centre of the book is the new arrival in the New World who is never quite able to forget the Old World from which he came and to which his memories and his thoughts return. He is a patriarch tortured by the suspicions that his own excessive love for his sons has brought about their deaths. He is the everyman philosopher trying to construct a metaphysics that will account for the too frequent triumph of evil. It is the measure of our identification with him that he does not cease to be credible even though in the climactic scene he commits an act that seems to be a negation of his whole past life. He becomes a murderer impelled to the deed by an atavistic impulse to blood sacrifice.

John Marlyn's *Under the Ribs of Death* (1957) is also a novel about immigrants, set, like *The Sacrifice,* in Winnipeg. Mr Marlyn's theme has a wide, general appeal; it is the theme, so common, and often so hackneyed, in our history and literature, of the emergence of nationality. It is a theme that has often been smothered in didacticism and banality, and that has elicited from critics their most piercing notes of disapproval. Mr Marlyn demonstrates that no theme is resistant to an artist of integrity and sensitiveness. He sees it from a new point of view—the point of view of a small European community, and generalities emerge from the particulars of incident and character. Mr Marlyn's young hero is constantly moving between two worlds: the small world of his own people that offers him security either by self-brutalization or idealistic withdrawal, and the big world of the 'English' with an outer surface of beauty and light, but with a hard, prosaic core

that can explode into ruthlessness. *Under the Ribs of Death* is the story of the hero's tragic enmeshment in these conflicts; and in its seriousness, its honesty, and its maintenance of a level tone, it illustrates the strengths and the limits of contemplative realism.

In the contemporary French-Canadian novel, too, one finds this same emphasis upon moral problems, as one would expect from writers educated in a strong humanistic tradition. Here, too, the novelist is perpetually searching for some meaning in raw human experience. Gabrielle Roy's *The Tin Flute* (1947) was the first of the contemporary French-Canadian novels to attract wide attention. It was about a family in a Montreal slum in the early years of the Second World War, and it had a certain extraneous appeal because of its apparent comment on French Canada and the war, and a wide popular appeal, because of the emphasis given to an adolescent love affair. But the romantic surface hid a tough inner core. *The Tin Flute* is basically an intense, sombrely poetic exploration of the effect of poverty on the human soul. In Roger Lemelin's *The Plouffe Family* (1950) the novelist uses the family as a centre for his study of a workingman's community in Quebec City, a study that he had already brilliantly begun in his first novel *The Town Below* (1948). The novel stands by itself as a series of character portraits, perhaps the most vivid and successful portraits in our fiction. (It is not difficult to see why these characters have been projected outside the novel in a television serial that apparently has no end.) And yet this is much more than a novel of brilliant characterization or of skilful reportage. Lemelin is really dealing in a series of ironies that lie at the root of our human experience. Ovide, the main character in the novel, enters a monastery because of a sense of personal humiliation, and he leaves it out of infatuation for a young girl who can only become a burden and a torture to him. Théophile, the father, is an exponent of the purest kind of French-Canadian nationalism. Yet he is dismissed from his job as a printer for a Catholic paper because he is too anti-British; and he lives to see his youngest son become a swashbuckling private in the Canadian Army. Robert Élie's *Farewell My Dreams* (1954) has a quality of sombre, concentrated introspection that cannot be duplicated in any contemporary English-Canadian novel. It is an existentialist analysis of human anguish and isolation, only a thin ray of salvation striking into the darkness in the concluding scenes. André Langevin's *Dust Over The City* (1955) is set in an asbestos town in Quebec where the constant dust seems to blow through the minds and hearts of the inhabitants. The novel is an unsentimental study of infidelity, in which the husband, realizing that his pretty and morally irresponsible wife is more an object of pity than of condemnation, stands out against the conventional judgments of the church and society.

The tradition of contemplative realism is, as I have suggested, the main one in contemporary Canadian fiction. It is on the whole a strong tradition that has already yielded a number of interesting and effective novels, and that will, no doubt, develop in subtlety and range. It does, however, have certain limitations. It encourages conventional techniques, and, by its heavy emphasis on the serious and the reflective, it tends to discourage wit and banter. There are, fortunately, two other trends in fiction that are providing necessary correctives.

The first trend is that of humour and satire. The major figure here is Robertson Davies, known first as essayist and dramatist and only recently as a novelist. His two novels *Tempest Tost* (1951) and *Leaven of Malice* (1954) are about a southern Ontario small town and the people in it who are attached in some way to the church, journalism, the university, or cultural life in general. The novels have a solid realistic basis, but to the Canadian taste the predominating flavour is rare and exotic. His people talk with an eloquence and wit for which Canadian speech, either public or private, is not noted; and they act with a diverting but untypical eccentricity. Mr Davies comes close to the world of artificial comedy but not close enough to sacrifice satiric point. His novels are a synthesis of some of the best, although often the least recognized, national qualities. They have the wit and intellectual gaiety of our radio drama, the urbanity of our best scholarly prose and the detached irony that is the work of our national character in its highest reaches.

The last ten years have yielded a few other novels where the humorous or satirical method is employed; two of them are about the Second World War. Mr A. J. Elliott's *The Aging Nymph* (1945) is set in an elegantly decayed Italian town where the Canadian soldiers—swaggering buccaneers in battle dress—become involved politically or amorously with the townsfolk. Earle Birney describes his hero, Turvey, in the novel of the same name (1949) as a 'military picaresque'. Turvey is a cheerfully moronic private, a cross between 'the little man' and the clown, whose entanglements with Army bureaucracy are both amusing and frightening. Two other novels of the

same general type make vigorous inroads into the life of the very rich—a subject that offers an increasingly wide scope in Canada. John Cornish's *The Provincials* (1951) is in the manner of Evelyn Waugh. His wealthy Vancouver characters make up a colourful and exotic menagerie. Ralph Allen, in *The Chartered Libertine* (1954) has a far sharper axe to grind. In the process of uncovering the sources of bigotry and moral confusion, he captures and pins down for display a number of choice satiric specimens (Toronto and Ottawa varieties): tycoons, who are unscrupulous traders in human fatuity, religious rabble-rousers of various kinds, politicians who never hesitate to put party before principle.

The other trend is characterized by an interest in technical experimentation. This is a limited trend, and so far has not enlisted many of our writers. Indeed until recently one searched in vain for any examples of technical experimentation. Woolf and Joyce, Gide and Proust, Dos Passos and Faulkner were all read in Canada and enthusiastically approved in the little magazines and academic quarterlies. But no practising novelist betrayed any deep influence from these or other experimental writers.

The most experimental of our novelists is Ethel Wilson, who has changed her method with each of her five novels in accordance with a change in material. *Hetty Dorval* (1947), her first novel, is a conventional and rather melodramatic story rescued from mediocrity by the skill in handling point of view. The writer, who is also a participator in the action, shifts her point of view in accordance with the stages of her own development from childhood to adulthood. *The Innocent Traveller* (1949) might have been a diffuse family history if it were not for the attention to point of view whereby all events are passed through the consciousness of one character. *Equations of Love* (1952), really two novelettes with tenuous connections, is entirely different from the first two books. The stories are not refracted through the mind of a participator. They are told directly, not by an omniscient commentator, however, but by an observer who can change from sympathetic identification with the characters to ironic objectivity. The new point of view is ideally suited to material, which is no longer a genteel middle-class society but the desert of loneliness, frustration and despair where so many of the poor and of the lower middle-class stretch out their lives. Her fourth novel, *Swamp Angel* (1954), is technically the boldest. She starts with direct narration, then abandons it, creating three distinct

centres of interest, related, not by action, but in the world of thought and emotion. For each of these she uses a different method: connected realistic narrative; dialogue or interior monologue; and a series of tawdry epiphanies (in the Joycean sense). In her last novel, *Love and Salt Water* (1956), the whole book is really about a point of view, the heroine's point of view, which is also the author's. And the point of view is always attractive, gay and warmhearted, with a tonic note of irony and withdrawal. Altogether, Mrs Wilson has made the most substantial contribution of our contemporary English-Canadian novelists. With her, experimentation is never a device; it is the inevitable way of finding an expression for her artistic vision.

Contemporary Canadian fiction presents a far more effective and varied picture than Canadian readers presumably think it does, for they appear to prefer any garish banality sponsored by a book club to the best Canadian novels. It is true that we cannot speak yet of a major achievement in fiction. The contemporary Canadian novel does not have, for instance, the intellectual hardness and sophistication of the English, nor the sheer staying power, the exuberance, and the imaginative boldness of the American, nor the rich national flavour of the Australian novel. One feels at times that the novelist is still ill at ease in Canada, that he is not yet able to see his country as a human society, and that his characterizations are, therefore, sketchy and insubstantial. It is significant that often the novelists who are most successful in creating genuine human beings in a living society are writing about communities that have their roots outside this country or that have carefully preserved their special traditions. I am thinking of Adele Wiseman and Mordecai Richler in their novels about Jewish communities and, of course, of all the major French-Canadian novelists. An illuminating commentary on the relatively pallid achievement of the average Canadian novelist in creating a human society is a novel by a recent arrival in this country, Brian Moore. *Judith Hearne* (1955) is about the author's native Belfast and on every page there is a sense of deep and intricate interrelationship between the community and the characters.

The novel, perhaps more than any other form, depends upon the existence of a complex and diversified society. Such a society does not yet exist in English-speaking Canada, but there can be no doubt that it is rapidly emerging. It can be confidently argued that we now have writers of sufficient subtlety to provide an adequate imaginative response to the mature society of tomorrow.

CREATIVE SCHOLARSHIP

F. E. L. PRIESTLEY

CREATIVE SCHOLARSHIP

DISCUSSIONS of Canadian culture, which have become almost a major indoor sport, seem invariably to define culture in terms of productivity in the 'creative' arts, and measure Canadian progress towards cultural autonomy and adulthood by anxious inspection of the gross national production of poetry, novel, drama, music, and painting. Occasionally a voice is raised to suggest that a healthy condition in these arts is not unrelated to a proper climate of criticism, but it is seldom suggested that criticism is itself an important part of culture, and that, except perhaps in primitive societies, creation and criticism depend upon and support each other. More commonly, one hears the naïve romantic view that sets one in opposition to the other, that sees the critic as merely parasitic, and that elevates the 'creative artist' at the expense of the supposedly destructive and unproductive commentator. This is essentially to define creativity in terms of *genre*: if the dullest and most unimaginative of writers strugglingly produces a highly derivative novel, he is a 'creative artist', albeit not a good one; if a brilliant and imaginative writer produces a critical work full of original insight, he is still 'merely' a critic. The truth of course is that the *genre* is not a reliable criterion, and that the best kind of critical and scholarly writing is at least as properly entitled to the adjective 'creative' as a high proportion of works of fiction, and does in fact call for most of the qualities of mind that are commonly called creative.

Scholarly works are often conceived by the unscholarly to proceed from patient, unimaginative industry, or at best from uninspired ratiocination. The scholar certainly needs patience, industry, and the ability to reason, but these qualities, essential as they are, are not enough for work of the first

quality; here the patient collection and analysis of details must be followed or accompanied by a genuinely imaginative synthesis. This is true even of that branch of scholarship which might appear to the uninitiated as the most simply mechanical: the editing of a text. A good editor has so steeped himself in the works of his author, and in the details of his author's *milieu*, that at every point of the text he can bring to focus a large and ordered context to illuminate meaning; he knows almost by second nature the habits of his author's mind, the kind of idea he is likely to have, the kind of expression he is likely to use; he has read what his author read, familiarized himself with the places, people, and events his author knew; he has done his best to become his author's *alter ego*. The process by which this sort of comprehension is reached can never be through mere mechanical industry, as we are reminded by one of the great editorial failures—Bentley's edition of Milton. Bentley was one of the great classical editors; he failed with Milton, not because he took too few pains, but because he did not comprehend Milton as a person and a writer, and Milton's age.

Art is often defined as an ordering of experience, and the artist is seen as faced with the task of composing into a significant pattern the unruly and unrelated details of his observation, first by a process of selection but ultimately by an effort of imaginative synthesis. The scholar who undertakes a biography, a history, or a unified interpretation of an author's complete works clearly is faced with a very similar task, and the quality of his result will depend, like the artist's, on the quality of imagination he brings to the synthesis as well as on the comprehensiveness of his mastery of the data.

It seems a particular pity that the creative aspects of scholarship should be so generally ignored in Canada, since scholarly writing is the one kind of writing in which Canadians have won really wide international recognition; the works of Canadian scholars are to be found in libraries all over the world, and it seems likely that they are making a major contribution to a recognition of Canadian culture. Indeed, I think it would be difficult to avoid being impressed by the quality and range of the work, of which only samples can be suggested here. Full annual check-lists are now available, and the annual survey, *Letters in Canada*, published by the *University of Toronto Quarterly*, offers a valuable descriptive bibliography. An excellent historical survey of literary scholarship has recently been contributed by Millar MacLure to the symposium *The Culture of Contemporary Canada* (ed. J. Park, 1957).

In some kinds of scholarship, of course, Canadians are at a disadvantage. Canada has no really large libraries, and very few special collections, so that in general Canadian scholars interested in textual work have to seek their material abroad. Young scholars tend to be attracted towards other kinds of research, and often receive little training in textual scholarship. Nevertheless, Canada has some achievements to show. One of the most important in English studies is of course Kathleen Coburn's edition of Coleridge's *Philosophical Lectures* (1949), and her recent edition of Coleridge's note-books. These admirably illustrate what was said above about the qualities of mind necessary in an editor. Miss Coburn has further placed Canadian scholars in her debt by being instrumental in acquiring for Victoria College, Toronto, a major collection of Coleridge manuscripts, one of the few important collections of primary material in Canada. Another major work of editing in English literature is Douglas Grant's edition of Churchill's poems (1956). In other languages, W. H. Trethewey's edition of the Anglo-Norman poem *La Petite Philosophie* (1939) and his forthcoming edition of a French version of the *Ancren Riwle*, and the Biblical translations of W. R. Taylor and T. J. Meek, may be taken as suggestions of the range of Canadian textual scholarship. A notable edition of historical texts is A. S. P. Woodhouse's *Puritanism and Liberty* (1938, 1950); the length and comprehensiveness of the introduction give it a dual quality as at once a careful edition of the Army Debates and also a long and brilliant essay in the history of ideas illustrated by the texts used as documentation.

In biography, the Canadian scholar is again at a disadvantage, except for Canadian subjects, and it is no surprise that the most distinguished biographies have been of Canadians, Donald Creighton's life of Sir John A. Macdonald (1952, 1955) being the most notable. Douglas Grant's life of James Thomson (1951) and Clarence Tracy's of Richard Savage (*The Artificial Bastard,* 1953) are the two chief exceptions.

Perhaps the most ambitious piece of historical scholarship produced in recent years by a Canadian, and certainly one of the most brilliant, is C. N. Cochrane's *Christianity and Classical Culture* (1940). The sub-title indicates its scope: A Study of Thought and Action from Augustus to Augustine. The wide range of detailed scholarship, historical, literary, and theological, the vigour of the writing, and the coherence of the conclusions make this a work whose impact was widespread and immediate. Besides Woodhouse's *Puritanism and*

Liberty, mentioned above, a number of valuable studies in literary history or the history of ideas have appeared: one might mention Arthur Barker's *Milton and the Puritan Dilemma* (1942, 1955), Malcolm Ross's *Milton's Royalism* (1943), Ross's later *Poetry and Dogma* (1954), an interesting and controversial study of the effect of the Reformation on the poets' use of sacramental symbol and image, and the recently published study by Millar MacLure of the Paul's Cross sermons, which is an essay in political, theological, and literary history. F. M. Salter's series of Alexander Lectures, *Medieval Drama in Chester* (1955), is the lively product of a great deal of detailed original research, and provides another good illustration of the essential role of the imagination in bringing fact to life. Examples of important work done in the history of other literatures are A. F. B. Clark's *Boileau and the French Classical Critics in England* (1925), Eugène Joliat's *Smollett et la France* (1935), C. D. Rouillard's *The Turk in French History, Thought and Literature* (1940), and E. J. H. Greene's *Eliot et la France* (1951). It seems significant that most of these are concerned with the relation of French to English literature. In German, the most important recent works are those of Hermann Boeschenstein, *The German Novel, 1939-1944* (1949), and *Deutsche Gefühlskultur* (1954).

Critical studies of individual authors are much more common, and indeed offer fewer obstacles to the Canadian scholar, since while they almost invariably demand some access to a large library and rare materials, they also allow much to be done at home. The most brilliant of such studies are undoubtedly H. N. Frye's of Blake, *Fearful Symmetry* (1947), and Barker Fairley's *A Study of Goethe* (1947), but they by no means stand alone. E. K. Brown's *Matthew Arnold* (1948) is penetrating and lucid, as is his posthumous *Willa Cather* (1953). Other important works which suggest the richness of this area of Canadian scholarship are A. F. B. Clark's *Jean Racine* (1939), J. E. Shaw's *Guido Cavalcanti's Theory of Love* (1949), G. M. A. Grube's *The Drama of Euripides* (1941), Gilbert Norwood's *Essays on Euripidean Drama* (1954), and *Pindar* (1945), and Ulrich Leo's *Torquato Tasso* (1951). W. O. Raymond's *The Infinite Moment* (1950) brings together some of the best critical essays on Browning written in our generation.

A more generalized type of criticism has not so far become popular with Canadian scholars. A good early example was the series of Alexander Lectures by G. G. Sedgewick, *Of Irony, Especially*

in Drama (new edition, 1948). More recent examples are the suggestive if occasionally obscure *Poetic Process* (1953) by George Whalley, E. K. Brown's Alexander Lectures, *Rhythm in the Novel* (1943), and H. N. Frye's *Anatomy of Criticism* (1957), which is unique in the range, comprehensiveness, liberality and originality of its ideas.

The prevailing interest in individual authors is not confined to literary scholarship. Most of our best philosophical studies have been of this nature, as witness Fulton Anderson's *The Argument of Plato* (1934), and *The Philosophy of Francis Bacon* (1948), T. A. Goudge's *The Thought of C. S. Peirce* (1950), A. H. Johnson's *Whitehead's Theory of Reality* (1952) and R. C. Lodge's *The Philosophy of Plato* (1956). H. R. MacCallum's volume of essays in aesthetics, *Imitation and Design* (1953), is a notable exception.

In purely historical scholarship, Canada can again show a commendable breadth and depth. Apart from the expected works, often of high quality, on her own history (a host of distinguished names come to mind) she can offer a smaller but by no means negligible list of contributions to other areas of historical research. One might cite as examples E. T. Salmon's *A History of the Roman World from 30 B.C. to A.D. 138* (1944), B. Wilkinson's *Constitutional History of Medieval England* (1952), Peter Brieger's volume in the *Oxford History of English Art* (*English Art, 1216-1307,* 1951), and Ralph Flenley's *Modern German History* (1953, 1956).

As one looks back over the complete scholarly production in Canada of the last ten years or so (not merely over the examples here cited) it becomes clear that these years have seen a substantial increase in scholarly activity.

It is still of course obvious that few scholarly works of importance are being produced by comparison with the numbers theoretically (or supposedly, rather) engaged in scholarly pursuits, but this is not a peculiarly Canadian tendency. There may be a smaller proportion of publications merely for the sake of publication than in some other quarters for the very simple reason that pressure to publish, to produce in God's name the infinitesimal product, is (or has been) less heavy in most Canadian universities than it is popularly reputed to be south of the border. The fact that, until recently, the rate of promotion or of salary increase in most of our institutions observed an almost geological time-scale regardless of publication, of brilliance in lecturing, or anything but offers, may have spared us the frantic laying of intellectual duck's-eggs which makes 'scholarly

work' a phrase of ill-repute in many circles.

What the future holds is hard to say. The opportunities for real scholarship are immeasurably vaster than they were even twenty years ago. Microfilm has made a wide range of rare books, indeed almost any rare book, available in measure to every library; it is true that the film is by no means a complete substitute for the book, but it does allow a good deal more to be accomplished away from the great library. Moreover, grants for research and for travel are now becoming plentiful and generous enough to give every first-class scholar with a project of importance something like a certainty of support. Nor should the aids to publication be forgotten, and the very large scale of scholarly publication undertaken by the University of Toronto Press; again, the day in which the scholar had to mortgage his own financial future to get a genuine contribution to knowledge published seems happily departed.

With all these present advantages, to which must be added the general improvement in university salaries, one might expect a great continued upsurge of sound scholarship, were not one's optimism tempered by what is perhaps an old-fashioned fear that none of these physical aids can produce the scholar, who must be born as well as made. Our scholars in the past have triumphed over the hardships of their circumstances (one is almost tempted to say have thriven on them); the real scholar of the future should have an easier path, but scholarship can never be anything but a career for the devoted, and can never be successfully pursued for any other than its own sake. Unless we find young students who prefer to subordinate other pursuits to research, who turn from their family to a stack of books with a sense of excitement and well-being rather than with a sense of putting on overalls, all the help in the world will not enable the future to out-do the past in solid accomplishment.

A brief article can of course do only very limited justice to Canadian achievement in scholarship, nor is it likely that any single writer can do anything like justice to the many areas it concerns itself with. The books mentioned above must not be taken as an attempt at a comprehensive survey nor as a complete roll of honour. No work has been cited that is not important, but many that are important have not been mentioned; the aim has been to illustrate by specific and recent examples something of the range and quality of Canadian work, and some of the particular interests it follows. Above all, these examples should make it clear that the part played by Canadian scholars in creating a Canadian culture is a major one; they carry to an international body of readers the evidence of the existence in their native land of those qualities of learning, taste, intelligence, and imagination which mark the cultured mind.

film

GUY GLOVER

film

IT WOULD be odd, in discussing writing, to limit the discussion to text-books and journalism, or, in discussing the plastic arts, to dwell for the most part on posters, illustrations and wrought-iron. But a discussion of film in Canada must be limited in somewhat this way, for here the art of the film has been, for the most part, an 'applied' art; that is to say, some of the principal art-forms of the film (for instance, the long fiction film, the short lyric film, the surrealist-symbolic film) either have not been attempted at all or have been attempted so sparingly as to be negligible. The reasons for this situation are, in part, as follows: (1) the Canadian film-market has been dominated, as far as feature-length fiction films are concerned, by the products of the large commercial film production centres—Hollywood, London and Paris; (2) there has been, until recently, a lack of Canadian investment capital for feature film production, although this has not ruled out the availability of capital (in smaller sums) for short film production—above all for films concerned with publicity, public relations, instruction and information; (3) the influence of the Government film agency, the National Film Board, in the development and use of the 'applied' categories of film has been all-pervasive.

The scope of this article does not permit a survey of our film history. I can only remind the reader that in 1939 Canadian film production was of small volume, technically and artistically backward, and without international reputation. By 1946, however, the National Film Board's war-time production had changed that situation markedly. Starting in 1939 from the modest basis of the Government's Motion Picture Bureau, John Grierson and a handful of talented British film men recruited a number of young Canadians, trained them in film techniques, and produced hundreds of short films geared to Canada's war effort. Technical facilities were expanded in the old sawmill on the banks of the Ottawa River, and an extensive distribution system was developed to put these films before the Canadian, and, indeed, the international, public. By 1946, the British group having left, the Board was in Canadian hands and, for the first time, 'on its own'.

By the end of the war (profiting by the expanded and still-expanding audiences for the short film), the number of private film production companies had increased and, as in the work of Crawley Films, these groups were beginning to produce films of improved technical and artistic quality, even though the conditions of commercial sponsorship often made imaginative film-making difficult.

From 1946 on, there was a consolidation of the technical knowledge gained during the largely apprentice activities of the war years, and signs of a 'Canadian' style in the short film began to be discernible. It was a style which had, inevitably, its good and bad points. On the one hand, the native film-maker had learned well some of the lessons taught him: respect for the 'documentary' approach ('the creative interpretation of reality'); the necessity of orderly exposition of the material and for neat and economic cutting; and the importance of exacting technical standards. Most of the new films demonstrated an ability to observe the surface aspects of the Canadian scene: our landscape was caught sensitively in all weathers (*Four Seasons,* N.F.B., 1947—F. R. Crawley); our peoples were presented well when on their best behaviour (*Listen to the Prairies,* 1945, *Opera School,* 1951, N.F.B.—Gudrun Parker) although, on the darker side, compassion and even criticism could be shown (*Feelings of Rejection,* N.F.B., 1947—Robert Anderson; *Look to the Forest,* N.F.B., 1950—Donald Fraser). In films dealing with the international scene, a keen sense of political and social awareness was perhaps more successfully articulated than in films on domestic subjects (*The People Between,* N.F.B., 1948—Grant McLean and Tom Daly; *Hungry Minds,* N.F.B., 1948—Tom Daly), a sense which grew from the tradition of the war-time 'World in Action' series, and which has borne fruit consistently until the present time. A number of films were produced using unusual techniques (*Chants Populaires* Series, N.F.B., 1943-6—Norman McLaren and others; *The Age of the Beaver,* N.F.B., 1951—Colin Low), most of which showed an imagination and a charm not found elsewhere in the country's film

output at that time. In films such as *Challenge—Science Against Cancer* (N.F.B., 1950—Morten Parker), a combination of elaborate animation techniques and conventional film photography presented a didactic subject in dramatic and poetic terms. For the most part, however, the mass of the information, instructional and educational films presented their subjects with clarity, through the unpretentious use of simple film idioms.

On the other hand, in many of the films of this post-war period, serious faults were observable: subjects were often not well enough researched and, more often than not, this was the main cause of a superficiality of treatment and a distressing lack of humility before the facts. To this must be added a tendency, in the films of the N.F.B., to present a partial, or 'safe', view of controversial material, a tendency which the Board's position as a Government agency made understandable, although some critics, Mr Gerald Pratley, for instance, have pointed out that the Board has not been as adventurous as its own Film Act, interpreted courageously, would allow it to be. (These criticisms hardly apply to the private film companies, since they have attempted no such controversial material.) In many films, commentaries inflated the material beyond its natural limits (*The Stratford Adventure*, N.F.B., 1954—Morten Parker), or added a false tone to the subject (*A Thousand Million Years*, N.F.B., 1954—Sidney Goldsmith), and even when over-writing was absent, lack-lustre verbal material often weighed down the visuals. Few directors showed strong instinct for 'pure' cinematic treatment, and most films, therefore, suffered from an indifferent handling of the subject in terms of planned or 'choreographed' movement, and from imposed forms which seemed merely accidental. Little grasp was demonstrated of the principle of the pacing, either of action within the frame or of cutting (the control of the rhythm in which the shot or scene is changed). The rhythmic structure, therefore, was often slack and arbitrary. In addition, as fictional or semi-fictional material began to appear in the form of films with plots, characters and dialogue, weaknesses in dramatic writing and in the direction of actors, professional and non-professional, began to appear. The above-mentioned faults were not in themselves remarkable or unnatural in so relatively young a group. What was, perhaps, remarkable was the time it took for

Three Frames from BLINKITY BLANK
(National Film Board, 1955 — Norman McLaren)
'*Palme d'Or*', International Film Festival, Cannes, 1955

these faults to be remedied. In picture after picture, directors repeated the same errors; some are still repeating them. In Canada the absence of informed critical reaction from either press or public has obviously contributed to this, although the poorly developed critical faculty among Canadians generally—a socio-psychological phenomenon of some interest—has probably been the root cause. In other words, what film criticism cannot, or does not, provide, the film-makers themselves seem unable to provide. The development of Canadian film-makers has been, therefore, somewhat slow. Neither has it been sure. The proportion of success to failure is about the same here as elsewhere, but our failures are not as abject, and our successes are not as glorious, as in other lands, and we have had an abundant crop of what might be called semi-failures and semi-successes. The only hopeful exceptions to this state of affairs, that is, in the direction of flawless successes, have occurred in the presence of a discipline and a criticism (self-discipline and self-criticism) unusual in Canadian film production circles.

Nevertheless, by 1952 Canadian film-makers, the majority of them not more than six years away from their apprenticeship and some much less

than that, were managing to keep Canada on the world film map by their work in the short film. The post-war period saw the development of the 'film festival movement'. Numerous festivals, some competitive, some not, sprang up all over the world, and at them the best films from many countries were shown before international audiences of film connoisseurs and judged by juries composed of well known film experts. In most of these festivals Canadian short films were shown, and a study of the list of awards gives some indication of the international recognition which Canadian films began to achieve during this period. Although there are Canadian films of merit which have not won international or domestic awards, the award-winning films must naturally command an objective respect.

But it is well to remember (and this has been pointed out before by the few critics venturing on the subject) that Canadian film production was, to a greater or lesser extent, sponsored; that is to say, Canadian films in general served some extra-cinematic function (publicity, public relations, education) and seldom represented the free expression of the film-maker; furthermore, they seldom aspired to 'entertain'—except for a handful

THE LOON'S NECKLACE (F. R. Crawley, 1947) *'Film of the Year'*, Canadian Film Awards, 1948

of low-budget and poorly-made French-language feature films. No individuals, no foundations, no institutions have provided money for creative film-making in this country *with no strings attached*. It is not without significance that the most interesting and the most internationally-acclaimed specimens of Canadian film-making have been created when sponsor demands have been least, or least specific (as in the case of certain N.F.B. films), or when a commercial film producer like F. R. Crawley, with strong film-making instincts, has sometimes found, or made, time to produce non-commercial experiments (*The Loon's Necklace* and *The Legend of the Raven* are examples.). On the whole, however, few Canadian film producers have been able to transcend the demands of their production schedule in order to express themselves in film on subjects of personal or public importance unrelated to sponsor requirements. It is not generally understood in the Canadian film world, or not understood with any burning conviction, that there are important kinds of film-making, and important kinds of subject, for which no known sponsors, or, for that matter, no known audiences, exist. The audiences, certainly, and possibly the sponsors, could be created for these films only *after* they had been produced. As long as Canadian film-making tags along behind the sponsor and the audience, it will, to a degree, be an art in servitude.

With the Canadian short film firmly on the way to technical maturity, there came in 1953 a revolution which had been in sight for some years—the inauguration of a Canadian television service. Nobody working in the film industry foresaw, I think, just how much, and in what way, this new medium would affect theirs—and them. Some had thought that television would do away altogether with film; others had thought of it as merely a new and additional device for projecting films, in the home and the classroom, if not in the theatre, although that, too, had been predicted. In any event, television began very early to use films as part of its programme material. And it began to use them in extraordinarily large quantities. Not in ten-minute films once a month (the pre-TV theatrical short film norm), but in 30-minute films once a week, in 26- and 39-week series, television now began to make its characteristic demand on the film-maker. The television audience required material to keep it amused, informed and edified and it needed this material regularly, on strict 'to-the-hour' deadlines and in 'to-the-minute' lengths. No film group, either private or state-operated, could ignore this vast demand, and, in various ways, they all set about the task of meeting it. This resulted in, for one thing, a technological revolution which brought into existence new cameras, new sound equipment, new film stocks, new laboratory processes. Budgets for individual television films were low; the work was long and hard, if not, at first, exacting. Film-makers, long trained in methods geared to quality, took some time to acquire others geared to quantity under conditions where, to put it mildly, quality had to fend for itself.

One positive development that has come out of television production—or production for television—has been an increased ability to deal with two related aspects of film-making which hitherto the Canadian film-maker had managed, largely, to avoid: dialogue and the dramatic-narrative form. The typical pre-television Canadian short film had offered little scope in these directions; the three-reel, and longer, story films for television offered little else. At first the 'documentary' writers and directors reacted grumblingly and, on the whole, unsuccessfully. Two years of effort, however, had their effect, and a certain ease and skill has become apparent in recent work. The National Film Board's French-language television series 'Panoramique' was an example of this new measure of skill. For this series, a group of writers (Reginald Boisvert, Fernand Dansereau, Bernard Devlin, Gerard Pelletier) created six stories, released in twenty-six half-hour parts, which were directed by Fernand Dansereau, Bernard Devlin, Claude Jutra and Louis Portugais. Whatever may be the final critical verdict on these films, they represented the first concerted effort to unite a documentary approach with dialogued narrative in long form. The 'documentary approach' in these films resides in the scrupulous research of the subject matter, the attempt to extract the narrative out of the mass of factual material itself, and the use of real locations and backgrounds, wherever possible, to reinforce the 'actual' aspects of the story. This use of background 'actuality' in 'the documentary approach' proved to have its dangers because in some instances the writing and acting appeared two-dimensional against the three-dimensional actuality of the background.

The National Film Board's English-language series 'Perspective' has had difficulty in turning to good account the rigours of the half-hour dramatic narrative where a complete story is presented within the half-hour time segment. The problem has been, in part, to find writers with a taste for documentary drama and the passion for

research which this type of drama demands. But the main problem has been the half-hour format itself. This arbitrary length requires excessive stylization in dramatic exposition, development and resolution, and few 'documentary' situations can be found which will fit comfortably these conditions. Nevertheless, writers such as Charles Israel and William Weintraub, and directors such as Julian Biggs, Donald Ginsberg, Don Haldane, Fergus MacDonnell, Alan Wargon and Don Wilder have managed to triumph over the difficulties of format, and have produced several items of true filmic quality.

Film narrative material, although of a more superficial kind, has been attempted outside N.F.B. Perhaps the best known example is *The Adventures of Pierre Radisson*, a serial story in historical setting, produced by Omega Productions (Montreal) for the CBC. This series began clumsily in its first year, but showed improvement in its second (1957-8), and achieved some success, with its simple, knockabout vitality, as a show for young people. As cinema it remained resolutely elementary. The other series, produced in Canada by Normandie Productions, Toronto, a subsidiary of a U.S. company, and using U.S. directors and starring actors, have been *The Last of the Mohicans* and *Tugboat Annie*. They are 'formula jobs', competently and plainly made, and of no artistic importance, and, it should be added, of no artistic pretensions.

The Canadian Broadcasting Corporation not only has used films produced by outside organizations, but is itself, and to an increasing degree, producing film material for special programmes. Most of this material displays, perhaps not surprisingly, no great technical facility, although the subjects have often been most interesting. The CBC television staff in Vancouver has shown more than usual talent in its film activities, and in *Skid Row*, a short item on alcoholic derelicts shot for the programme 'Explorations', produced by Allan King and photographed by Jack Long in 1956, it produced a little masterpiece of documentary observation which struck a fresh and welcome note in Canadian film and television. This group has produced other items which have attempted a poetic film style, involving word and image in a more controlled relationship than that generally met with in the Canadian film, and, although the verbal material has tended to be over-literary and the visuals are often too slackly edited, these experiments are to be admired and encouraged. It is in material of this type, not related to the mass-production pressures of the

filmed series, that TV could make a positive contribution to the art of the film.

Television, then, was a major crisis for the Canadian film-maker but his trials did not end there.

Cinema, from the time of the Lumière brothers, has had a documentary function, especially as a recorder of actuality, but in the late twenties John Grierson and others of a British group developed a naturalistic theory of 'the documentary' as 'the creative interpretation of reality', a phrase which came to be applied to a multitude of admirable and less-admirable film practices. At first this approach served well to catalyse a number of young film-makers and to form the basis of a non-fiction film tradition. Films differing as widely as *Drifters*, *Night Mail*, *Song of Ceylon*, *Housing Problems* were its early, and seldom surpassed, masterpieces; Grierson, Wright, Elton, Rotha, Watt were its masters, with Robert Flaherty (*Nanook*) as a kind of high-priest.

As the documentary matured, however, its theories tended to become dogmatized and its technical means (in the broadest sense) tended to become rigid. The eternal, earnest, plodding voice of the narrator; the over-indulgence in music-backgrounds; camera-work which, in a studied effort to be self-effacing, achieved only monotony; the flaccid cutting devoid of rhythmic order; the pervasive tone of sociological virtue and do-goodery—these became characteristic of 'the documentary' manners and mannerisms. The documentary film-maker seemed to have lost his earlier force. This was, in part, a matter of technical challenge: of itself, interest in subject will not save an artist from staleness if technical challenge is not also present. Technical challenge can apply to each or all of the elements of film-making: script-writing, direction, camera-work, sound editing.

Considerable production activity served to hide this creative exhaustion for almost ten years. By the post-war period, however, the nature of the creative crisis had become glaringly apparent.

Consider the predicament of the Canadian short film. In search of new creative incentives, various half-measures were tried: dramatic material using non-professional actors or 'real' people, semi-dramatic material using professional actors, 'voice-over' dramatic narratives, dramatic vignettes perched uneasily on blocks of 'documentary' material (all, be it remarked, in the direction of 'story'). One has only to compare, say, *Farewell Oak Street* (N.F.B., 1953) with *Housing Problems* (G.P.O., 1953—British Gas Association, A. Elton and E. Anstey) to appre-

NEWFOUNDLAND SCENE (F. R. Crawley, 1950) *'Film of the Year'*, Canadian Film Awards, 1951

THE SEASONS (Christopher Chapman, 1953) '*Film of the Year*', Canadian Film Awards, 1953

ciate the substantial decline in vitality, and to observe the latter-day sociological film-maker in his struggle to create new forms and new approaches. This creative crisis was, as it were, superimposed on the 'television crisis', and the two together created the prevailing climate for Canadian film production in the early fifties.

Fortunately, there have been advances, too. Norman McLaren, for instance, produced between 1946-57, for the National Film Board, a series of films using a rich variety of unusual animation techniques. *La Poulette grise* (1947), *Begone Dull Care* (1949), *A Phantasy* (1951), *Neighbors* (1952), *Blinkity Blank* (1955), *Rythmetic* (1956), and *Chairy Tale* (1957) were among these. They won for McLaren, and Canada, international film festival awards and public acclaim. In France (where a considerable body of critical literature on his work has come into existence), in Britain, Germany, Italy and South America, McLaren is considered a major artist (in the sense of 'one who creates a work of art') of mid-century cinema.

Through all his film runs a vein of drollery and fantasy rooted in a kind of choreographic vigour which is kinaesthetically irresistible to anyone with his eyes, ears and muscles in good working order. The fantasy, its surface effects to the contrary, is not all playful in intention and, indeed, is often charged with tragic implications and a profound poetry. McLaren's films, once having penetrated a receptive consciousness, unfold their significance as leaves and flowers uncurl from a germinating seed. While they share this characteristic with any authentic work of art in any medium, his films demonstrate to a degree more extreme than is ordinarily encountered, the curtain of technique, symbols and illusions which an artist inexorably weaves round the mystery of his 'meaning' and behind which the communion between him and the audience will take place if it's going to take place at all.

Those among the movie-going people who brush off McLaren's films as amusing trifles (a view particularly prevalent in Canada) are apparently not aware of the true nature of his films, nor do they appreciate the importance of his work as a whole in the history of cinema. One young critic writing in the University of Toronto's paper *The Varsity* as part of a symposium on 'The Arts in Canada', climaxed a long wail over Canada's failure to produce 'feature' films with

these words: 'And from the great heap of shame we will have brought upon us by our laziness, not all the doodles nor all the pixillations of the Great God McLaren can possibly save us.' I think it would be no exaggeration to say that whatever wretched record we may have in the field of the long fiction film, McLaren's work has saved Canada from ignominy in other just as important aspects of film and, what is more, the work of other Canadians has taken its place beside that of McLaren to create a 'film reputation' for this country. That reputation is neither illusory nor negligible.

Colin Low and Wolf Koenig, both trained as animation artists, were among those responsible for *The Romance of Transportation* (N.F.B., 1952), to date the most festival-crowned of Canadian films. Branching out from animation, these two artists (as director and cameraman respectively) moved into the field of 'documentary' to make *Corral* (N.F.B., 1954) and *Gold* (N.F.B., 1955), both of them films of sensitive observation and poetic insight, although the former was more unified and more immediately attractive. *Gold*, generally described as a 'straightforward documen-

tary' on gold production, is a subtle exercise in irony, an intention which its commentary and its music by Eldon Rathburn should have made quite clear. Working with Roman Kroitor, Low and Koenig produced, in 1957, *City of Gold*, a film on the Klondike gold rush, the main section of which was made up of 'animated' contemporary photographs, with a pithy commentary written and spoken by Pierre Berton. This film quickly established a reputation and won the 1957 Cannes Festival award in the short film category. Basil Wright, the British film producer and critic, has called *City of Gold* one of 'the really perfect documentaries of the past twenty years'.

Christopher Chapman, a young free-lance filmmaker, in 1953, as an amateur, won the 'Film of the Year' trophy in the Canadian Film Awards with his colour film *The Seasons*. This film showed an exquisite appreciation of nature and an ability to express this through a film style of controlled lyricism, not always sure of itself in terms of movement, but very certain in its use of light and texture. A new film *Quetico* has just been completed by this artist. It is the result of two years'

THE STRATFORD ADVENTURE (N.F.B., 1954 — Morten Parker) *'Film of the Year'*, Canadian Film Awards, 1955

more or less solitary work by a film-maker who has attempted to create outside the usual framework of commercial and government sponsorship.

In the less publicized, but very important, fields of science and technology, Canada has been producing in the last few years films of great, if specialized, interest and of considerable quality. Some of the productions of the National Film Board's Science Unit, concerned mainly with biological subjects, are examples: *The Colour of Life* (1954—J. V. Durden), a film on photosynthesis; *The Spruce Bog* (1956—Dalton Muir), one of a series on ecology; and *Man Against Fungus* (1955—Maurice Constant), a study of the life history, economic importance and control of stem-rust in wheat. These films use a variety of techniques including cinephoto-micrography and time-lapse photography, to present complex material in a way no other medium could attempt. In films like *Jet Beacon Let-Down* (N.F.B., 1957 —Frank Spiller and René Jodoin), for instance, animation has been used with skill and taste in combination with live photography to explain special air-navigational techniques: while in *Huff and Puff* (N.F.B., 1956—Grant Munro) the problem of hyperventilation has been wittily explained by means of cartoon animation. These, and others of an instructional nature sponsored by the Department of National Defence and produced by the N.F.B., may never be seen by the general public, but their high quality as film should be recorded in a survey such as this.

The feature film, for reasons suggested earlier in this article largely absent from the Canadian scene, is, at this writing, showing signs of appearing (or should one say 're-appearing'?). A number of French-language films, of which Gratien Gélinas' *Tit-Coq* (1951) alone had some original quality, pioneered in Canadian feature film production but, apparently, did not attract a sufficient audience to justify the production of any more since 1952. It remains to be seen whether English-language production can take a more permanent root.

One must add a word about the state of Canadian film criticism. Only two individuals come readily to mind. Clyde Gilmour, in his radio, magazine and newspaper reviews of current feature films, has been an excellent 'popular' critic. His notices, avoiding the technicalities of film jargon, manage to separate, with consistent justice, the wheat from the chaff. The nature of his job permits him seldom

THE ROMANCE OF TRANSPORTATION (N.F.B., 1953 — Colin Low) Special Award, British Film Academy, 1954

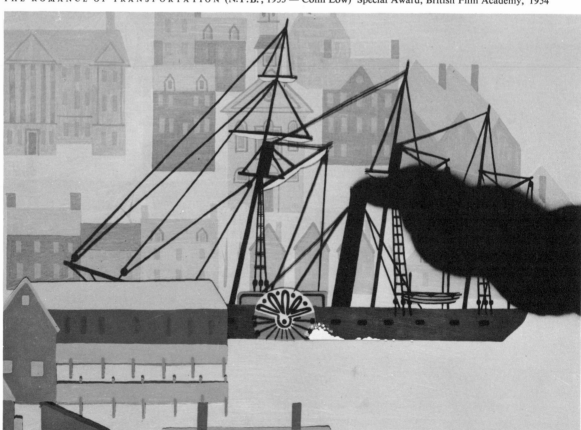

to mention short films, which, given the nature of Canadian film production, is a great local loss. The only other critic of some national reputation, Gerald Pratley, is a bird of a different feather, more analytical than his colleagues, more ready to grapple with technical problems, and sharp, too, in the expression of his likes and dislikes. His columns in the *Canadian Forum* were for years the only regular attempts seriously to take note of Canadian films and, with his articles published in other papers and journals, constitute a fairly complete record, albeit a very personal and sometimes exasperating one, of what has occurred in a decade of Canadian film production. His radio programmes on music in the film and, more recently, on various aspects of film production, have extended Pratley's range.

Out of the exchange and interpenetration of ideas in film, new developments will come, and to the extent that Canada and Canadians take part in that kind of exchange, to that extent the Canadian film will develop. It will certainly wither if it remains within an inbred, self-congratulatory, production community, attempting to operate in a kind of cultural closed shop. Actually, of course, the Canadian film *cannot* exist untouched by the general state of The Film, or The Cinema or The Moving Picture, whichever you wish to call it. If Film, no longer *the* mass-medium of the twentieth century, is reduced everywhere to being a mere recording, or 'storage' device for television programmes, prospects are poor for the Canadian film. But this is too dark a view. Just as Film itself did not destroy Theatre, so in all likelihood, Television will not destroy Film. But Film will change. Put to work almost from the day of its birth, and thrust into the rôle of mass-medium not long after, Film has had little chance to refine itself and to acquire the authority of an adult art. Perhaps when most of its labours and public responsibilities have been taken over by Television, perhaps only then, Film will have the opportunity, long denied it, of reaffirming its unique qualities, the qualities which distinguish it as an art and through which it communicates, or can communicate, most characteristically and most effectively to the emotions and intelligence of its audience. Time, Space and Space-Time are the secret mysteries of the Film, and *of* these are compounded its poetry and grandeur, and *on* these, in tragic or comic accents, and in forms unique to it, Film makes its most life-giving affirmations.

CITY OF GOLD (N.F.B., 1957 — Colin Low and Wolf Koenig) Documentary Award, International Film Festival, Cannes, 1957

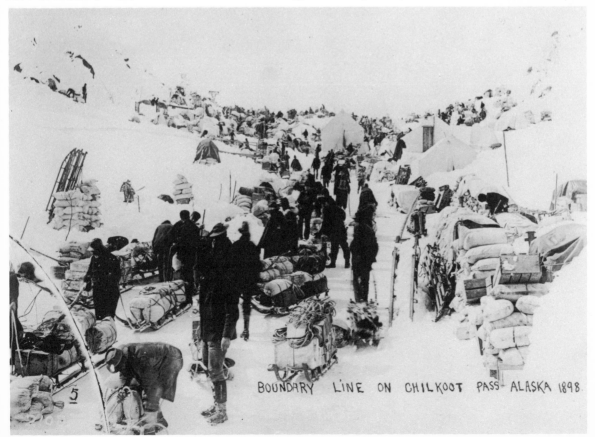

radio and television

MAVOR MOORE

radio and television

I

I FIND the sheer scope of the thing still startling.

Canada's radio network is the largest in the world. Some of its programmes have the largest organized listening groups in the world. Canada's television network is the second largest, and produces more hours of programming than any other single network anywhere. Montreal presents more French programmes than France, Toronto more English programmes than the BBC.

The importance of this activity inside the country may be gauged by noting that 96% of Canadian homes are furnished with radio sets, 63% (after only 5 years of operation) with television sets, and that the 45 extant public and private television stations reach over 80% of our entire population. 55% of their schedule is Canadian produced, and sets in the average household are viewed for a staggering 4½ to 5 hours every day. Its importance outside the country can be measured by these facts: aside from the millions of U.S. citizens who regularly or occasionally turn to Canadian stations, some of our radio programmes are already carried regularly by American stations and negotiations are under way regarding television programmes; British viewers have already seen several dozen CBC-TV dramas, Australia a dozen, and negotiations are (as of this writing) in hand with France, Belgium, Luxembourg, Germany, Sweden, Finland, Japan, and various South American countries. Internationally, the CBC International Service puts out the strongest short-wave signal from North America to Europe, and its recordings of Canadian music are played literally all over the world.

Canadians themselves have been spending well over $100,000,000 on television sets, which has materially affected employment in the fields of production, distribution and retailing, and has enlarged and changed the entire field of advertising and public relations. Its effect on the worker in the field known as 'entertainment' has been no less: musicians, actors, writers, designers, theatrical craftsmen and technicians of many kinds now represent, for the first time, a considerable national force as members of industrial unions and other bodies. And television threatens to revolutionize education as a teacher, politics as a vote-getter, and business and industry as a spy.

This astonishing growth has come about—like much growth in this land—in a way that, superficially, seems illogical and haphazard, but is in fact (given the circumstances) entirely logical and consistent. It bemuses many outsiders and not a few Canadians that a country so devoted to the cause of private enterprise should set up the world's biggest publicly-owned broadcasting system. It no less bemuses others that private stations as part of that system both co-operate with and compete with the national network; that the Canadian Broadcasting Corporation presents not only shows paid for out of the public purse but also those paid for in whole or part by advertisers; and that in all this pattern of seething compromise little political interference is discernible. As a final apparent anomaly it may be remarked that while about two-thirds of Canadian viewers prefer to watch American stations when they can, neither they nor their spokesmen in business or social organizations, in church, labour, farm or educational groups or even in Parliament, appear willing in any way to abate

their chance to view Canadian shows when they feel like it.

These seeming improvisations are actually consistent and sensible answers to the problems raised by trying to have this nation at all. From the very beginning, the establishment and maintenance of an east-west line of communication has been the first consideration of our people and our government, for without it we dissolve into separate pockets at the northern end of American trouser legs. It is still difficult to travel across Canada by road without going through a part of the U.S.A., and it is quite impossible to live in the south of Canada (most of us are within 200 miles of the U.S. border) without being hourly aware of our big, boisterous, generous, inventive neighbour. We cannot and would not live without her, but it takes considerable ingenuity to live with her.

This ingenuity is nowhere more conspicuous than in our broadcasting system. The first radio licence for a Canadian station was granted in 1919, and immediately stations sprang up quickly in the densely populated areas. But in 1923 the United States allotted to its stations *every wavelength in the broadcast band, including those already occupied by Canadian stations!* And despite frequent representations by the Canadian government to the U.S. government, it was not until 1929 that the U.S.A. took official steps to prevent American stations from interfering with (and in some cases

'CLOSE-UP' (CBC) Producer, Ross McLean Interviewer, Elaine Grand

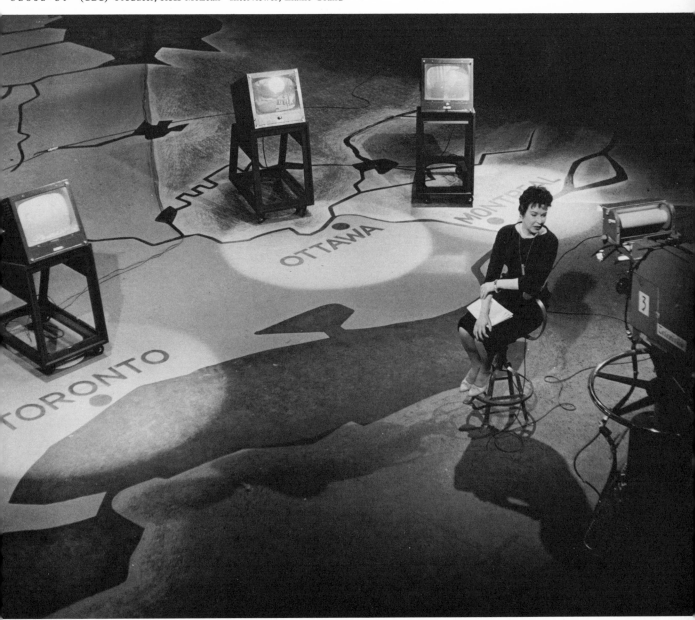

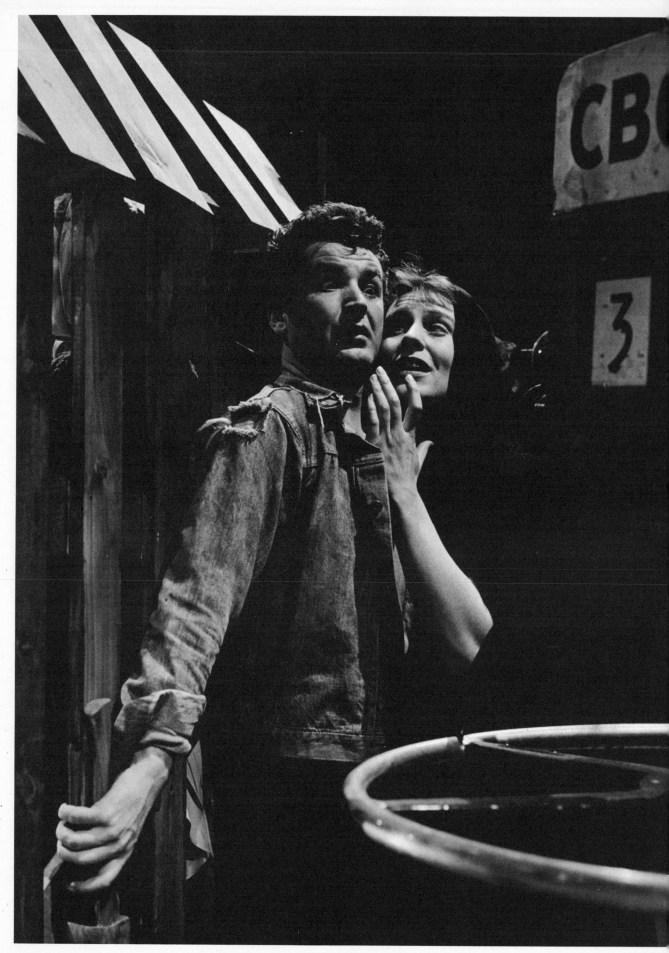

PEER GYNT (CBC 'Folio') Bruno Gerussi, Anne Morrish Produced by Robert Allen

blanketing) stations located in Canada broadcasting to Canadians. Moreover, many of the larger Canadian stations were in effect relay points for American shows, either live or recorded. The recordings upon entering Canada were subject, until only a few years ago, to an import tax on the materials of which the records were made. When one considers that the Canadian market represented gravy for the manufacturers, and that American artists—thus competing in Canada with Canadians—were paid no premium for Canadian distribution, it is easy to see why the unprotected Canadian performers of the time left home in droves, to the great detriment of our culture and our national income. This wholesale drain during the twenties and thirties has had serious and continuing effects on our growth.

Another situation that required national action was the need of bringing the benefits of broadcasting to areas which could not be served economically out of advertising revenue alone. And yet unless these areas were served, our populated cities would once more become northern extensions of north-south lines without the east-west connection which alone made sense of a northern nation. Whole areas in both eastern and western Canada would be left out, an altogether disproportionate handicap would be given listeners of French tongue (since *all* their programmes must be Canadian-produced), there would be no link between separated English or French regions, and in fact no advantage whatever would be taken of radio's peculiar genius: simultaneous reception by a scattered audience of programmes and events of mutual interest.

The history of Canadian radio and television is the continuing search for accommodation to these facts of our national life. Television, which combines the impact of so many of the arts—the visual effectiveness of the graphic and theatrical arts, the simultaneity of radio, the intimacy of literature—with a distribution that pales all else, is too powerful a mass medium to be used against the public interest, and since (so far) the control of a very few channels gives control over distribution, all parties in the Canadian Parliament have held this to be self-evident and inescapable: if we are to have Canadian broadcasting we must pay for it out of our own pockets, and we cannot afford not to have it.

II

I have felt this preliminary sketch of the system necessary, since of all the 'arts' included in this book, television is the only one which is in political fact, as well as aim, national: all facets of the medium are controlled by a national board responsible to the federal Parliament. Television is also the biggest industry among our 'arts', and in fact is a medium for the distribution of *all* the arts concerned, and of information about them. It therefore reflects in almost unique fashion the pressures of politics and industry as well as the cultural and artistic pressures applicable to each of the arts discussed elsewhere in this book. Moreover, the art forms developed in television are, in O'Casey's words, 'in a terrible state of chassis': they are in large measure dictated by swiftly changing technical considerations: the size of screen, quality of transmission, mobility of camera, use of film, new electronic gadgets, etc. They are also radically affected by gusts of fashion: e.g., whether the current predilection is for private or theatrical viewing, or for using the TV set as a focal point or as background to conversation. It therefore seems more sensible to examine Canadian broadcasting in its context as a mass medium, and leave value judgments about music, drama, dance, etc., to chapters on those arts.

The case for a distinctively Canadian culture has been kissed half to death by its supporters. It has suffered from those who believe culture to be a delicate flower, highly bred, only flourishing in an atmosphere of devotion, always in danger of being trodden underfoot by vulgarians and Philistines. Canadianism suffers equally from those whose instinctive reaction to the pressures of American culture is to fly into the arms of mother Europe: everything British or French is high-brow and good, everything American is low-brow and bad. Such people regard Canada as an outpost of Europe, a sane oasis in the mad American desert, and are thus able to feel European and patriotically Canadian in the same pang. Then, somewhere between these two, is the chauvinist who regards the adjective 'Canadian' as a synonym for 'virtuous', and who therefore insists that we Canadians always dress in a blue stocking, especially before the mirror of television.

To satisfy all these attitudes among its active supporters and to compete, as it must, for a still larger audience against American broadcasting, the CBC early developed certain definable techniques.

The Corporation divided itself administratively into areas of interest rather than of form: Farm, Schools, Talks and Public Affairs, Religious and Institutional, etc., were the titles of Departments. (There was also a Drama Department and a Features Department, but not until recently an over-all Music Department.) The programmes these departments produced, first in radio, had an

extraordinary appeal. The Farm Forum was (and still is) the largest organized radio audience in the world; Citizen's Forum in both languages has an immense and faithful organization pursuing its activities well beyond mere listening; the national and regional Schools Broadcasts are the most extensive in the world and, in the opinion of many, the best; the CBC News Department has a reputation for truth second only, if to any, to the BBC. In providing these services the CBC, carrying out its mandate to give Canadians Canadian matter, worked closely with other national bodies concerned: farm, labour, education, etc.

There is, of course, a disadvantage to this system. It is perhaps natural that there should develop among such pressure-groups (for that is what they are) the assumption that they should be consulted about matters in which they have an interest. But it is precisely because they do have an interest that their involvement is suspect. A prize example of a 'right' to interfere that seemed logical enough to those who claimed it but ridiculous (fortunately) to clearer heads, was the recent suggestion by a police chief that because some shows portrayed cruel or stupid policemen all plays involving police-

men be vetted by the police authorities. (Exeunt Gilbert and Sullivan, Sherlock Holmes, *et al.*) Add together all the lobbies representing groups which dislike seeing themselves or their work in any but the most virtuous light and you have a formidable array of self-righteousness. If part of the responsibility of our publicly-owned communication system is to let us get to know each other better, it is a betrayal of that trust to pretend we are all and equally exempt from criticism or ridicule.

In one area the CBC has capitulated entirely. It maintains, in co-operation with the major churches, a Religious Advisory Council, to whose 'advice' it invariably submits. This respectable gesture is in reality collusion of the first order; and the result is that religion, possibly the most important subject in the world, is practically never paid the compliment of open argument, never allowed the excitement of clashing views, never permitted to be held responsible for its views. There may be, it is true, a more or less balanced representation on the air of the major denominations (unquestioned even by each other), but where are the heretics, the sceptics, the critics without whom dogma becomes platitude and withers? Not on the

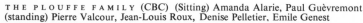

THE PLOUFFE FAMILY (CBC) (Sitting) Amanda Alarie, Paul Guèvremont (standing) Pierre Valcour, Jean-Louis Roux, Denise Pelletier, Emile Genest

CBC, because the churches, who have much to gain from constructive goading, short-sightedly prefer to regard themselves as unimpeachable, and the Corporation hands over to them the right to preside at their own trial.

In other areas, however, especially discussions and drama, the CBC has done a notable job of giving access to the airwaves to original and vital minds. It has developed many first-class commentators, such as J. B. McGeachy, Blair Fraser, John Fisher, and personalities from many fields of interest have become effective spokesmen on radio and television—people such as Leonard Brockington, William Blatz, Percy Saltzman, Arthur Phelps. Moreover, the same departmentalizing which created the hazard of outside pressures gave great freedom in terms of format, so that the CBC found itself better able than the American networks to render Public Affairs in the form of plays, music, discussion, demonstration, actuality, and often to fuse several forms into new patterns.

By the same token, and pursuing the strategy of giving the Canadian public what it could not get elsewhere, the CBC Drama Department, in the high noon of radio in the thirties and forties, became possibly the most important native artistic movement of its time. Charged with developing Canadian acting talent, and with finding inspiration for our dramatic writers in the Canadian scene, its mentors grasped the all-important issue: attention had first to be caught, and it was best caught by doing what we would never permit anyone else to do—sticking pins into the stuffed shirts we so delight to sport. Under the regime as Programme Director of E. L. Bushnell, a rare combination of intellectual vision and common touch, Drama Supervisor Andrew Allan began to make the new medium really work as a national expression. Abetted by Frank Willis (in the closely allied Department of Features), Esse Ljungh (first in Winnipeg, then in Toronto) and Rupert Caplan in Montreal, he was able to midwife a whole generation of writers, composers and performers who spoke in their own accents without embarrassment —Lister Sinclair, Len Peterson, Tommy Tweed, Fletcher Markle, W. O. Mitchell, Joseph Schull among the writers; Lucio Agostini, Howard Cable, Percy Faith, John Weinzweig, Morris Surdin among the composers; John Drainie, Bernard Braden, Barbara Kelly, Lorne Greene, Budd Knapp, Frank Peddie, Lloyd Bochner, Jane Mallett, Donald Harron, Dianne Foster, Toby Robins among the actors. In French Canada, an even earlier start had been made, a similarly imposing roster of artists was available, and significant exchange between the two language-groups now took place.

It is important to note that of Allan's masterpieces nearly all were satires, on the Canadian scene and on the outside world as seen through Canadian eyes: Peterson's *Burlap Bags,* Mitchell's *Jake and the Kid,* Sinclair's *We All Hate Toronto,* Tweed's version of Hiebert's *Sarah Binks,* Reuben Ship's *The Investigator*—the 'pirated' recording of which became a U.S. best-seller during the McCarthy dynasty. These programmes prompted letters to editors, questions in the House of Commons, arguments over coffee and domestic discord. But the achievement was that they cut across the divisions between listeners, pandered to no group but stimulated all, and made things Canadian, in one dramatic form at least, a general concern.

They proved, in brief, that radio could, at one and the same time, be intelligent and popular, entertaining and significant. On the heels of this proof Bushnell and Harry Boyle implemented the lofty 'CBC Wednesday Night' programme, in many ways analogous to the BBC's Third Programme, for the display of works of excellence in any field, whatever their length. If the programme has sometimes erred in the direction of the recondite, it none the less increased the reputation of Canadian musical and dramatic performance and won many international awards. And meanwhile the hockey and hit-parade enthusiasts had their programmes also, the original and skilful comedy team of Wayne and Shuster took successful aim at our popular funnybone, the private stations provided lively local coverage and the best of American broadcasts—and only a bigot could miss the fact that this pattern in its entirety was somehow uniquely Canadian. It has continued to be so.

But the coming of television in 1952 put an immense strain on the system, underlined old problems and exposed new ones.

III

Nearly every major city in southern Canada (with the notable exception of Montreal and Ottawa) was exposed to American television some five years earlier. The CBC's plan was to introduce Canadian television stations in the major centres as quickly as adequate staff and facilities could be made ready. These plans were largely drawn up in Ottawa, the administrative headquarters of the CBC, and Montreal, the technical headquarters— the very cities which almost entirely lacked television. Toronto, Hamilton, Vancouver and other cities already boasted thousands of sets on which was available the booming output from across the

border but no Canadian programming whatever. Not sufficiently aware of the mounting pressure in these cities, those in charge of the introduction of television permitted such a feeling of frustration to develop that by the time Canadian programmes appeared—too little and too late—they were met in many quarters with cries of pain, protest and derision. This initial miscalculation of the public mood was to have serious consequences, for it meant the battle already won in radio had to be fought all over again.

And the battle this time was harder, because infinitely more expensive. To help to meet its bills before and during the war, CBC radio had embarked on a course fraught with danger and heavy with irony: it actively sought commercial sponsorship of its programmes. During the war, particularly, this seemed natural and defensible enough, for were not government and sponsor alike on the side of God and country? But with the coming of television the practice increased, and a new wrinkle was added: the CBC began to 'subsidize' shows for which the sponsor paid only part of the cost. In some ways this compromise is a typically Canadian contrivance to meet the economic facts of North American life: we are running in competition with the American networks, with a programme schedule greater than any one of them, on a budget of about one-tenth as much. But as direct commercial control of the programme increases, the public interest is inevitably diluted by special interests. Most insidious of all, the very same trenchant iconoclasm which marked the mature and indigenous successes of Canadian radio has become increasingly unwelcome.

Scripts of sponsored shows are more often than not submitted to agencies prior to rehearsal, or edited in accordance with their orders. The consequent list of proscribed references is as long and as silly as an Italian opera libretto. Thou shalt not offend a potential customer (unless he's in jail); thou shalt not mention a competing product (cigarette advertisers have been known to forbid reference to 'Winston'—Churchill); thou shalt not mock big business or advertising, etc. We cannot blame the advertisers, whose job is to sell a product, but we must censure the CBC for abdicating its responsibility by giving in to them. The very essence of good advertising—sales impact on the largest number—is an untrustworthy guide for the preservation of minority interests, the introduction of new ideas, the exposure of hypocrisies, the presentation of palatable as well as unpalatable facts, and for many of the other refreshing dynamics by which a democracy functions.

The CBC has, however, tried to make amends with its unsponsored television programmes (and with its increasingly unsponsored radio programmes) by giving them free rein. While 'General Motors Theatre' and even much of the French 'Télethéâtre' are becoming indistinguishable from the better slick American dramas (except in locale or language), 'Folio', a sustaining CBC series presenting drama, opera, dance, documentary, etc., maintains the high-brow and experimental tradition of 'CBC Wednesday Night'. The bilingual 'Concert Hour' is in the front rank of anyone's musical television. The public affairs programmes, usually not offered for sponsorship, are currently—after a start wobbly with inexperience—among the livest and most challenging of all: 'Explorations', 'Close-up' (which has taken sharp looks at such tricky but pressing subjects as homosexuality and miscegenation), the panel quiz 'Fighting Words', the

THE POUNDING HEART (CBC) Animated film designed and directed by David MacKay, illustrations by Louis de Niverville. Toronto Art Directors' Club Medal, Television and Motion Picture Category

varied 'Cap aux Sorciers' and the artfully ingenuous daily 'Tabloid', all contrive to display originality of form and sincerity of character. Even the most esoteric of them, be it noted, has an audience in the hundreds of thousands. The variety shows, on the other hand—favourites of sponsors—are becoming more and more repetitive. The 'Cross-Canada Hit Parade', which confesses in its title to being a local version of an American show, sets the pattern: a superficial Canadian setting for a paste imitation of an American rhinestone. Only occasionally do we rise above the lingering shortage of experienced variety artists and make capital of our musical excellence and our native wit.

The lack of adequate funds, a particularly effective brake on our variety shows with their expensive cast, orchestra and settings, is a major problem for all departments, especially in the matter of keeping staff and performers here. Nowhere in the whole of our artistic life is the difference so great between the earning power of star performers and directors here and abroad as it is in television. There are, aside from personal considerations, only two magnets to draw Canadian artists home: patriotism and the opportunity to do more challenging work. Certainly it can be neither fame nor fortune. The audience obtainable for a Canadian transmission is a quarter the size of a British or French audience, a tenth the size of an American; moreover success in any one of these larger nations opens up greater chances of eventually invading the world stage. It is regrettably still true that real fame in Canada awaits recognition by the Board of Experts from Out of Town, and it will remain true just as long as Canadians prefer to let it.

The most persuasive of magnets, for both Canadians and newcomers, has always been the challenge of fresh and exciting programmes, made possible by our unique system. And by the same token, the course best guaranteed to weaken this system and drain it of its life-blood is to remove the challenge. All the pressures which I have suggested—the tendency of commercialism to seek out the safe Lowest Common Denominator, the wish of pressure-groups to prettify their own image, the too-successful attempts of others to avoid embarrassing controversy, the predilection of a large segment of the audience for American shows and the consequent imitation of them—are all helping to kill the Goose that Lays the Golden Eggs (if I may be permitted an unfortunate lapse into theatrical argot). For it is clear enough to the artist that if he is to surrender to these pressures he might as well be getting better paid for his surrender—elsewhere.

Pleasing a mass audience is a difficult task, even with the help of 'Motivation Research', since it is in reality a mass of little audiences. But—in addition to satisfying minorities with special programmes—a Highest Common Factor can and must be found if Canadian television and radio are to survive. It will never be found by always allowing the competitor to cut the stencil, because he will always be a jump ahead of our ditto machine. The wiser policy is to choose our own weapon—and we have two of them. The first is our ability to talk to each other as Canadians about things Canadian: this is a limited weapon, but one no one else can use so well. The other is to develop a style or styles recognizably our own, providing not only ourselves but the whole world with a new and vital article. The world's culture is not, praise heaven, one amorphous grey, but a rich and ever-changing colour scheme; and we shall serve ourselves and the world

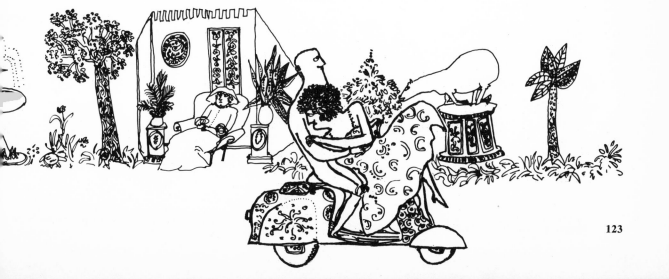

best by heightening our own hues.

It is easy to say that we have no distinguishing colour, but I believe we have shown in our broadcasting that we have. Whether we continue to be bright (in both senses) depends on our behaviour in these bullish times: will we take the bull by the horns or the tail?

At all moments of upheaval old patterns, accepted formulas, well-worn pigeonholes break down; television provides such swift and ubiquitous coverage that yesterday's popularity poll has become a symbol of useless information, and today's inspiration is tomorrow's cliché. Among other philosophies which television has knocked out but not killed is the old dualism of Entertainment versus Education. The future will be controlled by the men and women in television who grasp the futility of this dualism: communication, like an electric light, is either on or off. We cannot pay attention to anything without getting something from it, and we cannot get anything unless our attention is held.

Actors and professors are now banded together, members of one 'performers' union; the classroom is just another scene, the play instructs; the preacher wears make-up, the clown pleads charity's cause; drama is found in scenery and science, fun in intellectual wizardry. In Canada we have had perhaps a better opportunity than anywhere else

in the world to hasten the end of the old frames and produce new ones. From the beginning our system was envisaged as 'communication' rather than mere entertainment or restricted education, and we have so far had the good fortune to attract the services of inventive and far-sighted creative artists: writers like Arthur Hailey, who finds drama in planes, banks, hospitals, or Roger Lemelin, who finds sharp social commentary in the humble Plouffe family; directors like Ross McLean, who demonstrates that wit and significance are not mutually exclusive, or Jean-Paul Fougère, who seems able to turn his hand to anything.

With the inevitable increasing use of film or tape to distribute abroad programmes made in Canada, we shall be even better able to keep such creative people here, to make use of our pivotal position in relation to the English- and French-speaking worlds, and to demonstrate the leadership our approach makes possible. If we are able to hold at bay the forces which would anchor us to provincial mediocrity, or push us into timid counterfeiting, we shall be in a rare position to call the tune for the future of television everywhere. If we can so enrich ourselves and the world, the Canadian system of broadcasting, that curious hybrid, will have justified itself.

GATEWAYS TO THE
MIND (CBC).
One of a series of
science programmes
sponsored by the
Trans-Canada
Telephone System.

TRADITION
ET
ÉVOLUTION
AU
CANADA
FRANÇAIS

GUY SYLVESTRE

TRADITION ET ÉVOLUTION AU CANADA FRANÇAIS

T o u s les peuples américains ont ceci de commun qu'ils ont hérité d'un patrimoine culturel européen mais qu'ils ont évolué dans un milieu aux dimensions nouvelles. Leurs écrivains ont toujours eu à exprimer dans une langue toute faite ailleurs, des événements, des faits géographiques ou historiques, des impressions, des sentiments, des idées et des aspirations qui ont quelque chose de commun avec ceux des autres hommes mais qui en diffèrent aussi. Les Américains sont des Occidentaux, mais ils ne sont plus des Européens, bien que le cordon ombilical qui les reliait aux mères-patries tienne encore. Cela est vrai des Canadiens de langue française comme de langue anglaise. Les uns et les autres restent profondément attachés à la Grande-Bretagne et à la France, mais ils sont aussi nettement des Américains du nord. Il y a au pays une irréductible dualité culturelle, et il serait vain de vouloir cacher qu'anglophones et francophones sont restés jusqu'ici, en ce domaine, non pas des ennemis mais des étrangers. Et pourtant quiconque étudie un peu les deux littératures canadiennes a tôt fait de constater qu'elles ont suivi des voies parallèles et que, malgré leurs inévitables traits distinctifs, elles ont des caractères communs qui n'ont jamais été mis en lumière. Il est plus que temps d'entreprendre de sérieuses études de littérature comparée: elles démontreront que de Haliburton à Joyce Marshall ou de Sangster à Layton, les lettres canadiennes de langue anglaise ont de nombreaux caractères communs avec celles qui ont été produites de Gaspé à Langevin et de Crémazie à Anne Hébert. De telles études—ainsi que d'études semblables sur l'évolution des moeurs—pourrait sortir une conscience plus éclairée et plus aiguë de l'unité profonde des Canadiens au delà de leurs dissimilitudes. La plus grande partie de nos préjugés raciaux ne repose que sur l'ignorance. Il est devenu impérieux de dissiper cette ignorance.

Louis Hémon a écrit qu' 'au pays de Québec rien

English translation, page 163

ne doit changer'. Mais beaucoup de choses ont changé, depuis *Maria Chapdelaine,* et continuent de changer, malgré un solide attachement au passé. Une société qui n'évolue pas est une société morte et le Canada français semble bien vivant, même s'il évolue un peu plus lentement dans certains domaines que le reste du continent nord-américain. En fait, le Canada français est en train d'accomplir une véritable révolution sociale. De nombreuses transformations, visibles dans les institutions, se manifestent aussi dans ce miroir que sont les lettres et les arts. Il ne s'agit pas d'un simple progrès, naturel chez un peuple jeune, mais de certaines ruptures avec des traditions séculaires et de tendances nouvelles. Cette révolution n'est pas générale et elle n'est pas violente; maintes traditions survivent à côté des innovations, des mythes demeurent pendant que certains autres se meurent ou naissent, et cette coexistence de ce qui dure et de ce qui naît fait de notre temps une époque de transition. Il est assez facile de dire d'où vient le Canada français, il ne l'est pas autant de voir où il va.

Ces changements s'opèrent à l'intérieur des structures existantes et ils sont visibles dans presque tous les domaines. Si les conditions matérielles de la vie sont devenues presque partout conformes aux standards nord-américains, le Canada français reste une province de la culture française et, dans une certaine mesure, attaché à l'ancien régime d'avant 1789. La foi reste générale, mais elle est moins spontanée, et elle est repensée en fonction de nouvelles conditions de vie; l'attachement à la France et aux institutions monarchiques reste profond, mais il est moins sentimental et plus raisonné; le mythe de la supériorité de l'agriculture a été pratiquement détruit (sauf dans certains milieux) par l'industrialisation du Québec et par l'exode des *habitants* vers les villes; cependant, nous assistons peut-être à la naissance d'un nouveau mythe, celui du salut par les syndicats ouvriers; sans tourner le dos aux humanités, l'enseignement secondaire et universitaire accorde une attention plus grande aux sciences pures et appliquées. En somme, sans renier son passé et sans perdre ses traits distinctifs, le Canada français évolue conformément aux exigences de sa situation nord-américaine.

Les transformations économiques et sociales se font aussi sentir dans les oeuvres des écrivains, des artistes et des penseurs. Si Robert Choquette et Alfred Desrochers sont encore très près de Fréchette et de Gill, Anne Hébert et Roland Giguère n'ont plus rien de commun avec les poètes des générations précédentes; si Léo-Paul Desrosiers et Robert de Roquebrune continuent, mais avec un

art nettement supérieur, Joseph Marmette et Laure Conan, Robert Élie et André Langevin ne doivent rien à nos romanciers antérieurs; si le Père Lachance et Charles de Koninck restent fidèles à l'orthodoxie thomiste et continuent Mgr Louis-Adolphe Paquet, François Hertel et Jacques Lavigne n'ont pas de prédécesseurs parmi nos penseurs; si Jacques de Tonnancour peint, dans un style qui rappelle celui de Goodridge Roberts, des portraits et des paysages, la plupart des jeunes peintres font de la peinture non-figurative. De même qu'on exploite encore des thèmes folkloriques, on commence à écrire de la musique atonale ou dodécaphonique, mais sans atteindre vraiment le grand public. Ce ne sont là que quelques exemples d'interprètes de la vie au Canada français qui témoignent par leurs oeuvres soit des survivances du siècle dernier, soit des changements qu'on peut observer dans le comportement individuel et collectif des Canadiens français. Ce qui importe surtout ici, ce n'est pas le progrès très net accompli sur le plan de l'art, de l'écriture ou de la logique, mais l'approfondissement de la sensibilité et de la pensée, et surtout le fait que des thèmes nouveaux retiennent l'attention de la plupart des meilleurs écrivains, artistes et penseurs. C'est la substance même de la culture qui en est modifiée, plus que les instruments qui servent à la communiquer. C'est là qu'est la véritable révolution, et non dans l'introduction de nouveaux procédés d'écriture ou de composition.

Il est impossible de comprendre le sens et la portée de ces changements sans remonter dans le passé, sans rappeler certains facteurs géographiques, historiques, sociaux, économiques et culturels qui ont donné aux Canadiens français leurs traits distinctifs et les ont faits ce qu'ils sont. Toute évolution ou révolution se fait à partir d'un état donné, et cela est vrai dans l'ordre de la culture comme dans d'autres. Il arrive qu'une oeuvre donne l'impression de la génération spontanée—les génies donnent plus qu'ils ne reçoivent—mais l'ensemble d'une littérature, d'un art ou d'une culture est conditionné dans une large mesure par le milieu où ces derniers naissent, croissent et meurent.

Les Canadiens français sont des *Américains* vivant sous un régime *britannique* et parlant *français.* La réunion de ces trois caractères les met dans une situation unique sur ce continent. Ils sont près de cinq millions dans un immense pays qui compte plus de onze millions d'anglophones et sur un continent qui en compte cent soixante-quinze millions. Géographiquement, ils sont une enclave, même s'ils ont essaimé dans toutes les autres

provinces et aux États-Unis, et cela seul suffit à expliquer qu'ils aient eu tendance à se replier souvent sur eux-mêmes. Ce repli leur a d'ailleurs encore été imposé par l'histoire: peuple conquis en 1763, appauvri en hommes et en biens, menacé dans sa survivance et désireux malgré tout de rester lui-même, les Canadiens français y ont réussi grâce à leur imperméabilité, à leur inertie, à leur fidélité et à leur haute natalité.

La géographie et l'histoire expliquent pourquoi les Canadiens français sont restés si profondément attachés à leur passé, méfiants à l'égard de ce qui est nouveau et étranger: 'le nationalisme chez nous, a écrit Lorenzo Paré, est un réflexe de défense. Ce n'est pas un mode de vie.' Les Canadiens français sont restés presque tous insensibles au courant révolutionnaire qui a amené l'indépendance américaine, la révolution française et la libération des républiques latines. Comme le soulignait Henri-Irénée Marrou, ils sont 'à peu près les seuls Occidentaux à n'avoir pas la tête d'un roi sur la conscience.' En effet, ils n'étaient pas encore sujets britanniques lorsque Charles Ier fut décapité et ils avaient cessé d'appartenir à la France lorsque tomba la tête de Louis XVI. Un moment, sous l'influence de Papineau, un souffle de libéralisme agita profondément le Bas-Canada, alors même que William Lyon Mackenzie s'insurgeait contre l'autocratie royale. Mais tout rentra vite dans l'ordre et, depuis un siècle, l'histoire du Canada est celle d'une *évolution* vers la souveraineté et l'indépendance.

Les seules *révolutions* ont été l'industrielle et l'économique, et elles ont été faites surtout par des étrangers. Cette double révolution, à laquelle les Canadiens français n'ont guère contribué que la main-d'oeuvre, a fait de ces derniers des économiquement faibles. D'autre part, l'évolution politique où ils ont joué un rôle important—Papineau, Lafontaine, Cartier, Laurier, Lapointe, Saint-Laurent—en a fait des politiquement forts. Cet écart, assez considérable, entre la force politique et la faiblesse économique fait aussi des Canadiens français un groupe différent de la majorité anglophone. Ils jouissent (sauf dans certains domaines en dehors du Québec) de droits égaux à ceux de leurs compatriotes de langue anglaise, mais ils n'ont jamais eu les moyens financiers capables de leur assurer une jouissance de ces droits égale à celle des anglophones. Ils sont une minorité, une minorité plus pauvre que la majorité, et il est parfaitement naturel qu'ils aient les caractères collectifs propres aux minorités. La conscience de leur infériorité economique leur est d'autant plus pénible qu'ils ont été les premiers occupants blancs du pays et que

leurs ancêtres ont été, pendant un siècle, les maîtres d'un immense continent qui s'étendait de l'Atlantique aux Rocheuses et de la baie d'Hudson au golfe du Mexique. Il n'est pas étonnant que les Canadiens français aient la nostalgie du passé et que, groupe minoritaire, ils aient été sur la défensive. Cette nostalgie doit être surmontée.

Après la conquête britannique, les officiers anglais ont pris en main l'administration de la colonie, et les nouveaux colons anglais ont pris le contrôle de l'industrie et du commerce. Les Canadiens français ont dû vivre soit sur la terre, soit à l'emploi de patrons anglais. De là est né le mythe de la vocation agricole des Canadiens français, de la supériorité de l'agriculture sur l'industrie et le commerce, mythe inexistant dans la Nouvelle-France et qui n'a pu s'enraciner si profondément après la conquête qu'en raison du fait que le commerce et l'industrie étaient aux mains des 'étrangers'. Aussi, lorsque la révolution industrielle est survenue au dix-neuvième siècle, les Canadiens français, dépourvus de capitaux et sans expérience des grandes affaires, n'ont pu participer à l'industrialisation du Québec qu'à titre de prolétaires. Il y a quelques exceptions, mais elles ne font que confirmer la règle. Aujourd'hui encore, les Canadiens français ne possèdent qu'une petite partie de la richesse nationale, bien qu'ils aient fait des progrès dans certains secteurs de l'industrie et du commerce.

Ce sont des facteurs géographiques, historiques et économiques qui expliquent pourquoi, jusqu'à la première guerre mondiale, le Canada français est resté surtout agricole et pourquoi ceux qui quittaient la terre pour un sort pire devenaient des prolétaires chez eux ou aux États-Unis—l'émigration massive des Canadiens français aux États-Unis au dix-neuvième siècle sous la pression de la nécessité économique est une des grandes tristesses de notre histoire—et pourquoi ceux qui la quittaient pour un sort meilleur se dirigeaient, non vers les sciences, le génie, l'industrie ou le commerce, mais vers le sacerdoce, la médecine et le droit. Dans un pays agricole où l'élite est faite de prêtres, de médecins, d'avocats et de notaires, ce qu'on appelle les humanités jouit naturellement d'un plus grand prestige que les sciences; on préfère les *Géorgiques* ou les *Méditations poétiques* à *The Origin of Species* ou à *The Wealth of Nations*.

Aujourd'hui encore, malgré l'exode vers les villes et les progrès accomplis dans le monde du commerce et de l'industrie, le mythe agricole n'a pas encore complètement disparu et il existe encore des apôtres du retour à la terre. L'enseignement supérieur, qui ne s'est développé que lentement,

préparait, jusqu'à ces dernières années, surtout aux professions libérales l'élite d'un peuple qui a un énorme besoin de scientifiques, d'ingénieurs, d'industriels et d'hommes d'affaires. Les choses changent toutefois peu à peu et, récemment, les universités canadiennes-françaises ont produit pour la première fois plus d'ingénieurs que d'avocats. Ce mouvement vers les sciences s'accentue déjà, surtout depuis l'établissement du baccalauréat latin-sciences. Les réformes de l'enseignement sont trop récentes pour qu'il soit possible de juger de leurs effets, mais il est certain qu'une partie importante de la jeune génération universitaire est nettement orientée vers les sciences et il est possible que la prédominance séculaire des humanités touche à sa fin au Canada français.

Parce que la mise en valeurs des ressources naturelles et les grandes entreprises commerciales leur étaient plutôt fermées, les Canadiens français ont développé à leur égard un complexe de supériorité et ils ont pris l'habitude de considérer les anglophones comme des matérialistes et de se considérer eux-mêmes comme des spiritualistes. De là est né un messianisme facile et assez faux. Une littérature abondante repose sur ces mythes et n'est faite que de généralisations et de lieux communs, fleurs qui poussent facilement dans un pays encore jeune, peuplé de pionniers pour qui la pensée est un luxe, et la recherche, un gaspillage de temps et d'énergie; et qui recevait d'outre-Atlantique une pensée toute faite avec laquelle il ne lui était d'ailleurs pas possible de rivaliser.

Les facteurs économiques et psychologiques qui ont retardé la naissance d'une pensée adulte et l'éclosion d'oeuvres originales, et que le regretté E. K. Brown a très bien soulignés dans *On Canadian Poetry,* ont joué encore plus fortement au Canada français qu'au Canada anglais, bien que le Canada français ait dû avoir très tôt une littérature de résistance qui ne s'imposait pas à la majorité anglophone. C'est pour répondre à Durham que François-Xavier Garneau a écrit son histoire; c'est pour rappeler la vie sous l'ancien régime seigneurial que Philippe-Aubert de Gaspé a écrit *Les Anciens Canadiens*; c'est pour soutenir le sentiment patriotique qu'Octave Crémazie a écrit ses poèmes, et c'est toujours pour lutter en faveur des intérêts canadiens-français qu'Étienne Parent a pris la plume ou la parole. Cette tradition apologétique a dominé toute la littérature du dix-neuvième siècle et a survécu, à un degré sans cesse diminuant certes, au vingtième. Il suffit de lire les oeuvres de Louis Fréchette, de Pamphile Lemay, de Nérée Beauchemin, de Joseph Marmette, de Laure Conan, du cha-

noine Lionel Groulx, de Jules-Paul Tardivel ou de Mgr Camille Roy pour y retrouver la même inspiration religieuse et patriotique, le même culte du passé et le même mythe de la vocation agricole du Canada français. Les premiers écrivains qui ont eu des préoccupations esthétiques poussées—Nelligan, Morin, Delahaye, Asselin, Fournier, Laberge ou Henri d'Arles—ont longtemps fait figure de déracinés ou de révolutionnaires; on admirait leur style, mais on les considérait quelque peu comme des hors-la-loi parce qu'ils ne s'inséraient pas dans la tradition au pays où Louis Hémon allait dire que 'rien ne doit changer'.

Mais beaucoup de choses ont changé et continuent de changer. L'exode vers la ville, surtout depuis la première guerre mondiale, a conduit un million de Canadiens français des petites paroisses, où la vie était organisée dans des cadres fixes et en vertu de canons séculaires, vers des villes où ils se sont trouvés souvent seuls au milieu de la foule et perdus dans un monde complexe auquel rien ne les avait préparés. Le roman de Ringuet, *Le Poids du jour*, analyse longuement cette rupture de l'unité intérieure d'un Canadien élevé dans un petit village paisible et lancé dans ce monde hostile qu'est la métropole. Ce même thème est au centre des *Soirs rouges* de Clément Marchand, et on le retrouve dans plusieurs autres oeuvres récentes. La vision idyllique de la vie rurale que toute une littérature d'édification nous a présentée depuis le *Jean Rivard* d'Antoine Gérin-Lajoie jusqu'aux *Sources* de Léo-Paul Desrosiers, est périmée aujourd'hui; elle a d'ailleurs provoqué une réaction assez violente qui, conforme aux tendances de l'époque, s'est exprimée dans plusieurs romans, depuis les *30 Arpents* de Ringuet jusqu'au *Temps des hommes* d'André Langevin, en passant par *La Fille laide* d'Yves Thériault et *Neuf Jours de haine* de Jean-Jules Richard. L'image idéalisée du Canada français qu'on trouve dans presque toute la littérature antérieure à 1930 ne se retrouve guère dans les oeuvres récentes; la littérature a cessé d'être un instrument de prédication religieuse, patriotique ou sociale, elle est devenue, en même temps qu'un art, une prise de conscience personnelle et collective. En somme, on a cessé de peindre l'homme tel qu'on le voulait, on le peint tel qu'il est, et souvent en insistant davantage sur ses tares que sur ses vertus.

Plusieurs des meilleurs écrivains font actuellement un effort conjugué de démythification qui s'imposait. Un cathartique était devenu nécessaire, il faut souvent purger un organisme avant de le

reconstituer. Toute grande construction suppose des fondations solides, lesquelles supposent un travail de déblaiement et d'excavation. Certains ont semblé devoir n'être que des fossoyeurs—Pierre Baillargeon, Jean Simard, mais ce dernier vient de montrer dans *Mon Fils pourtant heureux* que la liberté peut être conquise au terme d'une ascèse pénible; d'autres, sans construire, ont nettoyé l'atmosphère grâce à d'heureuses satires, comme Roger Lemelin dans ses deux premiers romans; d'autres enfin, à la recherche de la lumière, ont exploré surtout la nuit, comme Robert Charbonneau, André Giroux et Robert Élie. De tous nos écrivains, celui qui a le mieux dominé ses démons intérieurs et les tentations du monde pour atteindre à un authentique équilibre spirituel est Gabrielle Roy qui, après une fresque sociale empreinte d'un humanitarisme profond, *Bonheur d'occasion*, a peint dans *Alexandre Chenevert* le portrait d'un homme simple qui porte, sans faux tragique et sans emphase, tout le poids de sa condition et de son temps. Il reste que la plupart de nos écrivains, conscients des tabous qui les paralysent et ayant entrevu où se trouve la lumière, se débattent encore dans la nuit.

Félix-Antoine Savard, pour sa part, a voulu reprendre certains thèmes idéologiques de Louis Hémon dans *Menaud, maître-draveur*, sorte de poème épique en prose qui est un de nos plus beaux livres mais qui n'est nullement accordé à la sensibilité de l'époque. Ce qui domine dans la poésie et dans le roman des dernières années, c'est l'expérience d'une terrible solitude spirituelle, d'une tragique recherche de la joie et de l'amour au milieu d'un monde qui en a perdu le sens. La critique de l'éducation, le refus de la morale bourgeoise, l'expérience de la faillite sociale, la difficulté extrême pour le couple d'atteindre à l'unité, la tentation du meurtre ou du suicide, la conscience d'une vie spirituelle frustrée et la hantise de Dieu sont des thèmes qu'on retrouve dans les poèmes d'Alain Grandbois comme dans les romans de Robert Charbonneau, dans le journal de Saint-Denys-Garneau comme dans les romans et la pièce de Robert Élie. Je ne trouve nulle part dans la littérature canadienne de langue anglaise, si ce n'est chez quelques poètes, une telle exigence spirituelle ni une image aussi tragique de la vie. On retrouve la plupart de ces thèmes *noirs* dans l'oeuvre d'André Giroux, d'André Langevin, d'Anne Hébert, de Roland Giguère et de Marcel Dubé et même chez d'autres, où ils sont cependant opposés à une non moins authentique expérience de la joie et de l'amour, comme chez Rina Lasnier ou Germaine Guèvremont. Il reste que le pessimisme est un des traits dominants de la littérature récente au Canada français, comme en font foi les seuls titres des oeuvres: *Le Gouffre a toujours soif, Le Tombeau des rois, Poussière sur la ville, Les Îles de la nuit, La Fin des songes, Présence de l'absence, Un Fils à tuer, La Coupe vide, Neuf Jours de haine, Impasse, La Fille laide, Les Inutiles, La Mort à vivre, Le Ciel fermé*. Cela fait une symphonie quelque peu macabre, et il est indubitable que la littérature canadienne est aujourd'hui aussi noire que la française ou l'allemande, quoique d'une autre manière.

C'est dans le roman et dans la poésie qu'une littérature canadienne française s'affirme aujourd'hui, mais on remarque aussi un certain progrès dans d'autres genres. La production dramatique reste encore pauvre, malgré les qualités qu'on trouve chez un Paul Toupin ou un Éloi de Grandmont; les seules oeuvres qui ont connu un grand succès—le *Tit-Coq* de Gratien Gélinas ou la *Zone* de Marcel Dubé—restent très près du folklore et si on peut les voir avec plaisir, on ne saurait les lire sans être choqué par la langue. Mais si le Canada français ne produit guère d'oeuvres théâtrales, il en consomme désormais beaucoup, surtout à Montréal, où plusieurs compagnies peuvent maintenant jouer la même pièce dix, vingt ou cinquante fois. Il est possible aussi que la télévision favorise la production d'oeuvres dramatiques importantes; elle est, en tout cas, un phénomène social dont la portée ne pourra être évaluée que plus tard. Il est certain, d'une part, qu'elle encourage les artistes et les écrivains, mais il n'est pas moins certain qu'elle engendre une passivité qui peut être nocive et une standardisation du goût qui peut porter atteinte à l'individualisme foncier du Canadien français. Ce qui est trop élevé ou trop original, trop profond ou trop osé ne saurait, sauf de rares exceptions, passer par les organes de diffusion collective: le plus grand génie sera toujours le parent pauvre de Maurice Richard, d'Edouard Carpentier ou de Guillaume Plouffe. Mais cela est vrai ailleurs comme ici.

Les hautes méditations ésotériques d'Alain Grandbois, les brefs coups de sonde d'Anne Hébert au royaume de la mort, le voyage de Robert Élie au bout de la nuit ou l'aventure intérieure d'Alexandre Chenevert ne se retrouvent guère dans les autres genres littéraires, qui ne se prêtent d'ailleurs pas à ce genre de thèmes, si ce n'est l'essai, genre encore inexploité ici. L'essai suppose une pensée aiguë et une écriture souple qu'on ne trouve guère qu'aux époques de haute civilisation: nous n'en sommes pas là. Mais la production philosophique, qui ne fut faite pendant un demi-

siècle que de commentaires de saint Thomas ou de Duns Scot, semble vouloir prendre une tournure plus personnelle, timidement d'abord avec François Hertel, puis résolument avec Jacques Lavigne dont *L'Inquiétude humaine* est un maître-livre. De même que romanciers et poètes ont tourné le dos aux clichés romantiques et tordu à l'éloquence son cou, penseurs, sociologues et historiens commencent à fuir les idées toutes faites, les généralisations faciles et les mythes traditionnels. L'éloquence n'est plus à la mode, ni le journalisme personnel, ni l'économie patriotique, ni la sociologie édifiante: au moment où la poésie et le roman deviennent l'aventure personnelle de l'auteur, les genres didactiques deviennent, au contraire, froidement objectifs. Dans un cas comme dans l'autre, c'est une évolution dans la bonne direction.

Roger Duhamel n'oserait plus se livrer au genre de polémiques que menait Honoré Beaugrand dans le même journal à ses débuts; *Le Fédéralisme canadien* de Maurice Lamontagne n'a rien de la chaleur qu'un Edouard Montpetit mettait jusque dans l'économie; les études sociologiques de l'école du Père Lévesque restent au niveau de l'observation et de la statistique et fuient les vaines prédications qui furent trop longtemps à la mode; nos parlementaires, sauf de rares exceptions, préfèrent maintenant les exposés documentés aux envolées oratoires; et les historiens, travaillant à même les archives mieux organisées et plus riches qu'autrefois, restent près des sources et évitent les approximations. Il suffit pour s'en convaincre de comparer un livre de Guy Frégault à un de Chapais. Il est regrettable toutefois que les historiens restent fascinés par les grands personnages de la Nouvelle-France au point d'ignorer à peu près complètement l'histoire qui a suivi 1763. Nous attendons encore les grandes biographies pourtant nécessaires de Papineau, Lafontaine, Cartier, Laurier, Lapointe et autres. Le progrès accompli dans les sciences de l'homme est accompagné d'un non moindre progrès dans les sciences pures. Un véritable réveil scientifique se manifeste à Montréal, à Québec et à Ottawa où les facultés de sciences et les écoles de génie se développent rapidement dans un effort pour rejoindre les Canadiens anglais qui ont pris les devants ici.

Il semble bien qu'il y ait eu récemment progrès assez considérable dans tous les domaines de la vie de l'esprit; il est certain, en tout cas, que nos oeuvres les meilleures ont commencé à retenir l'attention des étrangers en raison de leur valeur propre, et non par pure sympathie. Le succès à Paris d'une Gabrielle Roy ou d'un Alfred Pellan confirme la conscience que nous avons d'atteindre à la maturité: nous n'avons pas encore produit de Balzac ou de Baudelaire, de Pascal ou de Molière, non plus que de Chardin ou de Debussy, de Pasteur ou de Le Play—mais d'autres pays non plus n'ont pas produit d'hommes de ce calibre—et si nous savons que nous n'avons guère ajouté au patrimoine culturel de l'humanité, nous savons aussi que nous avons commencé à avoir quelque chose à dire et à savoir le dire. Au point où nous en sommes, un optimisme trop grand serait aussi nuisible qu'un pessimisme chagrin.

On s'est demandé longtemps si les Canadiens français survivraient ou seraient assimilés; on ne se le demande plus, mais ce qu'on se demande désormais, c'est à quel degré ils resteront français et à quel degré ils deviendront nord-américains. Il est certain qu'ils ont subi fortement l'influence de la civilisation américaine—surtout sur le plan matériel—mais il n'est pas moins certain que la barrière linguistique a contribué à les immuniser mieux que les Canadiens anglais contre les moins heureux aspects de l'influence américaine, surtout sur le plan culturel. Les organes de diffusion massive—journaux, magazines, radio, télévision, cinéma—du Canada français ont moins subi l'influence américaine que ceux du Canada anglais. Sur le plan de la culture, le Canada français est aujourd'hui plus près de la France que le Canada anglais ne l'est de la Grande-Bretagne. Ce qui ne veut pas dire que la littérature canadienne-française ne soit qu'une image appauvrie de la littérature française; elle tient du milieu où elle se développe des apports humains différents—Montréal n'est pas Paris—mais elle cherche à penser, à sentir et à s'exprimer selon le génie français. Tel est son caractère unique: une littérature *américaine* écrite en *français* dans un pays *britannique*. Elle exprime un monde aux dimensions inconnues en France, un peuple qui a adopté presque toutes les inventions américaines et participe à une civilisation qui n'est plus celle de la vieille Europe; elle exprime, en somme, un visage de l'homme qui est complexe, celui d'un homme qui a l'Amérique sous les pieds mais qui a, selon l'expression de René Garneau, 'la France dans le sang et dans la peau'. De cette rencontre d'éléments de civilisation nouveaux et de valeurs de culture anciennes va sortir un nouvel équilibre humain dont la littérature récente indique la venue sans avoir réussi encore à l'exprimer clairement et fortement. Ce qui est certain, c'est que cette coexistence de traditions françaises et d'apports américains fait du Canada français une entité distincte dont les lettres et les arts ont une saveur unique en Amérique du nord.

ARCHITECTURE AND TOWN PLANNING

ARCHITECTURE

WARNETT KENNEDY

JUST AS the wrinkles on the face of an old man reveal his character, so the architecture of an old and settled race tells us something of the quality of its civilization. But Canada presents many faces to the world and they are those of a smooth-skinned young family. It would be false to pretend to recognize a specifically Canadian architecture reflecting a distinctive national character.

Perhaps there never will be a Canadian culture on the traditional model. It may be that conditions under which nations could emphasize their distinctive traits through an incestuous evolutionary growth behind fixed frontiers have gone for ever. The speed and fluidity with which technological ideas spread across the network of planetary communications now constitute a new factor in our reckoning.

To many people the new cybernetic world architecture is repulsive. As an alternative to an international style, they have resurrected the old plea for regional architecture and we have to ask ourselves whether such a thing is still attainable. Perhaps the insistent desire for regional or provincial expression in Canadian architecture is only one aspect of a larger revolt against the impersonal buildings of the age of machine production: perhaps it is only part of a larger hunger for differentiation and individuality.

Our failure to create in Canada an acceptable romanticism out of contemporary thought, materials and techniques has left a vacuum which is all too readily filled by folksy or nostalgic period importations—Cape Cod, Tudor, French Renaissance, Spanish Hacienda, Disneyland and hamburger styles. Having no architectural tradition of our own, we are wide open to the meretricious attractions of roadside ribbon romanticism.

University of Manitoba — Entrance to Library
Architects: GREEN, BLANKSTEIN, RUSSELL & ASSOCIATES
As part of an existing campus composition of traditional masonry buildings, the new library is an exemplar of the application of the principles of contemporary architecture without violating the harmony of the group.

Before we can talk about architecture in Canada, we must talk about architecture itself. If we can understand the eternal opposition between the classical and the romantic approaches to design problems, perhaps we shall have the key to an understanding of this same struggle being fought again with new weapons, but this time over Canadian terrain. So, before looking too closely at specific buildings, let us set out the criteria by which we can appraise architectural trends.

First of all, we must recognize in these trends the ebb and flow of tendencies in our own mental and temperamental make-up. Our buildings reveal us to ourselves. It is no meaningless digression, therefore, to remind ourselves of the eternal conflict of opposites within each of us—the rational mind struggling with the animal senses, seeking not a one-sided victory but a mature balance between thinking and feeling.

In so far as we are classicists and thus controlled by reason, we believe that there are absolute and unifying laws of nature and design underlying the multiplicity of appearances. Generations of artists have sought for the magic formulae which would reveal these laws. A mystical belief in laws of harmonic proportions can be traced from earliest times. This recurring dream (this desperate resolve to identify ourselves and our design processes with laws in nature) gains credence largely by its persistence.

Architects know that in Nature recurring forms are shaped by forces seeking and finding their final balance. So, too, say the classicists, do men, by trial and error, by refinement and calculation, arrive at ideal forms. This is, of course, an essentially impersonal process. The Orders of Architecture were perfected in this way and it would, for

example, be an architectural solecism to enquire after the names of their designers. Capricious variations of these Orders for the sake of personal expression would have exasperated the Greeks, and, likewise, their modern counterparts, the neo-neo-classicists of today, have a puritanical horror of celebrity architects of the Romantic School.

Just as the Orders of Architecture were the perfected component forms of Greek architecture, so the three-dimensional structural space frames and the delicate standardized transparent walling are the classical components which are being perfected in our time. Again, as in ancient days, it is the structural system which is being idealized.

These open structural frames have become objects of aesthetic veneration. If opaque walling hides their rhythms and the fascination of their appearing to interpenetrate each other or their ability to outline spaces, then either the walls must be made transparent or the structure brought out beyond the walls and roof where it can be admired. In the last analysis, architects would like to reduce the visual bulk of these structural members to elegant spidery lines and, indeed, this is what happens when space frames are used in exhibition displays.

This school of architects produces giant translucent cages which are unfunctional in the old sense of providing precise conditions for each specific use for which they were originally designed—but are claimed to be highly functional in the flexibility of uses to which they lend themselves. Just as a nineteenth-century neo-classical façade in, say, Washington, Paris or London could be anything from a temple to a Government Office or department store, so today's catalogue-compiled classical counterparts can be office blocks, apartments, **135**

clinics, banks, schools or almost any type of building. In this rectilinear art, the placement of vertical and horizontal mullions and astragals, with coloured solid or transparent infilling panels, is accomplished with the finesse of a Mondrian painting.

Turning from our rational nature and surrendering to our romantic temperament, we find that interest now centres upon the particular rather than the general. Abandoning the universal outlook in favour of the local, the true romanticist appreciates the single innovation above the repetitive products of anonymous principles. He seeks special character rather than ideal beauty.

As against the classicist's search for a perfect prototype, the romanticist exults in the sheer proliferation of variegated forms. His temperament leans towards the novel or mystical. His senses are warmed by cosy, characterful muddle. Not for him the mechanistic precision, the standardized excellence of machine-age architecture—a branch of industrial design—with its lack of rich decoration and warm enclosure. Vain it is to argue with him that the clinical classicism of the machine caters more efficiently to human needs—with more sunlight, better ventilation, new equipment, and the more scientific use of space. All these he would trade for an imaginative personalized environment.

From the need to satisfy our dual natures arises the dilemma of today's architecture. How can we humanize our mechanistic architecture, or how find justification for individuality in design? These objectives are theoretically contradictory. Seeking a way out of the dilemma, today's architects proceed with understandable caution, for who could chart for us a definitive course between acceptable romanticism and mere sentiment? The rubbishy false-fronted stores of our pioneer towns have already been romanticized by Hollywood set designers. Romanticism in architecture is seldom supported by a logical structure of theory. The most valiant attempt to do so was that of Frank Lloyd Wright, whose evocative but obscurantist essays on 'organic, thought-built architecture' have further complicated the terminology of design.

We architects of the mid-twentieth century seem to be stuck with the gods who made us—Gropius, Corbusier, Van der Rohe—all in the rational classic tradition. Between them, they have sold us the virtues of standardization, prefabrication, abstraction, mathematical harmonics and the aesthetic of the machine. But Mumford has reminded us that 'the machine age, with its anti-historicism, anti-regionalism, anti-humanism, is not the last word in human culture'.

The search for a new romantic vision leads into a sentient world where mind-locked technologists cannot follow—a world wherein each architectural innovation must create the taste by which it has to be appreciated. But 'taste' is nowadays a bad word, and many would gladly see it abolished in favour of a Golden Rule—a safe democratic rule which would absolve us from the obligation of self-cultivation, in favour of a collective culture.

When we consider the character of our cities, we must recognize what might be called the old romanticism. In the ancient built-up cities of Europe, the new architecture can be absorbed with some degree of tolerance, but in the older New World cities like Ottawa, Quebec or Montreal, tradition has special value and its continuity is imperilled by the dialectical changes of our century, of which the new buildings are the feared symbols. The French idiom and period-style importations are expressive of the old humanist traditions which Easterners proudly contrast with the character of the 'nouveau riche' cities of the west. One could not change the traditional character of French-Canadian cities and it is clear that North American machine-age architecture has made no perceptible impact on them.

Even the vast new hotels such as the Queen Elizabeth in Montreal and other recent buildings have turned their backs on the 'glass skin-and-bone' ideal of building which makes play with the beauty of reflections and translucencies in favour of the traditional manner of exploiting the contrasts of light and shadow on opaque masonry surfaces. Ottawa, too, as custodian of this tradition, scarcely knows what to do with the new crop of architects and their twentieth-century ideas.

Ottawa! How solid, how reassuring, how gothic! That massive fairy-tale castle-cum-hotel, the Chateau Laurier, typifies the city's stony charm. Ruskin said, 'When we build, let us think we build for ever.' The old Scottish stone-masons of early Ottawa thought the same way. As the seat of government, the capital city has inherited that peculiar rag-bag of ideas about official dignity and monumentality which characterizes almost all capitals and preserves that frozen stone solidity which is so symbolic of any and every age except that in which we now live. Federal government departments, inhibited by this formidable tradition of permanence, have perpetuated it by creating a nameless 'public-works' style of building all across Canada. Is it any wonder that the young architect of today, standing in this heavy shadow, finds his ideal of a spidery, bodiless architecture melting to nothingness?

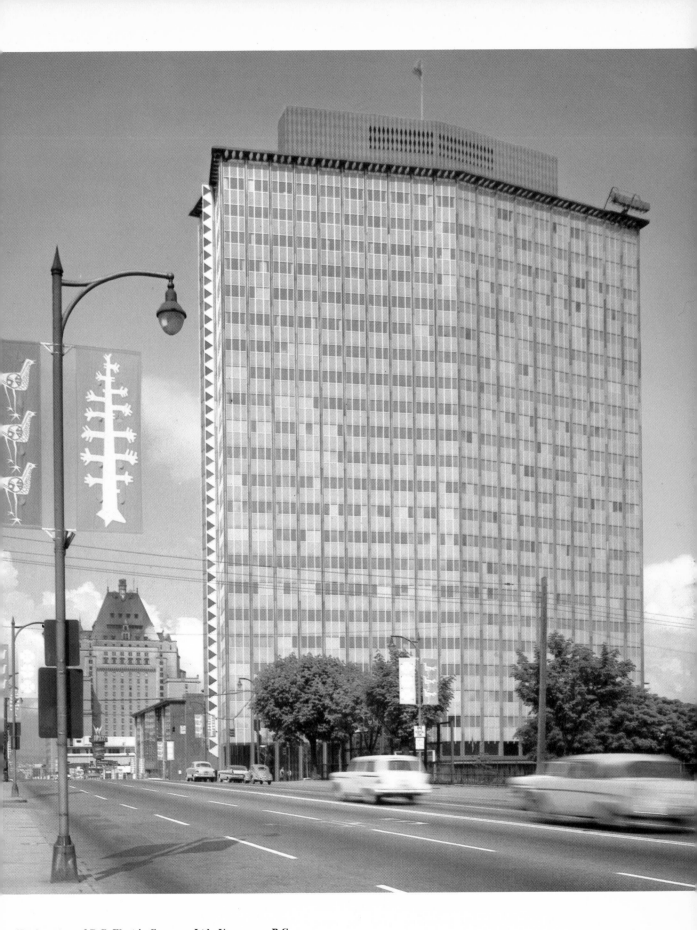

Headquarters of B.C. Electric Company Ltd., Vancouver, B.C.

Architects: THOMPSON, BERWICK & PRATT.

In the past, men built to glorify Church or State or a cultural ideal. Today, we find new inspirations of which the most mysterious is a vague entity known as 'public relations'. The Lever Building in New York was an outstanding American example and now Canada has produced its elegant, soaring B.C. Electric Building. The floors are branched out from a structural core. The ceiling lighting can be seen for miles and the people of Vancouver circulate around this beacon tower like moths around a candle. **137**

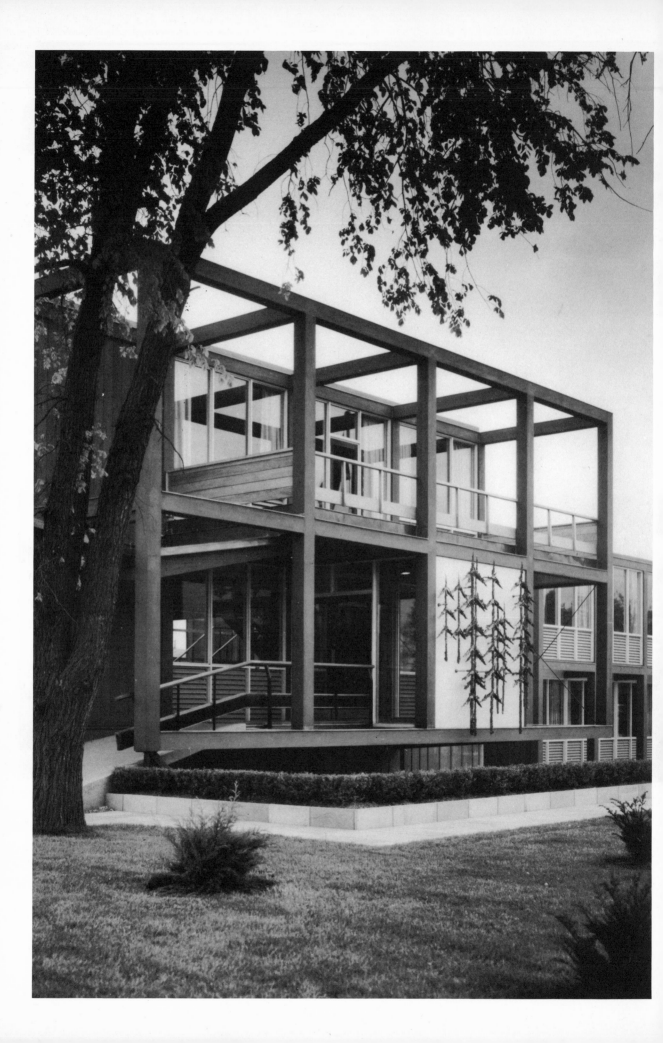

St Anthony's Catholic Church, West Vancouver, British Columbia

Architects: GARDINER, THORNTON, GATHE & ASSOCIATES

This delightfully simple design is a good example of the growing romanticism which characterizes West Coast regional architecture.

Yorkminster United Church, Toronto, Ontario

Architect: JAMES A. MURRAY, M.R.A.I.C.

The moulding of the shell determines the 'feel' of the interior spaces, thus achieving the traditional objective in a new and direct way. Externally, the same shell conveys a plastic expressiveness the extrovert character of which is appropriate to the form of a church, by tradition the spiritual rallying point of the community.

New church building in Canada is in a state of architectural ferment. Church design calls for a marriage of form and a spiritual idea. Sometimes, we find form and a structural idea, or form and an economic idea, or form expressive of 'stage-set' ideas.

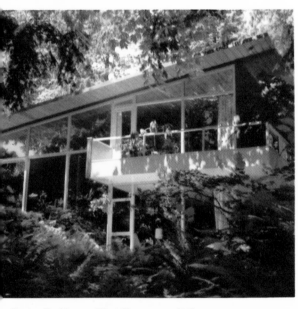

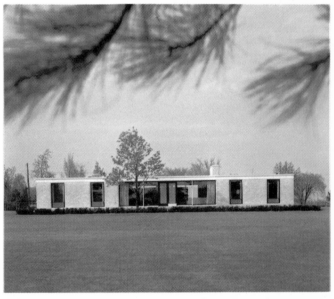

Porter Residence, West Vancouver, B.C.

Architect: JOHN PORTER, M.R.A.I.C.

A fine example of West Coast romanticism. The house is buried in deep foliage in the bed of a creek.

John C. Parkin Residence, Don Mills, Ontario

Architect: J. C. PARKIN, M.ARCH., M.R.A.I.C., F.R.I.B.A.

The design is deeply rooted in the universal classical tradition of rationality and proportion. No hint of the idiosyncratic is allowed to distract us from the purely abstract pattern of solids and voids, the proportions of which could scarcely be altered a hairsbreadth.

R. Laidlaw Lumber Co. Ltd., Weston, Ontario

Architects: PENTLAND & BAKER

'As in ancient times, it is the structural system which is being idealised . . . either the walls must be made virtually transparent or the structure brought out beyond walls and roof where it can be admired.' The symbolic metal free sculpture adds a contrasting touch of romanticism.

139

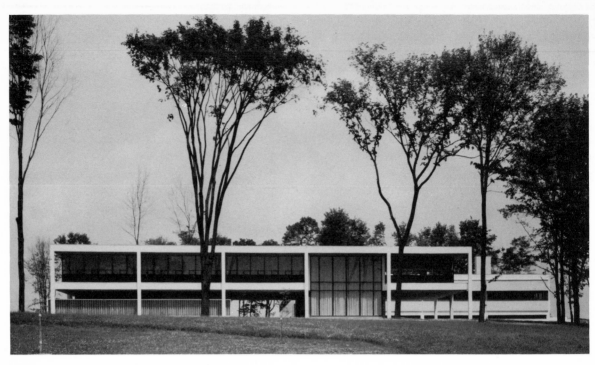

Ortho Pharmaceutical Building, Toronto, Ontario
Architects: JOHN B. PARKIN ASSOCIATES
. . . a face, that makes simplicity a grace.' Ben Jonson

The Canadian Pavilion at Brussels, 1958
Architect: CHARLES GREENBERG, B.ARCH., M.R.A.I.C., A.R.I.B.A.
Should World Expositions aim to bring out the national characteristics of each country's architecture or should each country seek to excel all others in the fine expression of a universally recognized idiom? Canada, having no architectural tradition of its own, had apparently no choice and chose to build a spaceframe and glass structure — as did Portugal, Hungary, Luxemburg, Turkey and West Germany.
A third approach might have been to break into the realm of science-fantasy, as did Belgium in building the Atomium.
How splendid it would have been for Canada if the Canadian Pavilion had been built in Canada instead of Belgium.

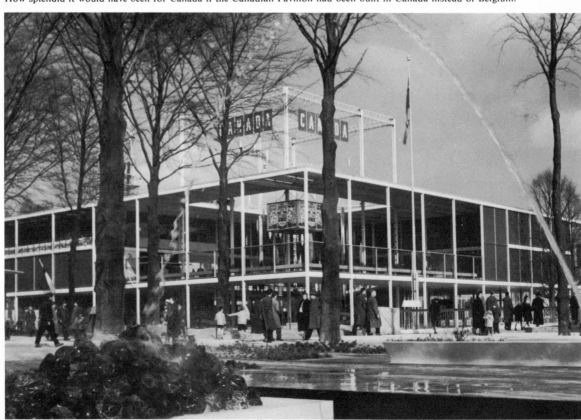

It is no surprise to find that, where the terrain is diversified as in parts of Quebec, Ontario and British Columbia, the buildings which grow thereon acquire a natural individuality, but the cities and buildings of the flat lands reflect the rational elements of architecture—economics, standard solutions and techniques. Thus it is that the Prairies offer the greatest challenge of all to their architects, who derive little stimulus for the imagination from the flat featureless plain. One can freeze at 40° below or approach the boil at 90° above. Skilled labour is hard to hold for a short building season. Small-scale subtle effects are meaningless against the vast sweep of space. A single building on the Prairies is like a pea on a drum. And so often it has to be the single, lonely unit, since land values are low and building sprawl is dangerously easy. In all these circumstances, it is difficult for the art of architecture to develop and flourish.

As a foil to the prairie lands, one instinctively seeks that cosy arrangement of buildings where, by the use of all the tricks of scale and contrast, light and shadow, reflections and silhouette, the spaces between the buildings become charged with feeling. How difficult it is to create these architectural tensions when, by permitting the building units to spread-eagle themselves, the psychic charge leaks out and is lost in the space of the flat lands beyond.

In a country where silhouette is of paramount importance, the vertical grain elevators have created a special regional romanticism, but it would be idle to pretend that this was by aesthetic intention rather than by functional technical necessity. Nevertheless, the feeling grows that, like Holland and her windmills, the provinces of Manitoba, Saskatchewan and Alberta will discover how to use the evocative powers of their legitimate vertical features—the church spires and the high-rise city centres.

Alexander Graham Bell Museum, Baddeck, Cape Breton, Nova Scotia
Architects: A. CAMPBELL WOOD, HUGH W. BLACHFORD, HAROLD SHIP
Design Consultant: O. HOWARD LEICESTER, Dept. of Northern Affairs and National Resources
Architects are at their best when they subordinate everything to the expression of an idea. Here, it was the geometrical spell of the tetrahedron which formed so large a part of the work of Dr. Bell, the inventor of the telephone. Suspended from the ceiling is an actual tetrahedral kite which he used in aeronautical research.

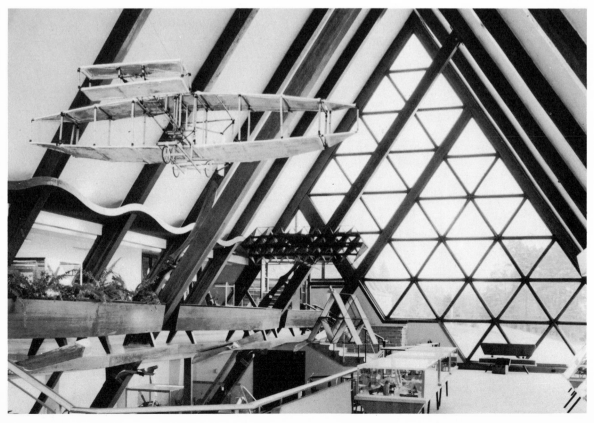

**Convenience and Shopping Centre,
Don Mills, Ontario**

Architects: JOHN B. PARKIN
ASSOCIATES

The entire layout is an essay in rational coordination of buildings for varied purposes on the basis of a unifying module. The whole orderly grouping is in the modern classic spirit. The blocks and spaces between them are shaped and reflected with masterly skill and restraint exemplifying the refined 'aesthetic' which characterizes this school of modern architecture.

**Park Plaza Hotel Extension,
Toronto, Ontario**

Architects: PAGE & STEELE

'. . . makes play with the beauties of reflections and translucencies'.

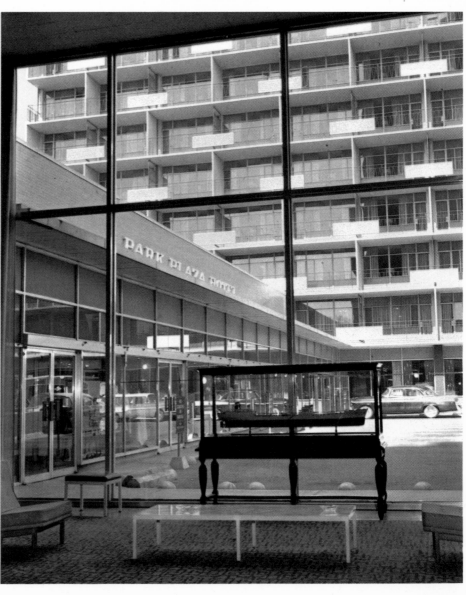

If flat terrain affords little opportunity for idio-syncratic design, the converse becomes true when we cross the Rockies. It has been remarked that a filtering process has been at work in North America and that the Pacific coast is now the 'natural habitat of dreamers and poets, faith healers and characters, cranks and bums'. Certain it is that individualists have found a spiritual home amidst the lush and variegated scenery of British Columbia. Distinc-tively West-Coast-style homes are carefully posi-tioned to exploit Nature's prolific beauties—a view of the ocean, the backdrop of the coastal moun-tains, the intimacy of the waterfront homes cling-ing to the rocks and coves of the serrated coastline or the magic closed world of the forest. Eastern Canadian architects complain that almost any old shack looks good in these settings.

The mild climate permits the use of extensive areas of glass in home locations where privacy is assured. Post-and-beam construction, long raking shed roofs and flexible open planning are natural expressions of the use of plentiful timbers. The gardens and scenery are consciously integrated with the designs to create a regional style. Most of these characteristics are to be found in tradi-tional Japanese architecture, so it is not surprising to find the conscious accentuation of the Japanese motif.

Vancouver's silhouette can be seen across its many waterways. The relatively few high buildings have been more than doubled within two years, emphasizing the characteristic profile of the city. With no tradition to counterbalance or restrain contemporary design, this third largest of Canadian cities is beginning to show that 'glassy' look which seems to be the goal of our architectural drive.

Air Terminal Building, Calgary, Alberta, Public Lounge
Architects: CLAYTON, BOND & MOGRIDGE
The design grew from a student thesis to full realization — the precursor of a chain of new air terminals strung across 3,000 miles of Canada like beads on a string. The mural is the work of DONALD FRACHE.

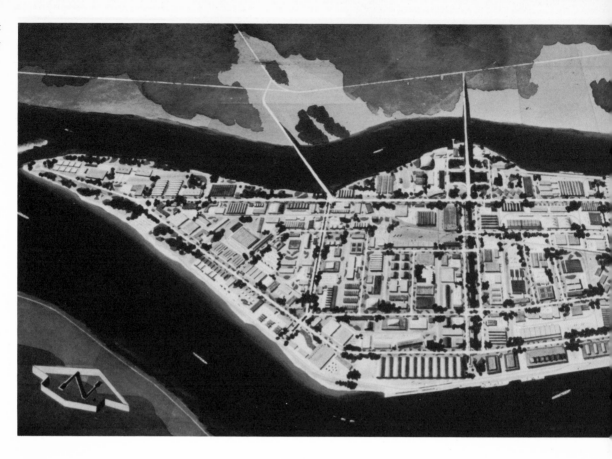

It would appear (and Vancouver supports my generalization) that city centres must necessarily develop along modern classical lines. But in the suburbs, where the pattern is looser, a greater freedom is afforded to the architectural imagination. This is certainly true of the entire Pacific coast of America and accounts for the now world-renowned West-Coast romantic style of home building.

Like the Pacific coast, the Atlantic seaboard lends itself to romanticism—but romanticism of another kind. One would have to be insensitive, or suffer from a mental block of doctrinaire ideas, to resist the spell of the simple unselfconscious buildings found throughout the Maritimes and so reminiscent of those early days of discovery, settlement and the birth of a continent. The architectural story of the eastern seaboard began with the wigwam and, in that endearing manner so characteristic of the white man, jumped almost directly to Colonial Gothic, Cape Cod, Georgian and Italian Renaissance. But this is only imported period romanticism added to the romanticism which all things acquire through time and associative memories—not a genuine regional romanticism. An indigenous architecture is still inexplicably missing here despite that physical and cultural isolation which is the usual prerequisite of strong regional expression.

Conversely, one does not expect to find regional romanticism in industrial Ontario. On the contrary, the explosive growth of metropolitan Toronto has, of necessity, focused all energies on the rational control of the expanding waffle-iron grid which men have created. This 'subtopia' sprawls across the flat terrain of Ontario. Romantic variations only arise legitimately from the few special natural features which happily get in the way of this mad geometry. But these are all too few and a debased romantic impulse erupts in gaudy buildings and deformed period styles. All these circumstances evoke the classical spirit to create order and harmony and that visual simplification without which urbanism is so often merely a jumble of masonry.

If industrial Ontario is to enjoy an architectural simplicity in the appearance of its many large-scale projects, the hope lies in the kind of planned relationship which is to be seen in the Don-Mills area—the new shopping centres, the banks, the terrace housing, the new offices, the residential areas, and in the layout of the area itself.

The relics of pioneer growth and uncontrolled enterprise can be seen in our city centres—high

Annacis Island Industrial Estate, British Columbia
Chief Architect: FRANCIS DONALDSON,
A.R.I.B.A., M.R.A.I.C.

In the past, the blessings of industry have been mixed. Sprawl and visual blight have resulted all too often from rapid industrial expansion. Then, in Europe, came the planned industrial estates which replaced chaos with working order but still fell short of high visual standards. Now we have, in Canada, the Annacis Island Industrial Estate, precursor of the industrial estates of the future — a leasehold operation allowing design control of both architecture and planning to be maintained at all times in the interests of all tenant industries. Stage I is nearing completion.

blocks interspersed between one-storey buildings, the street façades looking like irregular broken teeth. But Canadian architects now subscribe to a broader vision and identify the development of their art with that of community planning.

Public interest in planning techniques has reached the embarrassing level of a 'do-it-yourself' movement. Worthy citizens, who play with planning as a home hobby, are coming to see the need for properly-organized institutes of trained planners in each province; but, while planning is accepted as a necessary scientific technique to control the growth of Canadian cities, it is not yet recognized as an art.

From Saint John and Moncton in the Maritimes to Greater Vancouver on the Pacific, the same planning trends and objectives are being pursued —metropolitanization, protection for the inner cores of cities and vigorous re-zoning to articulate the functions of each city.

Our major cities face crises which are all too easily traceable to the automobile. Montreal, for example, foresees the necessity in twenty years' time of handling a million automobiles. In this period its population should rise to four million. The same problems repeat themselves in Toronto,

Winnipeg and Vancouver. As the traffic arteries push out from the city centres to connect with the surrounding regions, they encircle, like tentacles, villages and small municipalities. Despite vigorous political squirming, these smaller communities are being drawn, by the inexorable logic of economics and planning, towards forms of metropolitan government.

The establishment of an over-all planning body for greater Toronto created a precedent for the whole North American continent. This authority has embarked upon a 10-year project and assists in the planning of surrounding territory about twice the size of the present metropolitan area.

Ottawa is a special case. It is the only capital where the city, as such, is entirely self-governing. The now famous plan for Ottawa's future foresees half a million inhabitants residing within a five-mile radius of the Parliament buildings, which area it proposes to protect by a green belt. It lays down a nuclear system of neighbourhoods. The regional plan shows the skeletal highways, railways and arterial roadways serving both city and environs.

Planners are for ever speculating on the whimsical notion that they may help North American man to rediscover the use of his legs. They hope to do this by protecting the heart of the city from **145**

through traffic and by creating an inner core planned for shoppers and pedestrians only. The core would be fringed by multi-decked parking structures. This ideal concept is being studied warily but variants of the idea have already been proposed for Montreal and Vancouver.

Zoning is the most effective single instrument in the hands of the town planner. Elected bodies find it easy to enshrine zoning objectives in books of regulations and on maps. In many municipalities, however, day-to-day adminstration of such regulations and the application of planning formulae are taken as a substitute for more flexible and conceptual thinking.

An example of creative re-zoning is that of Vancouver where the twenty-year plan is aimed to bring the city's first growth under proper control and re-organize the functions of the downtown area round a central core.

In this day and age, the planning of towns and cities *de nouveau* is commonplace practice. Townships are becoming almost assembly-line productions. Canada's rapid expansion and the oppor-

Kitimat, British Columbia

Planned by MAYER, WHITTLESEY & GLASS, NEW YORK
Planning Consultant: CLARENCE STEIN, NEW YORK

Kitimat is a new town created to serve the giant aluminum smelting industry of British Columbia. Being under full design control from its inception, it is a good example of a 'diagram' town plan where current principles are applied directly and are modified only by the rugged topography of the chosen site. Basically, it consists of a group of neighbourhoods, each with its open space and community buildings, school, shopping, etc. and protected from through traffic. The neighbourhoods are connected to a City Centre. The industrial zone has been set apart from the township proper.

Master Plan presented by the Aluminum Company of Canada Ltd. to the District Municipality of Kitimat for further development.

LEGEND

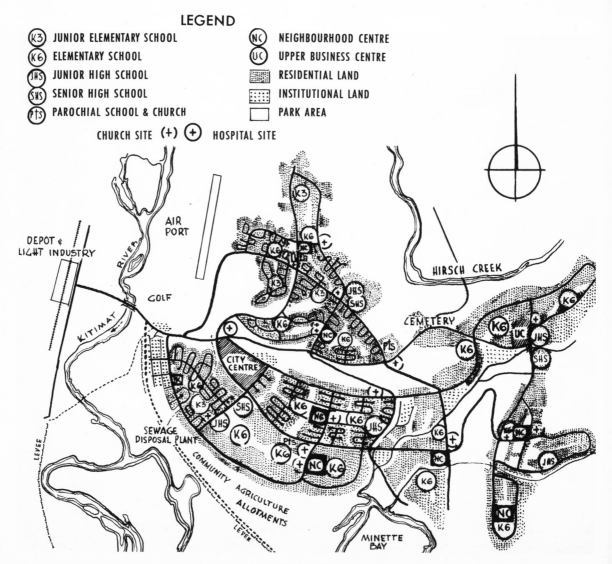

tunities arising from new large-scale industrial developments are eagerly grasped to lay down the new 'diagram' towns—Kitimat in British Columbia to serve the new aluminum-smelting empire of the Alcan Company; Ajax new town, the corollary of the Ajax Industrial Estate in Ontario; and the township of Deep River, Quebec, sparked into life by the Atomic Energy Establishment in that area.

There are some who doubt the efficacy of the re-planning proposals for the major Canadian cities. They see the heavy capital investments of their fathers as a millstone about their necks. Why, they ask, should each generation be expected to live out their lives within the patched-up patterns of cities which grew, unplanned, to serve the now obsolete needs of their ancestors? Why should we think of our cities as though they were old masonry mansions, heavy solid structures which can be made over from generation to generation by the installation of new plumbing, new partitions, a stable-cum-garage block and a new coat of paint?

The National Capital Plan

Planning and direction under the control of JACQUES GREBER

The now famous Ottawa plan is no doctrinaire exercise but is a development from and re-articulation of the city as it is known and loved by most Canadians. Everyone has had a finger in the pie but it promises to triumph over its network of Committees and advisers. The Federal District Commission's scale model shows the restoration of the Chaudière Falls area, west of Parliament Hill, and the Ottawa River waterfronts in the centre of the Ottawa-Hull metropolitan area.

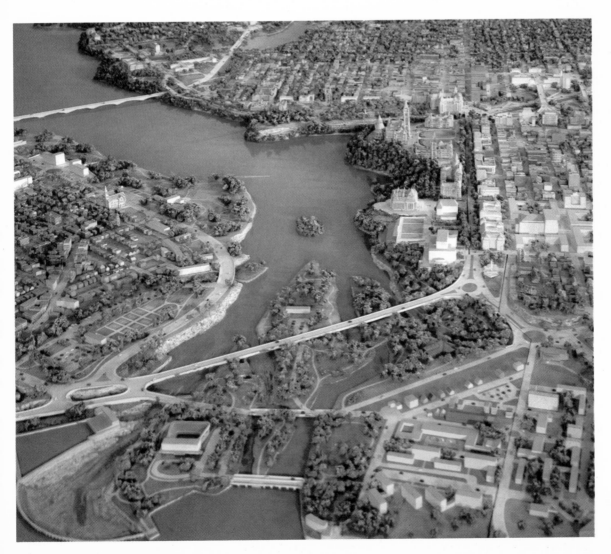

Instead, they want a more radical reconstruction—cities for modern living in the age of rapid transport, completely rational and constructed like exquisite pieces of clockwork. In the Canada of the future, new cities would be strung along a super trans-continental highway like beads on a string. These text-book towns would be modular diagrams permitting only those variations which would logically arise from special natural features. The main goal would be order and the perfect functioning of repetitive elements. However, if we cannot live in this modern world without order, it is being demonstrated that we can be made to live without diversity. All too often man's spirit is impoverished by life in monotonous 'planned' subdivisions.

So here is the choice—cities built to ideal concepts or cities which re-make themselves endlessly according to the changing desires of a society pledged to democratic individualism. Once again, this time in the planning field, we observe the old dichotomy between classical rational thinking and the romantic spirit seeking to transcend mere technique and to establish planning as an art which could give tangible expression to the best thought of our astonishing century.

Cities can be likened to trees drawn as seen from above in plan. The central core is the trunk; the highways which radiate from it are the branches from the trunk. The leaves on the branches are the individual buildings. The city, like the tree, is all one organic growth and we cannot truly consider the planning as divorced from the architecture.

To change the metaphor: architecture is like a ballet consisting of a few main stock characters —Function, Technique, Art. They appear in successive scenes with changing costumes and new names. A host of minor characters dance on and off stage—Form, Style, Taste, Tradition, Idea,

etc. The dances and music vary from wild romantic pirouetting to the prim and classical minuet or, as at present, ring-a-ring-a-roses. The company, which formerly danced round Function, now revolves round a new central character—MAN. A few new extras have joined the cast—Biology, Psychiatry and Human Needs.

How does all this affect Canada? We recognize that the material conditions of our spectacular growth can be satisfied only too easily by rational design—Function and Technique. But architects are no longer content to be mere purveyors of technique. It is not enough to claim that a building is clean, efficient and simple. That is only the A, B and C of expression. We want an architectural alphabet which expands the sensory range to justify on occasion the adjectives warm, mellow, dignified, delicate, charming, sensitive and sometimes even gay, surprising, vital and inspiring. Only by extending their language can architects re-unite with the vast body of laymen from whom they have been so long estranged and only thus can we realize that new flowering of the human spirit which we need to match Canada's material progress. The dream-image of a machine millenium has lost its power of inspiration.

What would be the Canadian ideal? On the personal level, we would like to see whatever individuality we possess expressed in our architecture. Beyond this, and at the level where we share the same climatic, physical and social environment, we seek an authentic regional idiom. Yet again, in so far as we are part of the developing world consciousness, we shall expect to see international and universal ideas reflected in our architecture.

These three strands are the warp of our Canadian fabric. The woof is comprised of the traditions of our variegated racial stocks. The whole loom is in ceaseless shuttling motion, spinning the pattern of our lives.

Industrial Design

WARNETT KENNEDY

Industrial Design

'A problem in design is a problem in design,
whether it has to do with a train, a
skyscraper, a national capital, a grinding
machine, a housing project or a fountain pen.'

150 WALTER DORWIN TEAGUE

ALL ACROSS Canada, the Industrial Design
Award insignia has become familiar to manufac-
turers, retailers and the buying public. It denotes
that the products to which it is attached have been
chosen as the best of their kind during a specific
year—that the chosen articles do the job for which
they were intended and that they display qualities
of simplicity and good taste.

The story of the Design Award programme
begins in 1948, when the National Industrial
Design Council was set up as a division of the
National Gallery of Canada. This Council, com-
prised of manufacturers, retailers, designers, archi-
tects, teachers and consumer representatives, con-
sulted with the Canadian Manufacturers' Asso-
ciation to devise a practical method of promoting
the sales of well-designed mass-produced articles
for personal, household and institutional use. The
Council took the view that, if good design was
not necessarily good business, it was its job to
make it so. To this end, the Council uses every
technique of advertising to support award-winning
products—radio, TV, displays and exhibitions,
and other forms of promotion.

The success of the programme encouraged
many related activities, including the training and
placement of designers in industry, scholarships,
conferences and lectures, and the establishment
of a Design Centre in Ottawa as the power-house
of the entire effort. Any prospective buyer can
visit the Centre and examine the official Design
Index—a photographic record of Canada's finest
products.

Nineteen forty-eight was a germinal year for
industrial design. Not only did it see the founding
of the N.I.D.C. but also in that year the Secretary
of State granted a Federal Charter to the Associa-
tion of Canadian Industrial Designers, a profes-
sional body whose membership is restricted to
qualified practising industrial designers.

It is not surprising to find that industrial design
activities in Canada have grown around the indus-
trial areas of Ontario and Quebec, but the efforts to
create a critical buying public are not limited by
geography. So it is that in British Columbia a spe-
cial Committee comprised of representatives of
varied Associations, from Commerce and the Arts,
has been active for some years.

The improvement of public taste towards the
multiplicity of machine-made objects has proved
to be beyond the adequacy of 'capsule education'
techniques. There seems to be no substitute for the
slow process of creating in each individual a
heightened awareness of design in the objects

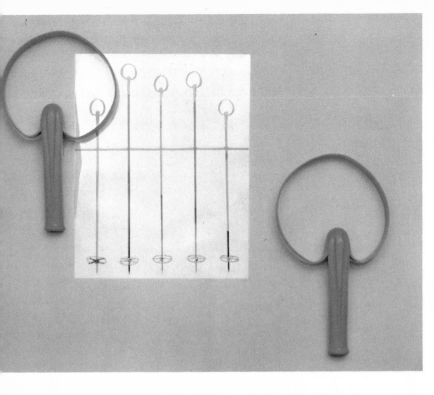

Ski Pole Grips
(Design Award, 1957)

These polythene ski pole grips are especially designed for safety of release as well as comfort when skiing. They are made in blue, red and white.

Designers: J. DOUGLAS MOSSOP and F. JOHNSTON

Manufacturers: ALLCOCK, LAIGHT & WESTWOOD CO. of Toronto Ltd.

Wall Coat Rack
(Design Award, 1957)

Science is the source of many designs. Molecular pattern has been transmuted into designs for carpets, textiles, etc. and appears to be the inspiration for this gay coat rack. It is in steel tubing with flat black finish with birch balls and has adjustable centres of attachment.

Designer: C. S. NOXON

Manufacturer: METALSMITHS CO. LTD., Toronto.

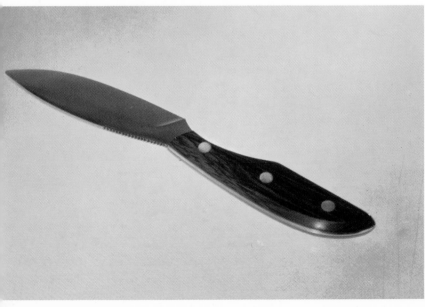

Canadian Outdoor Knife
(Design Award, 1958)

The form of this hunting knife goes beyond the special functions which it must perform and achieves a sculptural fascination owing nothing to capricious variation for the sake of style. The blade is of high-calibre steel with handle of selected hardwoods. Handle is shaped to fit palm and fingers.

Designer: DEANE H. RUSSELL

Manufacturer:
RUDOLPH GROHMANN
for The Knife Shop, Ottawa.

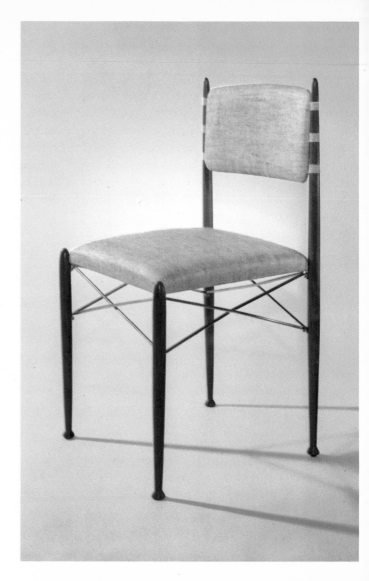

Dining-Chair (Design Index, 1956)

This dining-chair derives its aesthetic feeling from the elegance of its structural members as does modern architecture. The frame is of walnut with plated steel-rod cross structure. The laminated plywood back and webbed seat is covered with foam rubber padding and muslin. Extremely light and sturdy.

Designer: ROBERT KAISER

Manufacturers: PRIMAVERA DESIGN GROUP, Toronto.

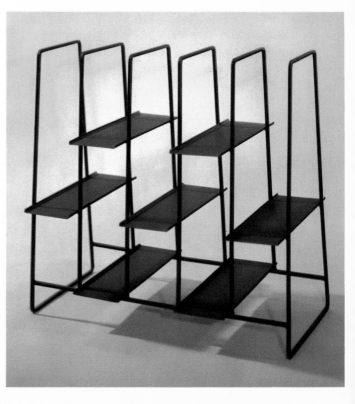

Phonograph Record Storage Rack
(Design Index, 1956)

The aesthetic content of this design is similar to that of a contemporary building. The elegant framing, the floating discontinuous slabs and the interpenetrating elements are all calculated to create an effect of bodilessness. The minimum of material is used to give the maximum visual delight. Structure and shelves are made of steel in flat black finish.

Designer: C. S. NOXON

Manufacturer: METALSMITHS CO. LTD., Toronto.

around us. By the education of the eye and the mind's eye we may hope to save ourselves from a future 'gadgetopia'.

Just as 'in every fat man there is a thin man screaming to get out', so in every mass-produced article there is a potentially right form. The search for perfect form is the day-to-day preoccupation of the industrial designer. He seeks solutions which will embody the use of the least amount of material upon which minimum labour is required to achieve the maximum performance and aesthetic response. That is the industrial designer's creed and the philosophy underlying it has deep roots in Nature's own working methods. In Nature, 'form follows function'. How convenient it would be to leave it like that—to pursue the problems of design for industry without reference to aesthetics, by simple analysis of needs and the use of suitable techniques with perhaps a few laws of harmonic proportions thrown in to guide us.

The aesthetic faculty, however, is one of Nature's most powerful selective mechanisms and the mystery of beauty is hardly explicable by means of a Golden Rule which anyone can apply to any object. Lying at some more hidden depth is the well-spring of creative imagination and from it the occasional upsurge of fresh invention slips through and around the flimsy sieve of our logically constructed theories of design. Perhaps it is this overspill which is the raw material of the romantic imagination.

All that has been said about the classical and romantic attitudes to design becomes clear when we turn to consider the multifarious products of Canadian manufacture. On the one hand we see the Platonic idealists at work and, on the other, we can trace the fertile imagination of the romantics, expressed all too often as mere surface styling.

The 'stylers' find the puritanism of the machine-aesthetic boring and uninspiring. Not for them the logic of dull theoreticians. They have captured the *mystique* of the machine and made it their business to apply it to autos and instrument panels, stoves and equipment, knobs and industrial bric-a-brac. With this *mystique* goes a special jargon, which reads like a sales invitation to a 'coloramic motorama'.

In the life cycle of an industrial product, the crisis is at the counter—at the point of sale. This is where 'styling' is so misleading. It tends to paralyse the critical faculties and all too often the key questions remain unasked. Here the N.I.D.C. insignia proves most effective, acting as an *aide memoire* to the simple design considerations which distinguish between a product overlarded with sur-face slicknesses and one which shows sensible good taste or rare imagination.

Design is indivisible. The design process and our response to it ranges over the familiar objects of our lives, from our sleek automobiles to something as simple as a well-laid dinner table. A heightened responsiveness is a continual joy and refreshment, whether it be the pin-point of pleasure when we examine a tiny exquisite piece of jewellery or the expansive thrill of turning a corner suddenly and looking up to a sparkling glass and aluminum skyscraper. All is design and, if we only knew it, we are all designers.

Those nations which export manufactured goods need no reminder of the importance of design in relation to sales. Nowadays they have perfected the use of special government agencies to stimulate teaching, employment of designers, and higher standards throughout industry.

Canada now ranks among the giants of the exporting nations but it is her raw materials which are shipped abroad. When the time comes to export manufactured articles, she will collide with competition from countries which have enjoyed decades of design development and have long since achieved sophisticated standards. It is too early to recognize distinctively Canadian characteristics in design. Through the vision of far-sighted men, however, the Design Centre in Ottawa was brought into existence and through it Canada is beginning to make her influence felt both at home and abroad.

HANDICRAFTS

ENAMEL ON COPPER By Françoise Desrocher Drolet (*Award for Enamels, Canadian Ceramics Exhibition, 1957*)

VASE AND BOWL (thrown earthenware) By Rose Truchnovsky (*Grand Award, Canadian Ceramics Exhibition, 1957*)

HANDICRAFTS

A. T. GALT DURNFORD

FORTY YEARS ago the word 'handicraft' called to mind only the hooked rug, the *ceinture fléché*, the Indian basket. Indeed, even these rural arts were well on the way to extinction in Canada by the turn of the century.

Today, we are enjoying an exciting revival of these traditional folk arts. And, notably since 1945, handicraft in this country has come to mean ceramics, silverware, jewellery, metal work of all types, wood-carving, book-binding, and so on. Increasingly, too, Canadian architects and interior designers are using handicrafts in their *décor*. (Note, for instance, the new Queen Elizabeth Hotel in Montreal with its tapestry, carving, panels, and ceramic tiles designed and executed by Quebec artists and craftsmen.)

How does one account for this striking renaissance in Canadian handicrafts? Many forces are at work. One is the pervasive power of contemporary design itself and the itch (seemingly an international itch!) to explore and expand all the media for formal expression of every kind. So we now have a studio as well as a 'habitant' handicraft and much of the recent work in ceramics and metals is thoroughly sophisticated in sensibility and technique.

Nor can we overlook the stimulus imparted to handicrafts here by the arrival since 1945 of hundreds of expert craftsmen from Europe. The work of these New Canadians in all the major crafts is already beginning to influence our sense of design and our treatment of colour. Particularly in the prairie provinces, by way of exhibitions, competitions and discussions, a lively interchange of ideas and methods goes on between Anglo-Saxon Canadians, these very recent newcomers, and second- or third-generation Canadians of non-Anglo-Saxon origin. Here is a creative situation, ripe for cross-fertilizations and unpredictable departures and advances.

Nevertheless, we must remember that the ground for this present activity was prepared half a century ago in the province of Quebec. By 1900 the habitant arts of weaving, rug-making, hand-carving and the making of furniture were clearly dying out. A small group of zealots in Montreal, headed by Miss Mary Phillips and Mrs James Peck, scoured the province for competent craftsmen who might be willing to train young disciples in the old arts. A shop was opened in Montreal to market the craft work and by 1906 the success of the venture was so evident that a non-profit organization, the Canadian Handicrafts Guild, was incorporated to retain, revive and develop handicrafts throughout the country. The active influence of the Guild today extends from Newfoundland to British Columbia and the North West Territories. Beyond question, the Guild has worked miracles to restore life to the traditional crafts. It has also given the fullest encouragement

to contemporary design (as is apparent from the articles selected from Canada for display at the Brussels 1958 International Exposition).

In recent years the most important advances have been made in ceramics and, of course, in Eskimo carving. But let us look first at the state of the more familiar crafts. Of these, weaving still holds its rightful place. If the *ceinture fléché* has become an heirloom, the hand-woven tie is found in many shops and the homespun of the weaver is a staple for the modern decorator. Weaving is

one craft which has been adapted to new conditions and the changing demands of the market without loss of standards and individuality. In all parts of Canada now, weavers, thoroughly at ease in contemporary design, fashion upholstery, curtains, linens, drapery. One could name names— Karen Bulow, Krystina Sadowska, Mrs A. Tamosaitiené. Personal styles emerge. The tradition comes to life again in an untraditional thrust of individuality and varied invention.

The other familiar crafts flourish, too. The pop-

Group of pottery exhibited in Montreal in 1950

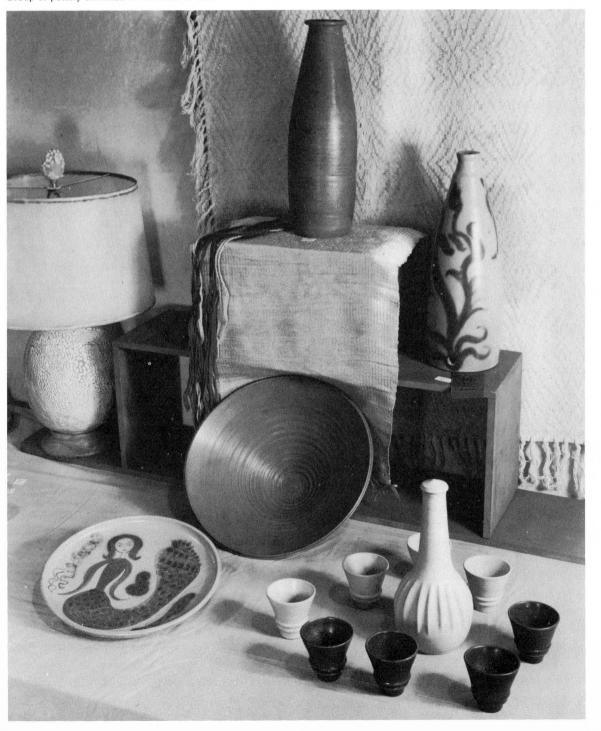

ularity of the Quebec and the Maritime hooked rugs continues unabated and, in tourist season, the country highway blazes with them. The woven, the tufted and the tapestry woven rug are all made in abundance (the last a special accomplishment of New Canadians from the Balkan States).

In wood-carving, silverware, jewellery, metal and leather-work, the quality is at the moment distinctly uneven. However, Arthur Price of Ottawa, Leo Gervais of Montreal and W. G. Hodgson of Alberta, work in wood with imagination and inventiveness. John Nugent of Saskatchewan, Gilles Beaugrand of Quebec, Harold Stacey and George Davey of Toronto, are silverworkers with a fine contemporary flair, while Scandinavian influence is strong in the silver articles of the Roulston brothers of New Brunswick and Rudy Renzius of Ontario. In jewellery, one must mention the West Coast Indian designs of W. A. Reid and C. H. Fox's novel treatment of native Maritime stone. Much of our recent metal work is in wrought iron with a trend nowadays towards aluminum, copper and brass—often executed by craftsmen hidden away in commercial foundries such as Iron Cat Registered, Montreal. This firm, run by the architects H. E. Devitt and J. B. Woollven, is creating iron furniture of striking and unusual design.

Leather-work has been the neglected craft. Recently, however, the Canadian Society of Creative Leathercraft has sought by exhibition and display to improve public taste and attract good craftsmen. Once again the New Canadian begins to come to our rescue, and in Endel Ruberg, Estonian in origin, our leathercraft has recruited an artist of the highest order.

The most popular and certainly the liveliest of the crafts at the present time is ceramics, as indicated by the tremendous public response to the 1957 Canadian Ceramics Exhibition in both its Toronto and Montreal showings. It would seem that ceramics is becoming the hobby of every man. Serious professional work goes forward, too, and at an incredible pace. One notes a marked development of regional differences. Notable, also, is the trend, everywhere in Canada, away from earthenware and towards the higher fired stoneware. Controversies rage—always a sign of life. Personalities, distinctive styles begin to emerge—always a sign of maturity. And we begin to reach beyond the parish. Thirteen Canadian craftsmen were represented in the Nineteenth Ceramic Exhibition at Syracuse. Twenty-five pieces from the First National Fine Crafts Exhibition at the National Gallery in Ottawa are on display in the

Canadian Pavilion at the 1958 International Exhibition in Brussels.

In a craft as active as ceramics it is no longer easy to mention a few representative artists. The New Brunswickers, Kjeld and Erica Deichman have achieved a well-deserved international reputation. To indicate the range of Canadian work in ceramics one might cite the leading prize-winners at the 1957 Ceramic Exhibition: Rose Truchnovsky (earthenware); Thomas Kakinima and Bailey Leslie (stoneware); Virginia McClure (sculpture); Françoise Desrocher Drolet (enamel on copper); Mary B. Dickenson (porcelain); Krystina Sadowska (ceramic tiles).

Outside the orbit of these movements, both traditional and contemporary, in Canadian handicrafts is the Eskimo stone-carving. This work, only recently brought to public attention, proves that fine primitive art is still possible. (Archaeologists liken Eskimo sculpture to the work of the prehistoric cave artist of Aurignasin in the South of France. And art critics see analogies with contemporary sculpture, particularly with the work of Henry Moore.)

How long can the Eskimo continue to carve in this manner? As Bishop Marsh points out, the Eskimo is a stone-age man living in the atomic age. Until a very short time ago he was a simple hunter and fisherman. Now, with the discovery of ore deposits in the Far North and with the building of the DEW Line, he has suddenly become subject to many of the pressures of modern society. He lives by the law of the white man. He earns money. He no longer travels where the wild game goes. If the hunt fails, he gets government relief. The Eskimo is changing. His art is changing. The carvings done during 1956 were larger. more elaborate, often more skilfully executed than the carvings of the previous year. The shipment of the summer of 1957 showed a further increase in skill—yet a certain loss of simplicity, perhaps even of character.

On the East Coast of Hudson Bay, the material used for carving is 'steatite', a soft soapstone, in colour a grey-green, which turns almost black when rubbed with seal oil. Farther north, the stone used is harder, almost like granite. Accessory material in the work of the Eastern Arctic is ivory, of the Central or Western Arctic, hammered copper.

Whatever the ultimate fate of this primitive craft it has yielded up treasures. And to the list of significant Canadian artists we can and must add names like these—Akeeaktashook, Kopee, Munamee, Oshweetok, and Tungeelik.

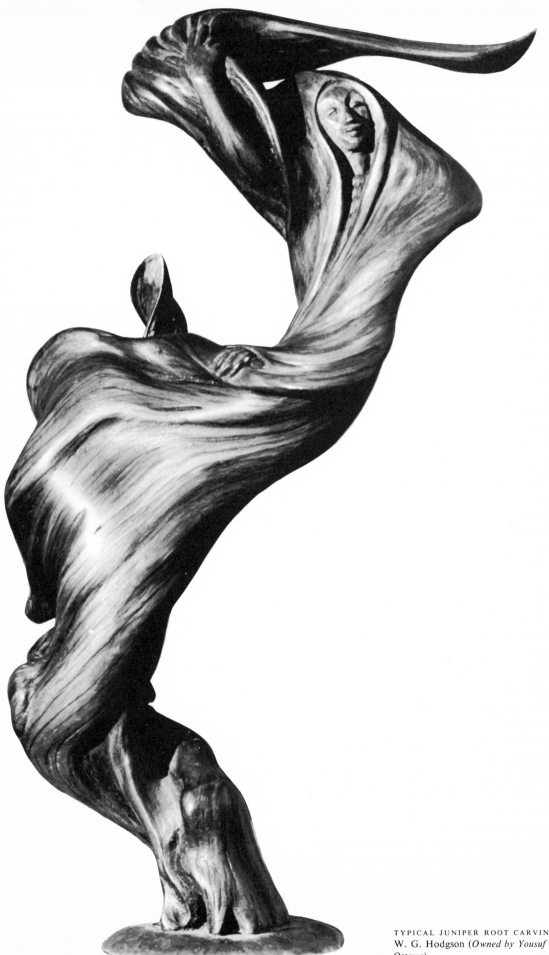

TYPICAL JUNIPER ROOT CARVING By
W. G. Hodgson (*Owned by Yousuf Karsh,*
Ottawa) **159**

Translations by Glen Shortliffe

Theatre in French Canada

JEAN BÉRAUD

T H E position of the theatre in that part of Canada commonly called French Canada, and almost entirely confined to the Province of Quebec, is a rather special one. Geographically, because of the vast spaces separating Quebec from most of the other provinces, ethnically, because English is the language of the majority of the country as a whole, this position is distinguished by an enforced isolation from the rest of the population. This unfortunate state of things arises partly from force of circumstances, but partly also from what would appear to be a rather unreasoning ill-disposition on the part of English-speaking Canadians.

A backward glance into the history of the theatre in Canada reveals that at the time of the English conquest of New France in 1760 the first plays given in Montreal by the officers of the English garrison were in French, Molière rather than Shakespeare being their favourite author. These officers and their soldiers, as well as the first governors of the colony, spoke French fluently. Subsequent generations of English-speaking Canadians —influenced no doubt by political events, and in particular by the struggle for official bilingualism— thought it well to repudiate the French tongue, thus depriving themselves of the incontestable advantages of a double culture.

Now in our own time the whole country appears to have succumbed, often uncritically, to an admiration for the French-language theatre as practised in Montreal, and for its principal exponents. None the less the situation remains very complex; at best it can be described as satisfactory. It reminds me of that malicious caricature showing Maurice Rostand, son of the author of *L'Aiglon* and of *Cyrano de Bergerac*, kneeling before the feminine figure of Glory and begging her to grant him her favours, only to receive the pitying reply: 'Go your way, young man; I have already given myself to your father.' This is to say that some inheritances are heavy burdens. To cite more serious testimony, Lucien Dubech in his *Histoire générale du théâtre* comments as follows in the chapter devoted to the Latin tragedians: 'We are justified in supposing that only the outer covering, so to speak, of this theatre was Latin, and that remembrance of Greece was its guiding force. A national theatre could not be built from the ground up while heads were filled with the Athenian masterpieces.'

What then is the position of the French-Canadian playwright and actor in the face of the task of writing and playing dramatic works reflective of national attitudes? Is it not precisely that of the Latins whose heads were filled with the masterpieces of another country? Can our playwrights prevent themselves from imitating the outlook and the turn of mind of the French playwrights? Are our actors not quite naturally captured by the prestige of foreign playwrights? If one recalls too that, for French Canadians at least, Canada is a country of two cultures—not to say three if we take into account our proximity to the United States—it becomes easy to understand the difficulties impeding the birth and growth of a distinctly Canadian drama. It is obviously an advantage to have at one's disposal a cultural heritage, but to have two or even three, and to be expected to make them bear fruit in two different camps which have an understanding *with* rather than *of* each other, is enough to suggest that excess of wealth may lead to ruin. If, for French Canada, the French heritage offers a special advantage, it also presents a special danger. We cannot do without models, but it would be folly to imagine that we can go on forever drawing upon our legacy. The fruits of this truly fine inheritance must be ripened

in the Canadian climate. It is to this task that some French-Canadian playwrights have devoted themselves over the past ten years or so, assisted by acting companies who have succeeded in imparting a special flavour and a distinctive bearing to some of the great works of the French theatre.

These newcomers deserve extra praise for having set to work on land that had been allowed to lie fallow. The predecessors of the playwrights had found their main outlet in the presentation through types of pageants of heroic figures called up from the history of New France, or in the fabrication of melodramatic or drawing-room comedy situations for the most part imitative of a repertory popular in certain Paris theatres. The pioneer actors had sometimes turned to surprisingly good account a competency due entirely to practical stage experience and unrefined by any formal dramatic training. The burden of work turned out by these actors, left as they were to their own resources and unsupported by even the smallest subsidy from the public purse, was bound to exhaust them before long. The coming of radio, and then of television, led inevitably to their total disorganization. Out of all these efforts nothing of durable value remained; everything had to be started again from the beginning. The war, motion pictures (French, English, American, Italian, etc.), radio and television discouraged the construction of playhouses, while the public authorities (federal, provincial and municipal) found in the abandonment of the theatre a convenient excuse for their towering apathy.

This unforeseen termination in a dead end seemed particularly unaccountable in Montreal which, as the metropolis of Canada, has been throughout her history a meeting-point for the world's greatest dramatic artists: Sarah Bernhardt, Coquelin, Mounet-Sully, Réjane, de Féraudy, Albert Lambert, Cécile Sorel, Louis Jouvet, as well as Irving, Mansfield, Terry, Kean, Arliss, Barrymore, Hayes, appearing in the most varied offerings. But the theatre of that day had had its day. New forms were needed to recapture public interest. The torch was picked up by a new group who came to the stage directly from the school.

In 1937 Father Émile Legault, C.S.C., founded the company called Les Compagnons (de Saint-Laurent), and this, along with the Montreal Repertory Theatre (French Section), the Équipe Company and the Rideau Vert Company (as well as the Stella Company), was to be the nest from which most of the performers now featured on our stages and our television screens were to take wing. The director's aim was 'to establish in Canada, in a Christian atmosphere, a theatre which should be

cultural, poetic, spiritual, and popular at the same time', and this demanded a new style which became manifest not only in the stylized presentation but in a choice of plays that gave the position of honour to Molière and Shakespeare, Anouilh and Edmond Rostand, Racine and Giraudoux, Claudel and Wilder. This fine movement lasted fifteen years. The Compagnons were held in high esteem throughout the whole country; they twice won the Bessborough Trophy, and gave more than fifteen hundred performances before the day came when, lacking sufficient means to resist television, with its enviable scale of fees, the company had to disband.

In March 1938 on the stage of the Monument National a producer of revues by the name of Gratien Gélinas, appearing under the name of Fridolin, asserted himself from the outset as the complete man of the theatre: author, director, actor, manager, in a comic vein which owed nothing to anyone else. His was a native accent, different from that of all his precursors in the field. Moreover he brought to his series of 'Fridolinons' a manner of presentation which gave proof of a taste in the choice of scenic materials quite as fresh as were his impertinent tone and his spontaneous comic sense. With Gélinas, in short, the revue became important theatre, with an impact that was nation-wide, for he succeeded not only in demolishing the well known East-West barrier which, symbolically at least, divides English-speaking from French-speaking Montrealers, but also in attracting to his performances Canadians from all provinces. Long before the production of his three-act play Tit-Coq in May 1948 Gratien Gélinas had thus become the outstanding theatrical personality of Canada. This play, like his revues, was to have hundreds of performances, thanks to his attachment to the principle of putting before Canadian audiences Canadian characters with whom they feel a communion of mind and heart. This was to be the new trend of an essentially Canadian dramatic art, which was to find still another spokesman in Marcel Dubé, author of Zone, while other young playwrights, such as Paul Toupin, remained faithful to the older aesthetic, classical both in subject and in style.

Gratien Gélinas remains alone in his class in that all other playwrights have to rely on a happy stroke of fortune to get their works played. But conscious of his responsibilities, and wholly given over to the idea that not only actors, but writers above all are required to build a national theatre, Gratien Gélinas is throwing wide open the doors of the theatre of which he has recently become manager and which he has named the Comédie

Canadienne, to all Canadian playwrights, whether they write in English or in French, who have something to say and who know how to say it in the language of the theatre. Enjoying strong financial support from the government of the Province of Quebec as well as from a prominent brewing company, he realizes fully in his new capacity that the time has now passed for handing an evening or a week of polite approbation to writers suffering from the itch to be played, and that financial security provides no more justification for the long current slogan: 'Let us encourage our own.'

Mention must be made of another acting company, now defunct, which had given rise to great hopes: the *Équipe* company, founded by the young director Pierre Dagenais in 1941 and which lasted only five years. This too was a hothouse of actors which was not without its effect upon the French-language theatre, especially as Pierre Dagenais was on several occasions invited by English-language groups to direct their performances, and as it was he who brought about the production of a Canadian author's first play, Paul Toupin's *Brutus*.

Other companies have been formed since: the *Théâtre du Nouveau Monde*, which had the honour of representing Canada at the International Festival of Dramatic Art in Paris in 1955; also the *Théâtre-Club* and the *Rideau Vert*. All these companies have their importance, for at the present time it is upon them that the hope rests for any drama we might truly call our own.

Do all these isolated efforts, and even successes, display any sort of unity, any definite line which might permit us to say in what direction the Canadian theatre is now moving? Unfortunately, no. For the moment we are still in our apprenticeship. French-Canadian universities, unlike their American and English-Canadian counterparts, have not yet admitted the dramatic arts to full citizenship in their curricula, with the result that the beginning author must continue to place his trust in his own self-taught instinct in endeavouring to delve into the very special laws of dramatic composition.

Still some names must be borne in mind: Lomer Gouin who, before his premature death, had given us a charming and moving *Polichinelle* in the mood of Gozzi's *Princess Turandot*; Yves Thériault, a novelist who gave proof in his *Le Marcheur* of dramatic gifts in the folklore style; Félix Leclerc, a balladist much in fashion, who achieved a popular success with a sketch stretched out to three acts entitled *Sonnez les matines*; Éloi de Grandmont and Paul Toupin, whose elegance of style may be said to compensate for shortcomings in dramatic

construction; Marcel Dubé, who succeeded in recasting in a truly dramatic mould the light social fancies of his *Zone* characters; and Gratien Gélinas once again, who is far from having said his last word.

Television, through its dramatic broadcasts, can play a great part in the training of playwrights by offering them opportunities to practise their hand, witness rehearsals, and study the means employed by the broadcast producer to translate his text into pictures suggestive, after a fashion, of the living presence with which the stage endows its characters. But the fact remains that these are two different means of expression, and that this kind of experience will still need readaptation for stage use, as is the case also for actors, whose vocal range and variety of inflection are sometimes impaired by habitual use of the microphone. Television, moreover, brings serious problems to managers of stage companies, who are unable to offer such munificent fees either to writers or actors.

There is, of course, one area which has greatly enriched the scenic arts of French Canada in recent years, and that is the area of stage setting. A closer attention to the text; a sustained collaboration between, on the one hand, producers like Gratien Gélinas, Jean Gascon, Jacques Létourneau, Yvette Brind'amour, the managing board of the Montreal Festivals, and, on the other, designers like Robert Prévost, Jacques Pelletier, Michel Ambrogi; the pains taken to re-create a period atmosphere through stylization or else to create a tasteful modern setting—all these have justified the critic, sometimes taking into account the interpretation as well, in comparing without hesitation certain local productions to those of famous visiting companies from France. This was notably true in the case of the *Théâtre du Nouveau Monde* when this company received even in Paris the testimonial of having 'dusted off' Molière, and when it was placed in Montreal on the same footing as the *Théâtre National Populaire* of Jean Vilar.

One of the most encouraging aspects of this very promising new impulse in French-Canadian dramatic literature is the intense interest in it evinced by English-speaking Canadians. I have called their admiration uncritical. What I mean is that English Canadians may be so impressed by the energy and the sense of conviction which French-Canadian actors bring to the stage or the television screen as to be persuaded that the works of our own playwrights represent a true creative art derived from the Canadian context. They would be right about the revue sketch, or even about some radio and television plays. But on the stage only Gratien

Gélinas and Marcel Dubé, up to now, have managed to throw off the shackles of outside influence, look about them with their own eyes, and produce character studies comparable for truth of observation to those, for example, of Roger Lemelin in his *Les Plouffe*. Some others, like Félix Leclerc and Yves Thériault, have succeeded to a degree, but their work displays less mastery of the basic principles of dramatic composition.

If this account appears somewhat pessimistic, this is because there is no escaping the fact that a truly original dramatic art capable of commanding the interest of the European public has yet to appear in this country. If we wish to confine our attention to the successes of local companies in presenting works from France (Anouilh, Musset, Molière, Guitry, and so forth) then there is no room for argument: the theatre in French Canada is far advanced and of high quality. Fortunately conditions are so changing as to furnish our own playwrights with constant opportunities for training, and for the development of their own undeniable gifts in accordance with the generally accepted notion of a national art. So much so as to justify the hope, reinforced by the highly desirable help from both the Greater Montreal Arts Council and the National Arts Council, that within the next few years we may see the rise of a sustained and meaningful dramatic movement, capable of transcending political conflicts and of bringing about in mind and in fact that national unity which we all desire without knowing too well by what means we may achieve it. The participation of French-Canadian actors in the performances of Shakespeare's *Henry V* at the Stratford Festival may serve as an indication of that greater harmony and better understanding in our cultural as well as our national life.

Tradition and Change in French Canada

GUY SYLVESTRE

ALL THE PEOPLES of America share a common experience in having inherited a European culture, but in having themselves evolved in a setting marked by new dimensions. Their writers have always had to use a language received ready-made from somewhere else to give voice to geographical facts and historical events, to impressions, sentiments, ideas and aspirations which have something in common with those of other men, but which also have something quite different. American man is Western man, but he is no longer European man despite the umbilical cords still binding him to various mother-countries. This is true of French-speaking and of English-speaking Canadians alike. Both remain deeply attached to France and to Great Britain, but at the same time they are distinctly North American. Our country has a basic cultural duality, and it would be futile to deny that in this domain English-speaking and French-speaking Canadians, though no longer enemies, are strangers still. And yet a little study of the two Canadian literatures quickly reveals that they have followed parallel tracks, and that despite their inevitable differences they share common characteristics that have never been brought to light.

The time is overdue for some serious studies in comparative literature. Such studies will show that from Haliburton to Joyce Marshall or from Sangster to Layton, English-Canadian writing has numerous points in common with that produced from Gaspé to Langevin or from Crémazie to Anne Hébert. Such studies, combined with similar studies on social development, might heighten and enlighten our awareness of the deeper bonds which unite Canadians beneath their superficial dissimilarities. Most of our racial prejudices have no basis other than ignorance. Dissipation of this ignorance has become urgent.

Louis Hémon wrote that 'in Quebec nothing must change'. But many things have changed since *Maria Chapdelaine*, and change continues despite a solid attachment to the past. An unchanging society is a dead society, and French Canada seems very much alive, even if it does change more slowly in certain respects than the rest of the North American continent. The fact is that French Canada is undergoing a veritable social revolution, and many of the institutional changes involved are clearly mirrored in our arts and letters. This is not just

163

the straightforward progress expected of a young people. In some areas it involves a clear break with long-standing traditions, which are giving way before entirely new tendencies. This revolution is not total and it is not violent. Many traditions survive alongside the innovations. Some myths still remain while others are dying or being born, and this co-existence of old and new marks our time as an age of transition. It is easy to say where French Canada has come from; much less so to see where it is going.

These changes taking place within existing social structures are visible in almost all areas of life. While the material conditions of life have come almost everywhere to conform to North American standards, French Canada still falls within the French cultural domain, remaining attached to some degree to pre-Revolutionary France. Faith is still widespread, but it is less spontaneous and it is being re-examined in the light of new conditions. The attachment to France and to monarchical institutions is still profound, but it is less and less a matter of sentiment, more and more a matter of reason. Outside a few circles the myth of the superiority of agriculture has been practically destroyed by the industrialization of Quebec and the influx of the *habitants* into the cities. Meanwhile we may be witnessing the birth of a new myth, that of salvation through the workers' syndicates. Without turning their back on the humanities, secondary and university education are giving increased attention to the pure and applied sciences. In short, without repudiating its past or losing its distinctive characteristics, French Canada is evolving in conformity with the logic of its North American location.

These economic and social changes are reflected in the works of writers, artists and thinkers. Where Robert Choquette and Alfred Desrochers are still very close to Fréchette and Gill, Anne Hébert and Roland Giguère no longer have anything in common with the poets of preceding generations. Where Léo-Paul Desrosiers and Robert de Roquebrune represent a higher level of the art of Joseph Marmette and Laure Conan, Robert Élie and André Langevin owe nothing to our earlier novelists. Where Father Lachance and Charles de Koninck remain faithfully attached to the Thomist orthodoxy of Monsignor Louis-Adolphe Paquet, François Hertel and Jacques Lavigne have no precursors among our thinkers. Where Jacques de Tonnancour gives us portraits and landscapes reminiscent of the style of Goodridge Roberts, most of the younger painters are turning to non-representational painting. While continuing to

embody folk-tunes in their works, our composers have begun to write atonal or twelve-tone music, though these last have scarcely reached the larger public. These are only a few examples of the manner in which interpreters of French-Canadian life reflect contemporaneously survivals from the last century and observable changes in their individual and collective way of life. What is important here is not just the definite progress in art, writing or philosophy, but the deepening of both feeling and thought, and more important still the fact that new themes are being explored by most of the best writers, artists and thinkers. This is the kind of change that alters the very substance of a culture, not just its channels of communication. The real revolution lies here, and not in the introduction of new techniques of writing or composition.

It is impossible to grasp the range and significance of these changes without a glance into the past to recall certain geographical, historical, social, economic and cultural factors which have given French Canadians the distinctive characteristics that make them what they are. Any change, whether evolutionary or revolutionary, must have its starting-point in an existing situation, and this is just as true in the cultural realm as in any other. Once in a while a work may seem to spring to life by a kind of spontaneous generation—for genius gives more than it receives—but the general pattern of a literature, an art, or a culture is always largely conditioned by the environment in which these are born, grow, and die.

French Canadians are *Americans* living under a *British* system of government and speaking *French*. The combination of these three elements places them in a situation which is unique on this continent. There are just under five million of them in an immense country inhabited by more than eleven million English-speaking people and on a continent containing one hundred and seventy-five million. Though they have sent out shoots into all the other provinces and into the United States, as a group they are geographically confined, and this alone would suffice to explain their common tendency to retreat into themselves. But their history has also encouraged this retreat. Conquered in 1763, impoverished in men and in goods, threatened with absorption but determined in the face of all obstacles to retain their identity, the French-Canadian people have succeeded only because of their resistance to penetration, their conservatism, their attachment to their faith, and their high birth rate.

Geography and history explain why French Canadians have remained so deeply rooted in the past, so distrustful toward the new and strange. 'Our nationalism,' wrote Lorenzo Paré, 'is a defense mechanism. It is not a way of life.' French Canadians have felt almost nothing of the revolutionary current which brought American independence, the French Revolution, and the liberation of the Latin-American republics. As was emphasized by Henri-Irénée Marrou, they are 'almost the only people in the western world not to have on their conscience the head of a king'. Indeed, they were not yet British subjects at the execution of Charles I and they had ceased to belong to France before the decapitation of Louis XVI. When William Lyon Mackenzie revolted against royalist autocracy a brief surge of liberalism, excited by Papineau, stirred French Canada deeply; but order was quickly re-established, and for more than a century the history of Canada has been one of *evolution* toward sovereignty and independence.

The only *revolutions* have been the industrial and the economic, and in the main these have been carried out by others. Having contributed little but the work of their hands to this twofold revolution, French Canadians have been economically weakened by it. At the same time the political evolution in which they have played an important part, with Papineau, Lafontaine, Cartier, Laurier, Lapointe, Saint-Laurent, has made them politically strong. This rather considerable disparity between political strength and economic weakness further differentiates French Canadians from the English-speaking majority. Except in a few regions outside Quebec they enjoy the same rights as their English-speaking compatriots, but they have never had the financial means which would enable them to enjoy these rights to the same degree. They are a minority, a minority which is poorer than the majority, and it is only natural that they should display the collective character typical of minorities. The consciousness of their economic inferiority is all the more painful to them because they remember that they were the first white inhabitants of the country, and that for more than a century their ancestors were masters of a vast continent stretching from the Atlantic to the Rockies and from Hudson Bay to the Gulf of Mexico. It is not surprising that French Canadians suffer from nostalgia for the past, and that as a minority group they have been on the defensive. This nostalgia must be overcome.

After the British conquest British officers took over the administration of the colony, and the new English colonists took control of industry and commerce. French Canadians had to live either on the land or as employees of the English master. Hence the myth of the French-Canadian's agricultural 'vocation' and of the superiority of agriculture over industry and commerce, a myth which did not exist in New France and which was able to take root after the conquest only because commerce and industry were in the hands of the 'foreigners'. With the coming of the industrial revolution in the nineteenth century, moreover, French Canadians, lacking capital and without experience in big business, could contribute only their labour to the industrialization of Quebec. There are a few exceptions, but these only confirm the rule. Even today French Canadians own only a small part of the national wealth, despite some penetration into certain sectors of commerce and industry.

These are some of the geographical, historical, and economic factors which explain why, up to the First World War, French Canada remained primarily agricultural, and why those who worsened their situation in abandoning the land became proletarians either at home or in the United States. (The mass emigration of French Canadians to the United States in the nineteenth century, under the pressure of economic necessity, is one of the great tragedies of our history.) These same factors explain why those who left the land for better things directed their steps not toward science, engineering, industry or commerce, but toward the priesthood, medicine or law. In an agricultural society with an *élite* consisting of priests, doctors, lawyers and notaries, the so-called humanities naturally enjoy a greater prestige than the sciences; the *Georgics* or the *Méditations poétiques* are preferred to the *Origin of Species* or *The Wealth of Nations*.

Even today, despite the influx into the cities and the growth of commerce and industry, the myth of agriculture has not completely disappeared, and apostles of a back-to-the-land movement still exist. Until the last few years a slowly developing higher education was mainly occupied with furnishing an *élite* trained in the liberal professions to a people in great need of scientists, engineers, industrialists and business men. Things are gradually changing, however, and recently French-Canadian universities have for the first time graduated more engineers than lawyers. This move toward the sciences has been accelerated by the establishment of the combined Classics-Science diploma. Educational reforms are too new for their effects to be gauged, but it is clear that a significant number of the present generation of undergraduates are committing themselves to the sciences and it may be that the

traditional predominance of the humanities in French Canada is reaching its end.

Because the exploitation of natural resources and the great commercial enterprises were more or less closed to them, French Canadians have assumed an attitude of superiority in this regard, and have come to view English-speaking people as materialists while considering themselves to be devoted to things of the spirit. This has given birth to a facile and ill-founded messianic complex. An abundant literature rests on these myths, a literature made up entirely of those generalities and commonplaces which find a fertile field in a young country peopled by pioneers for whom thought is a luxury and research a waste of time and energy; —a country furthermore which had ready-made for it overseas a body of thought it could not hope to emulate.

The economic and pyschological factors which delayed the birth of independent thought and the blossoming forth of original works, and which were emphasized by the late E. K. Brown in his essay *On Canadian Poetry,* operated more forcefully in French Canada than in English Canada, though French Canadians did produce very early a kind of resistance literature for which the English-speaking majority had no motivation. François-Xavier Garneau wrote his history as a reply to Durham; Philippe-Aubert de Gaspé wrote *Les Anciens Canadiens* as an evocation of life under the old seigneurial system; Octave Crémazie wrote his poems for the purpose of stimulating patriotic feeling; Étienne Parent devoted pen and tongue to the service of French-Canadian interests. This defensive tradition dominated the whole literature of the nineteenth century and has survived, though with diminishing vigour, into the twentieth. The works of Louis Fréchette, Pamphile Lemay, Nérée Beauchemin, Joseph Marmette, Laure Conan, Canon Lionel Groulx, Jules-Paul Tardivel or Monsignor Camille Roy all breathe this same religious and patriotic fervour, this same worship of the past, this same myth of French Canada's agricultural 'vocation'. The first writers to be moved by an urge that was primarily aesthetic— men like Nelligan, Morin, Delahaye, Asselin, Fournier, Laberge or Henri d'Arles—looked for a long time like men who had lost their roots, men in revolt. Their style was admired, but they were considered something in the nature of outlaws because they did not fit into the tradition of the country where, as Louis Hémon said, 'nothing must change'.

But much has changed, and change continues.

The influx into the cities, above all since the First World War, has taken a million French Canadians out of the little parishes where life was organized within an immovable framework set by traditional canons, and has placed them in cities where they have often found themselves alone in the midst of the crowd and lost in a complex world for which they were totally unprepared. Ringuet's novel *Le Poids du jour* analyses at length this disturbance of the emotional balance in a Canadian brought up in a peaceful little village and thrown into the hostile world of the metropolis. Clément Marchand's *Soirs rouges* has the same central theme, and it is to be found again in several other recent works. The idyllic vision of rural life presented to us by a whole moralistic literature running from *Jean Rivard* by Antoine Gérin-Lajoie to *Sources* by Léo-Paul Desrosiers is outmoded today. As a matter of fact it has provoked a rather violent reaction which, true to the trend of the times, has found expression in several novels, from Ringuet's *30 Arpents* to André Langevin's *Le Temps des hommes,* and including *La Fille laide* by Yves Thériault and *Neuf Jours de haine* by Jean-Jules Richard. The idealized picture of French Canada found in almost all writing up to 1930 is scarcely visible in the more recent works. Literature has ceased to be a vehicle for religious, patriotic or social preaching; raising itself to the level of an art, it has become an instrument of moral and intellectual awareness, both individual and collective. In short, writers no longer portray man as one would like him to be but as he is, often laying more stress on his blemishes than on his virtues.

Several of our best writers are now engaged in the kind of concerted attack which the persistence of these traditional myths invited. A cathartic was indicated, for an organism often needs purging before it can be restored. Every great work of construction demands a solid foundation, and this in turn entails some clearing away and digging. Certain writers have seemed to be only grave-diggers—Pierre Baillargeon and Jean Simard, for example, though the latter has recently shown in his *Mon Fils pourtant heureux* that freedom can be won by dint of a painful self-discipline. Others, while not builders, have cleared the air with well-aimed satires like the first two novels of Roger Lemelin. Still others, like Robert Charbonneau, André Giroux and Robert Élie, have sought the light in an exploration of the darkness. Of all our writers the one who has best overcome both inner demons and worldly temptations to the point of attaining a genuine spiritual balance is Gabrielle Roy who, having painted in *Bonheur d'occasion* a

social fresco coloured by a deep humanitarianism, portrayed in *Alexandre Chenevert* a simple man who bears without false pathos or ostentation the whole weight of his destiny and his age. But most of our writers, though conscious of the taboos which paralyse them and dimly aware of the path that leads to the light, are still struggling in the dark.

Félix-Antoine Savard, for one, has tried to re-awaken some of Louis Hémon's ideological themes in *Menaud, maître-draveur,* a sort of prose epic which is one of our finest books, but completely out of tune with the feeling of our time. The dominant feature both of poetry and of the novel in recent years is the testimony of a terrible spiritual solitude, a tragic search for joy and love in a world that has lost all feeling for either one. Scepticism toward education, the rejection of middle-class moral values, the experience of social bankruptcy, the obstacles in the way of any real harmony between man and woman, the temptation to murder and suicide, the consciousness of spiritual frustration, and the haunting presence of God—these are the themes to be found again and again in the poems of Alain Grandbois, the novels of Robert Charbonneau, the journal of Saint-Denys-Garneau, the novels and plays of Robert Elie. Nowhere in English-Canadian writing, except perhaps in a few of the poets, do I find so urgent a spiritual quest or so tragic a picture of life. Most of these dark themes are found again in the works of André Giroux, André Langevin, Anne Hébert, Roland Giguère, Marcel Dubé and many others, matched, it is true, by a no less genuine experience of joy and love, as with Rina Lasnier or Germaine Guèvremont. The fact remains that pessimism is one of the dominant traits of recent French-Canadian writing, as the mere titles of the works serve to indicate: *Le Gouffre a toujours soif* (The Bottomless Pit), *Le Tombeau des rois* (The Tomb of Kings), *Poussière sur la ville* (Dust over the City), *Les Îles de la nuit* (Islands of the Night), *La Fin des songes* (Farewell, My Dreams), *Présence de l'absence* (Ever-present Absence), *Un Fils à tuer* (A Son to Kill), *La Coupe vide* (The Empty Cup), *Neuf Jours de haine* (Nine Days of Hate), *Impasse* (Dead End), *La Fille laide* (The Ugly Daughter), *Les Inutiles* (The Useless), *La Mort à vivre* (Death to be Lived), *Le Ciel fermé* (The Heavens Are Closed). All this forms a rather lugubrious symphony, and Canadian writing today is unquestionably as blackly pessimistic as French or German writing, though in a different way.

It is in the novel and in poetry that French-Canadian literature is asserting itself today, but noteworthy progress has also been made in other fields. Dramatic production remains skimpy, despite the qualities to be found in men like Paul Toupin or Éloi de Grandmont. The only works to have had any great success—*Tit-Coq* by Gratien Gélinas and *Zone* by Marcel Dubé—are still very close to folk-lore, and while one may take pleasure in seeing them played one cannot read them without being disconcerted by their use of language. But if French Canada is producing few dramatic works it is consuming a great many, particularly in Montreal, where several companies can now continue the same play through ten, twenty, or fifty performances. It is possible too that television may encourage the production of important dramatic works. It is at all events a social phenomenon whose eventual effects cannot yet be foreseen. On the one hand it is certain to encourage artists and writers, but it seems no less certain to engender a passive attitude which can be ruinous and a standardization of taste which may weaken the basic individualism of the French Canadian. With rare exceptions nothing too elevated or too original, nothing too profound or too daring, can find an outlet through the mass media: the greatest genius will always take second place to Maurice Richard, Edouard Carpentier or Guillaume Plouffe. But this is no less true elsewhere.

The rarefied esoteric meditations of Alain Grandbois, the quick nervous probings of Anne Hébert into the realm of death, the journey of Robert Élie to the end of night or the adventurous inner life of Alexandre Chenevert are scarcely to be found in other fields of literature, which are in any case ill-suited to this kind of theme. A possible exception is the essay, a field still uncultivated in this country. The essay demands a sharpness of thought and a suppleness of style usually found only in the great ages of civilization, and we have not reached that point. But philosophical writing, which for more than half a century was occupied with commentaries on Saint Thomas or Duns Scotus, seems to be beginning to take a more personal turn, first timidly with François Hertel, then resolutely with Jacques Lavigne whose *L'Inquiétude humaine* is a masterful book. Just as the novelists and poets have turned their back on the romantic *clichés* and wrung the neck of eloquence, so the thinkers, sociologists and historians are beginning to shun ready-made ideas, facile generalizations, and the traditional myths. Eloquence is no longer in style; neither is personal journalism, patriotic economics, or moralizing sociology. While poetry and the novel are becoming the personal adventure of the author, academic writing, on the contrary,

is becoming coldly objective. Both of these are moves in the right direction.

Roger Duhamel would not venture today to indulge in the kind of polemics waged by Honoré Beaugrand in the early issues of the same journal; *Le Fédéralisme canadien* of Maurice Lamontagne has none of the heat which Edouard Montpetit once injected even into economics; the sociological studies of the school of Father Lévesque confine themselves to observation and statistics and shun the futile preaching which was too long the fashion; our parliamentarians, with few exceptions, now prefer the documented case to the oratorical flight; and our historians, now able to draw upon fuller and better organized archives, keep close to source material and eschew approximations. To be persuaded of this it is sufficient to compare a book by Guy Frégault with one by Chapais. At the same time it is unfortunate that historians continue to be so fascinated by the great figures of New France as to neglect almost entirely our history since 1763. We still lack major biographies covering the lives of Papineau, Lafontaine, Cartier, Laurier, Lapointe and others. The progress achieved in the social sciences is matched by that of the natural sciences. A real scientific awakening is evident at Montreal, Quebec and Ottawa, where faculties of science and schools of engineering are developing rapidly in an effort to overtake the English-Canadian lead in these fields.

There is assuredly strong evidence of considerable recent progress in all realms of intellectual life. For one thing it is clear that our very best works have begun to command the kind of attention from other countries which bespeaks a recognition of intrinsic merit rather than a mere courtesy dictated by fellow-feeling. The acclaim received in Paris by people like Gabrielle Roy and Alfred Pellan confirms us in our consciousness of having reached maturity. True, we have yet to give the world a Balzac or a Baudelaire, a Pascal or a Molière, a Chardin or a Debussy, a Pasteur or a Le Play. But our country is not alone in having failed to produce men of this stature, and if we know we have added little to the cultural heritage of mankind, we know too that we have begun to have something to say and are learning how to say it. At the present juncture an excessive optimism would be as damaging as a gloomy pessimism.

For a long time the question was whether French Canadians would maintain their identity or be assimilated. This is no longer the question today. Henceforth the only question is to what extent they will remain French and to what degree they will become North American. Certainly they have been strongly influenced by American civilization, particularly on the material plane, but just as certainly has the language barrier given them an immunity not enjoyed by English-Canadians to the more unfortunate aspects of American influence, particularly on the cultural level. The mass media of French Canada—newspapers, magazines, radio, television, motion pictures—have felt American influence much less than have those of English Canada. Culturally, French Canada today is closer to France than English Canada is to Great Britain. This does not mean that French-Canadian literature is merely a pale image of French literature, for it bears the imprint of a different human experience: Montreal is not Paris; but it does mean that its thoughts and feelings tend no less than its modes of expression to be attuned to the French genius. Such is its unique character: an *American* literature written in *French* in a *British* country. It expresses a world of dimensions unknown in France and gives voice to a people who have adopted almost all American inventions and who share a civilization which is no longer that of the Old World. In short, it unveils the countenance of a complex man: a man with his feet on American soil but, as René Garneau has phrased it, 'with France in his blood and under his skin'. This fusion of new social elements and old cultural values will give a new human synthesis, whose birth recent writing has heralded without yet being able to express its character with clarity and force. One thing is certain, and that is that this interplay of French tradition and American material makes of French Canada a distinct entity whose literature and art have a flavour unique in North America.

Contributors

MALCOLM ROSS is Head of the Department of English, Queen's University; President of the Humanities Association of Canada (1956-8), and Fellow of the Royal Society of Canada. He was editor of *Queen's Quarterly* (1953-6). His previous books include *Milton's Royalism*, *Poetry and Dogma* and *Our Sense of Identity*.

ROBERT AYRE, co-editor of *Canadian Art*, is in charge of motion picture and television production distribution for the Public Relations Department of the Canadian National Railways. Mr Ayre is art critic of the *Montreal Star* and has contributed articles and fiction to leading Canadian and American journals.

WILLIAM S. A. DALE, curator of the Art Gallery of Toronto, is the author of many articles and reviews in leading art journals. He was on the staff of the National Gallery of Canada from 1950-7 and from 1951-5 was lecturer in Fine Arts at Carleton University, Ottawa. Dr Dale is a member of the College Art Association of America, the Mediaeval Academy of America and the Royal Society of Arts.

JOHN BECKWITH, a lecturer in the Faculty of Music, University of Toronto (Royal Conservatory of Music), is the composer of about sixteen works, including a chamber opera, *Night Blooming Cereus*. He has organized several series of recorded music programmes for the CBC, has served as public relations director for the Royal Conservatory of Music of Toronto and as secretary of the Canadian League of Composers. Mr Beckwith has contributed critical essays to such volumes as *Music in Canada, The Culture of Contemporary Canada* and *Encyclopedia Canadiana*. His articles and reviews have appeared in *University of Toronto Quarterly, The Canadian Music Journal, CBC Times*, etc.

KEN JOHNSTONE is a free-lance writer for *Maclean's* and *Weekend Magazine* as well as translator and coach for the English version of CBC's *The Plouffe Family*. Mr Johnstone has worked for leading newspapers and journals in Britain and North America, was for several years a member of the National Film Board staff, and acted as production manager for the English version of *Tit-Coq*. He has for a number of years been a regular correspondent for the New York magazine *Dance News*.

BOYD NEEL, since 1953 the Dean of the Royal Conservatory of Music of Toronto, founded the internationally famous Boyd Neel Orchestra in 1933. Dr Neel has conducted most of Europe's leading orchestras as well as the Sadler's Wells and D'Oyly Carte Opera Companies and the English Opera Group. In the New Year's Honours List of 1953, he was made a Commander of the British Empire for his services to British music. His Hart House Orchestra (Toronto) was formed in 1953.

MAVOR MOORE, actor, producer, playwright, is equally at home in the theatre, radio and television. His best-known writing includes the play *Who's Who*, the musicals *Sunshine Town* and *The Optimist*, and the television plays *Catch a Falling Star* and *The Son*. He has directed over fifty plays as well as the New Play Society's annual *Spring Thaw* revue. In 1957 he received the award of the Canadian Council of Authors and Artists for 'distinguished contribution to Canadian television'.

JEAN BÉRAUD (JACQUES LAROCHE) is Editor of the Drama, Music Literature and Film section of the Montreal newspaper *La Presse*. His published works include *Initiation à l'Art Dramatique*; *Variations sur Trois Thèmes* (in collaboration with Marcel Valois and Léon Franque); *350 ans de théâtre au Canada français*; and the one-act play *Monsieur Chauvain*. M. Béraud is a member of the Critics' Circle of Montreal.

NORTHROP FRYE, Chairman of the Department of English, Victoria College, University of Toronto, is the author of *Fearful Symmetry* and *Anatomy of Criticism*. Since 1950 he has written the annual survey of Canadian Poetry for 'Letters in Canada' (*University of Toronto Quarterly*). In 1958 he was awarded the Lorne Pierce Medal by the Royal Society of Canada for literary achievement. His critical essays have appeared in leading journals throughout the world.

C. T. BISSELL, President of the University of Toronto, since 1947 has contributed the annual survey of Canadian fiction to 'Letters in Canada' in the *University of Toronto Quarterly*. Dr Bissell has published critical articles on Butler, Shaw and George Eliot and is the editor of *University College: a Portrait* and *Our Living Tradition*. He was for two years a member of the Board of Governors of the Stratford Shakespearean Festival and is a director of the Australian-Canadian Association. Since 1956 he has been adviser on Canadian articles for the *Encyclopaedia Britannica*.

F. E. L. PRIESTLEY, Professor of English, University College, University of Toronto, is one of the authors of the recent *Science and the Creative Spirit*. He has published many articles in learned journals, mostly studies of nineteenth-century literature, particularly Browning. His three-volume edition of William Godwin's *Enquiry Concerning Political Justice* appeared in 1946. Professor Priestley is a member of the Board of Directors of the *Journal of the History of Ideas*.

GUY GLOVER, Executive Producer of the National Film Board, has collaborated in the production of many short films. Since 1954 he has been associated with the National Film Board's television section. In 1956 he became producer of the Board's French Language TV unit, a position which he held until 1958. Mr Glover is also a poet, an experienced actor and theatre director. He has taken an active part in the development of ballet in this country and is a director of the Canadian Ballet Festival Association.

GUY SYLVESTRE, Associate Librarian, Library of Parliament, Ottawa, is the author of *Louis Francoeur journaliste, Situation de la poésie canadienne, Anthologie de la poésie canadienne d'expression française*, etc. He has held a number of government posts and was a Canadian delegate to the fourth session of UNESCO in 1949. His book reviews appear regularly in the Ottawa newspaper *Le Droit*.

WARNETT KENNEDY, the Vancouver architect and planning consultant, is executive director of the Architectural Institute of British Columbia. Born and educated in Glasgow, Scotland, Mr Kennedy was Chief Designer for display for the 'Power and Production' building at the Festival of Britain, 1951. He is a member of the Royal Architectural Institute of Canada and the Society of Industrial Artists, an associate member of the Town Planning Institute and an associate of the Royal Institute of British Architects.

A. T. GALT DURNFORD, a senior partner of Durnford, Bolton, Chadwick and Ellwood (Architects), Montreal, was President of the Canadian Handicrafts Guild 1955-7. He is a Fellow of the Royal Architectural Institute of Canada, an Associate of the Royal Canadian Academy, an Associate of the Royal Institute of British Architects and a member of the Province of Quebec Association of Architects.

GLEN SHORTLIFFE, who made the English translations of the articles by Jean Béraud and Guy Sylvestre, is Professor of French at Queen's University and was recently appointed editor of *Queen's Quarterly*.

Picture credits

KEN BELL 34 (Innukpuk), 54, 58, 59 (Dark of the Moon), 65, 138

DAVID BIER 120

CAMPBELL AND CHIPMAN 59 (Roundelay), 135

CANADIAN ARCHITECT 139 (Yorkminster United Church), 140 (Ortho Pharmaceutical Building)

CAPITAL PRESS 40 (Price)

PAUL DAVIS 37

DWIGHT E. DOLAN 78

GLOBE AND MAIL 69

ALEX GRAY 63, 64

RICHARD HARRINGTON 159

IMPERIAL OIL 20 (Wilson), 106, 109, 110

R. KAYAERT 140 (Canadian Pavilion, Brussels)

ROY MARTIN 66 (Turn of the Screw)

JEAN GAINFORT MERRILL 39 (Wyle)

NEWTON 34 (Kahane)

HERB NOTT 73 (Hamlet), 74

PANDA 139 (Parkin Residence), 142 (Shopping Centre, Don Mills)

HENRI PAUL 80

FRED PHIPPS 117

MAX SAUR 75

JOHN STEELE 71

PAGE TOLES 118

Index

Adams, David, 54, 57, 59
Adaskin, Murray, 45, 47
Agostini, Lucio, 121
Akeeaktashook, 35, 158
Alarie, Amanda, 120
Allan, Andrew, 72, 121
Allen, Ralph, 96
Allen, Robert, 118
Allen, Ted, 70, 72
Allward, Walter, 36
Ambrogi, Michel, 82, 162
Ambrose, Kay, 57
Anderson, Fulton, 100
Anderson, Patrick, 89
Anderson, Robert, 104
Anderson, W. H., 44
Anhalt, István, 47
Apine, Irene, 59
Applebaum, Louis, 57
Archambault, Louis, 14, 34, 36, 37, 41
Arles, Henri d', 129, 166
Armstrong, Kay, 57
Asselin, Olivar, 129, 166
Association des Artistes Non-Figuratifs, L', 12
Association of Canadian Industrial Designers, 150
Avison, Margaret, 87
Ayre, Robert, 2, 4, 5, 9, 170

Bailey, Alfred, 87, 88
Baillargeon, Pierre, 130, 166
Bain, Conrad, 74
Banff School of Fine Arts, 58
Barbeau, Marius, 48
Barker, Arthur, 100
Barkley, Beverley, 59
Barrett, Cynthia, 60
Barry, Fred, 81
Beauchemin, Nérée, 129, 166
Beaugrand, Gilles, 158
Beaugrand, Honoré, 131, 168
Beaulieu, Paul, 16
Beckwith, John, 3, 4, 5, 44, 170
Bellefleur, Leon, 26, 27, 29
Beny, Roloff, 9, 10, 14, 23
Béraud, Jean, (Jacques LaRoche), 3, 4, 78, 160, 170
Bergeron, Suzanne, 30
Berlin, Eugenia, 39
Berton, Pierre, 111
Biéler, André, 29
Biennial Exhibition of Canadian Painting, 16, 30
Biggs, Julian, 108
Binning, B. C., 14, 19
Birney, Earle, 48, 88, 95

Bissell, C. T., 2, 5, 92, 171
Blachford, Hugh W., 141
Blackburn, Maurice, 64
Blatz, William, 121
Bobak, Bruno, 12, 29
Bobak, Molly, 16
Bochner, Lloyd, 121
Boeschenstein, Hermann, 100
Boisvert, Reginald, 107
Borduas, Paul-Émile, 2, 5, 12, 14, 15, 16, 19, 20
Boyle, Harry, 72, 121
Braden, Bernard, 70, 121
Brandtner, Fritz, 15, 19, 22, 26
Brieger, Peter, 100
Brind'Amour, Yvette, 82, 162
Brockington, Leonard, 121
Brooker, Bertram, 5, 6, 15
Brott, Alexander, 45, 47
Brown, E. K., 86, 100, 129, 166
Buchanan, Donald W., 16
Buckler, Ernest, 94
Bulow, Karen, 157
Bushnell, E. L., 121

Cable, Howard, 121
Cahen, Oscar, 14
Caiserman, Ghitta, 11, 29
Callaghan, Morley, 72, 92, 93, 94
Canada Council, 2, 3, 12, 58, 76
Canadian Arts Council, 2, 6
Canadian Ballet Festival, 56
Canadian Broadcasting Corporation, 45, 60, 66, 108, 116-24
CBC Opera Company, 65
Canadian Ceramics Exhibition, 158
Canadian Conference of the Arts, 6
Canadian Folk Music Society, 48
Canadian Group of Painters, 11, 17
Canadian Handicrafts Guild, 35, 156
Canadian League of Composers, 44, 45
Canadian Music Journal, 51
Canadian Players, The, 75
Canadian Repertory Theatre, Ottawa, 71
Canadian Society of Creative Leathercraft, 158
Canadian Theatre Centre, 76
Caplan, Rupert, 121
Carman, Bliss, 84, 87
Carr, Emily, 12, 26, 84
Carter, Carlu, 55
Champagne, Claude, 45, 47
Chapais, J. A. T., 131, 168
Chapman, Christopher, 110, 111
Charbonneau, Robert, 130, 166, 167
Charpentier, Gabriel, 47
Chilcott, Barbara, 71

Child, Philip, 94
Chiriaeff, Ludmilla, 59
Choquette, Robert, 127, 164
Christmas, Eric, 74
Clark, A. F. B., 100
Clayton, Bond & Mogridge, 143
Coburn, Kathleen, 99
Cochrane, C. N., 99
Cohen, Nathan, 72
Colville, Alexander, 24, 29
Comédie-Canadienne, La, 59, 76, 80, 161
Comfort, Charles, 17, 26
Compagnons (de Saint-Laurent), Les, 79, 161
Conan, Laure, 127, 129, 164, 166
Connor, Ralph. See Gordon, Charles William
Conseil des Arts de la région métropolitaine de Montréal, Le, 82
Constant, Maurice, 112
Cornish, John, 96
Cotes, Sarah Jeanette Duncan, 92
Coulter, John, 70, 72
Coulthard, Jean, 45, 51
Cox, Elford, 34, 39, 41
Crawley, F. R., 104, 106, 107, 109
Crawley Films, 104
Creighton, Donald, 99
Crémazie, Octave, 126, 129, 163, 166
Crest Theatre, Toronto, 71, 75, 76

Dagenais, Pierre, 80, 162
Dale, William S. A., 2, 34, 170
Dallaire, Jean, 30
Daly, Tom, 104
Daniells, Roy, 87, 88
Dansereau, Fernand, 107
Daoust, Sylvia, 35, 39
Davey, George, 158
Davies, Robertson, 71, 72, 76, 95
Davis, Donald, 71
Deichman, Erica, 158
Deichman, Kjeld, 158
Delahaye, Guy, 129, 166
de la Roche, Mazo, 70, 72, 92, 93
Denison, Merrill, 71
Desrochers, Alfred, 127, 164
Desrosiers, Léo-Paul, 127, 129, 164, 166
Devitt, H. E., 158
Devlin, Bernard, 107
Dickenson, Mary B., 158
Doherty, Brian, 70
Dominion Drama Festival, 38, 71
Donalda, Madame Pauline, 64
Donaldson, Francis, 144-5
Drainie, John, 121
Drolet, Françoise Desrocher, 156, 158

173

Index

Dubé, Marcel, 80, 81, 82, 130, 161, 162, 163, 167
Dudek, Louis, 87, 89
Duhamel, Roger, 131, 168
Dumouchel, Albert, 26
Durden, J. V., 112
Durnford, A. T. Galt, 2, 5, 156, 171

Élie, Robert, 95, 127, 130, 164, 166, 167
Elliott, A. J., 95
Équipe, L', 79, 80, 161, 162
Everyman Players, 71

Fairley, Barker, 100
Faith, Percy, 121
Farrally, Betty, 55
Festivals de Montréal, Les, 82
Filion, Armand, 41
Finch, Robert, 87, 88
Fischer, Juliette, 60
Fisher, John, 121
FitzGerald, LeMoine, 17
Flenley, Ralph, 100
Fontaine, Robert, 70
Foster, Dianne, 121
Fougère, Jean-Paul, 124
Fournier, Jules, 129, 166
Fox, C. H., 158
Fox, John, 30
Frache, Donald, 143
Fram, Michael, 64
Franca, Celia, 55, 56, 57, 58, 59
Fraser, Blair, 121
Fraser, Donald, 104
Fréchette, Louis, 127, 129, 164, 166
Freedman, Harry, 47, 48
Frégault, Guy, 131, 168
Frye, Northrop, 2, 4, 5, 84, 100, 171

Gagnon, Clarence, 30
Garant, Serge, 47
Gardiner, Thornton, Gathe & Associates, 139
Garneau, François-Xavier, 129, 166
Garneau, René, 131, 168
Gascon, Jean, 82, 162
Gaspé, Philippe-Aubert de, 126, 129, 163, 166
Geiger-Torel, Herman, 63
Gélinas, Gratien, 59, 69, 70, 72, 76, 78, 79, 80, 81, 82, 112, 130, 161, 162, 163, 167
Genest, Émile, 120
George, Graham, 51, 64
Gérin-Lajoie, Antoine, 129, 166
Gerussi, Bruno, 118
Gervais, Leo, 158
Gibbs, Terence, 65
Giguère, Roland, 19, 26, 127, 130, 164, 167
Gill, Charles, 127, 164
Gilmour, Clyde, 112
Ginsberg, Donald, 108
Giroux, André, 130, 166, 167
Glover, Guy, 3, 4, 59, 104, 171
Goldsmith, Sidney, 105
Gordon, Charles William, (Ralph Connor), 92
Gordon, Hortense, 14
Gotshalks, Jury, 59
Goudge, T. A., 100
Gouin, Lomer, 81, 162
Gould, Evelyn, 64

Graham, John, 56
Grand, Elaine, 117
Grand Opera Company, Ottawa, 64
Grandbois, Alain, 130, 167
Grandmont, Éloi de, 80, 81, 130, 162, 167
Grands Ballets Canadiens, Les, 59
Grant, Douglas, 99
Gratton, Hector, 45, 57
Gray, John, 76
Gray, Theresa, 63, 66
Greater Montreal Arts Council, 163
Greber, Jacques, 147
Green, Blankstein, Russell & Associates, 135
Greenberg, Charles, 140
Greene, E. J. H., 100
Greene, Lorne, 70, 121
Grierson, John, 104, 108
Groulx, Canon Lionel, 129, 166
Group of Seven, 9, 11, 12, 15, 30, 38
Grove, Frederick Philip, 92, 93
Grube, G. M. A., 100
Guèvremont, Germaine, 130, 167
Guèvremont, Paul, 120
Guthrie, Tyrone, 5, 72, 74, 75

Hahn, Emanuel, 36, 39
Hailey, Arthur, 124
Haldane, Don, 108
Haliburton, Thomas Chandler, 126, 163
Harris, Joey, 57, 59
Harris, Lawren, 15, 17, 19, 23, 26, 28
Harron, Donald, 70, 72, 76, 121
Hart, Harvey, 60
Hébert, Anne, 126, 127, 130, 163, 164, 167
Hébert, Henri, 36
Hébert, Julien, 36
Hébert, Louis-Philippe, 36
Heeley, Desmond, 74
Helpmann, Max, 71
Hémon, Louis, 126, 129, 130, 163, 166, 167
Herlie, Eileen, 74
Hertel, François, 127, 131, 164, 167
Hine, Daryl, 90
Hodgson, Tom, 13
Hodgson, W. G., 158, 159
Hoffmann, Guy, 80
Honigman, Saul, 57
Horne, Cleeve, 39
Horton, John, 74
Humphrey, Jack, 14, 17, 21
Hutt, William, 74
Hyland, Frances, 73
Hyrst, Eric, 59

Iliu, Josef, 14
Innukpuk, Johnny, 34
Israel, Charles, 108
Ivey, Joanne, 64

Jackson, A. Y., 11
Jarvis, Alan, 19
Jarvis, Donald, 33
Jarvis, Lilian, 58
Joachim, Otto, 5, 46, 47
Jodoin, René, 112
Johnson, A. H., 100
Johnston, F., 151
Johnston, George, 87

Johnstone, Ken, 3, 54, 170
Joliat, Eugène, 100
Jones, Jacobine, 38, 41
Joudry, Patricia, 70
Journal Musical Canadien, 51
Journal of the Royal Architectural Institute of Canada, 41
Jukes, Mary, 70, 76
Jupiter Theatre, 72
Jutra, Claude, 107

Kahane, Anne, 34, 36, 40, 41
Kaiser, Robert, 152
Kakinima, Thomas, 158
Kasemets, Udo, 47
Kelly, Barbara, 70, 121
Kenins, Talivaldis, 47
Kennedy, Leo, 87
Kennedy, Sybil, 39
Kennedy, Warnett, 3, 134, 150, 171
King, Allan, 108
Kirkpatrick, Joyce, 74
Klein, Abraham M., 2, 88, 89, 94
Knapp, Budd, 121
Koenig, Wolf, 111, 113
Koninck, Charles de, 127, 164
Kopee, 158
Kraul, Earl, 58
Kreisel, Henry, 94
Kroitor, Roman, 111
Kvietys, Yone, 60

Lachance, Père, 127, 164
Laliberté, Alfred, 36
Lambert, Ron, 14
Lampman, Archibald, 84, 86, 87, 88
Langevin, André, 95, 126, 127, 129, 130, 163, 164, 166, 167
Langham, Michael, 73, 74
Lasnier, Rina, 130, 167
Lavallée, Calixa, 49
Lavigne, Jacques, 127, 131, 164, 167
Layton, Irving, 88, 89, 126, 163
Leacock, Stephen, 72, 74, 92
Leclerc, Félix, 81, 82, 162, 163
Leduc, Fernand, 15, 22, 29
Leduc, Ozias, 30
Leese, Elizabeth, 57, 59, 60
Legault, Father Émile, 79, 161
Leicester, O. Howard, 141
Lemay, Pamphile, 129, 166
Lemelin, Roger, 82, 92, 95, 124, 130, 163, 166
Lemieux, Jean-Paul, 26, 30
Leo, Ulrich, 100
LePan, Douglas, 89, 90
Leslie, Bailey, 158
Letendre, Rita, 19
Létourneau, Jacques, 82, 162
Lévesque, Père, 131, 168
Limon, José, 60
Lismer, Arthur, 9, 11, 30
Livesay, Dorothy, 48, 87
Ljungh, Esse, 121
Lloyd, Gweneth, 54, 55, 56, 58
Lochhead, Kenneth, 25, 26
Lodge, R. C., 100
Long, Jack, 108
Loring, Frances, 36, 37, 38, 39, 41
Low, Colin, 104, 111, 112, 113
Luke, Alexandra, 14
Lyman, John, 30

174

MacCallum, H. R., 100
McCarthy, Hamilton, 36
McClure, Virginia, 158
Macdonald, Brian, 57, 59
Macdonald, Grant, 69
Macdonald, Jock, 14, 15, 23
MacDonald, Wilson, 86
MacDonnell, Fergus, 108
McGeachy, J. B., 121
McGill, Don, 59
McGrath, Bill, 55
MacKay, David, 122
MacKay, Louis, 87, 88
McLaren, Norman, 4, 30, 104, 105, 110, 111
McLean, Grant, 104
McLean, Ross, 117, 124
MacLennan, Hugh, 93
MacLure, Millar, 99, 100
MacMillan, Andrew, 63, 64
MacMillan, Sir Ernest, 45
MacMillan, Keith, 64
Macpherson, Jay, 90
Maddox, Diana, 74
Mallett, Jane, 121
Mann, Stanley, 70, 76
Marchand, Clément, 129, 166
Markle, Fletcher, 121
Marlyn, John, 5, 94
Marmette, Joseph, 127, 129, 164, 166
Marrou, Henri-Irénée, 128, 165
Marshall, Joyce, 126, 163
Martin, Shirley, 66
Masson, Henri, 31
Matière Chante, La, 16
Matte, Denys, 30
Matton, Roger, 47
Maxwell, Roberta, 74
Meek, T. J., 99
Melody Fair, 63
Mercure, Pierre, 47, 50
Milne, David, 12
Mitchell, Roy, 70
Mitchell, W. O., 121
Moiseiwitsch, Tanya, 73
Mol, Leo, 39
Moller, Ray, 57
Montpetit, Edouard, 131, 168
Montreal Festivals, 162
Montreal Repertory Theatre, 71, 79, 161
Montreal Theatre Ballet, 59
Moore, Brian, 96
Moore, Mavor, 2, 3, 5, 68, 71, 116, 170
Morawetz, Oskar, 5, 47
Morel, François, 47
Morin, Paul, 129, 166
Morrish, Anne, 118
Morrison, Frank, 64
Morrow, Arthur, 57
Mossop, J. Douglas, 151
Mousseau, Jean-Paul, 26, 29
Muhlstock, Louis, 17
Muir, Dalton, 112
Munamee, 35, 158
Munn, Kathleen, 15
Munro, Grant, 112
Murray, James A., 139

Nakamura, Kazuo, 25, 26
National Ballet, 54, 55, 56, 57, 58, 59, 60
National Film Board, 45, 104, 105, 107, 108, 111, 112, 113

National Gallery, 14, 16, 41
National Industrial Design Council, 150, 153
Neel, Boyd, 62, 170
Nelligan, Émile, 48, 129, 166
New Play Society, Toronto, 71, 72, 76
Nichols, Jack, 27, 30
Niverville, Louis de, 122
Norgate, Robert, 36
Norwood, Gilbert, 100
Nova Scotia Opera Association, 64
Noxon, C. S., 151, 152
Nugent, John, 158

Ogilvie, Will, 29
Oligny, Huguette, 81
Oliphant, Betty, 58
Opera Festival, Toronto, 63
Opera Festival Association, Toronto, 63, 64, 65, 66
Opera Guild, Montreal, 64
Opera School, Royal Conservatory of Music, 63
Oshweetok, 158

Page, P. K., 89
Page & Steele, 142
Painters Eleven, 12, 14
Palmer, Franklin, 30
Papineau-Couture, Jean, 45, 46
Paquet, Monsignor Louis-Adolphe, 127, 164
Paré, Lorenzo, 128, 165
Parent, Étienne, 129, 166
Parker, Gudrun, 104
Parker, Morten, 105, 111
Parkin, J. C., 139
Parkin, John B., Associates, 140, 142
Peck, Mrs James, 156
Peddie, Frank, 121
Pellan, Alfred, 2, 3, 5, 12, 14, 15, 16, 23, 24, 131, 168
Pelletier, Denise, 80, 120
Pelletier, Gerard, 107
Pelletier, Jacques, 82, 162
Pentland, Barbara, 45, 46
Pentland & Baker, 138
Pepin, Clermont, 47
Peterson, Len, 121
Phelps, Arthur, 121
Phillips, Mary, 156
Picher, Claude, 30
Pickthall, Marjorie, 85
Pierce, Judith, 66
Plaskett, Joseph, 5, 12, 14, 29, 30
Plummer, Christopher, 70, 73, 74
Porter, John, 139
Portugais, Louis, 107
Potten, Billy, 66
Pratley, Gerald, 105, 113
Pratt, E. J., 2, 48, 85, 86, 87, 88, 89
Prévost, Robert, 82, 162
Price, Arthur, 40, 41, 158
Priestley, F. E. L., 5, 98, 171
Prisme d'Yeux, 16

Rakine, Marthe, 14
Rathburn, Eldon, 111
Raymond, W. O., 100
Reaney, James, 90
Rebelles, Les, 16
Redsell, Pauline, 39

Refus Global, 16, 22, 23
Reid, W. A., 158
Reiser, Anna, 74
Renzius, Rudy, 158
Richard, Jean-Jules, 129, 166
Richler, Mordecai, 96
Rideau Vert, Le, 79, 81, 161, 162
Ringuet, 129, 166
Riopelle, Jean-Paul, 5, 12, 14, 17, 19, 22, 29
Roberts, Charles G. D., 84
Roberts, Goodridge, 12, 19, 30, 127, 164
Robins, Toby, 121
Ronald, William, 19, 26
Roquebrune, Robert de, 127, 164
Ross, Malcolm, 2, 100, 170
Ross, Sinclair, 94
Rouillard, C. D., 100
Roulston, E. N., 158
Roulston, M. L., 158
Roy, Monsignor Camille, 129, 166
Roy, Elyane, 30
Roy, Gabrielle, 92, 95, 130, 131, 166, 168
Royal Winnipeg Ballet, 54, 55, 56, 58, 59, 60
Ruberg, Endel, 158
Russell, Deane H., 151
Rutherford, Richard, 59

Sadowska, Krystina, 157, 158
Saint-Denys-Garneau, 130, 167
Salmon, E. T., 100
Salter, F. M., 100
Saltzman, Percy, 121
Sangster, Charles, 85, 126, 163
Savard, Félix-Antoine, 130, 167
Schull, Joseph, 121
Scott, Duncan Campbell, 84, 85, 86
Scott, Frank R., 86, 87, 89
Scott, Marian, 30, 31
Sculptors' Society of Canada, 36
Sedgewick, G. G., 100
Shadbolt, J. L., 3, 14, 15, 26, 29
Shaw, J. E., 100
Ship, Harold, 141
Ship, Reuben, 121
Shortliffe, Glen, 160, 171
Shuster, Frank, 121
Silva, Howard da, 58
Simard, Jean, 130, 166
Sinclair, Lister, 72, 73, 121
Smith, A. J. M., 86, 87, 89
Smith, Gordon, 16, 26
Smith, Leo, 44
Smith, Lois, 54
Smith, Nellie, 63
Somers, Harry, 46, 47, 48, 57, 64
Souster, Raymond, 87, 89
Spiller, Frank, 112
Spohr, Arnold, 55, 56
Stacey, Harold, 158
Stella, Le, 79, 161
Stewart, Donald, 39
Stoneham, Jean, 55
Strate, Grant, 57
Stratford Shakespearean Festival, 69, 72, 73, 74, 75, 76, 82, 163
Sturgess, Sydney, 74
Surdin, Morris, 121
Sutherland, John, 88
Suzor-Coté, M. A., 36
Sylvestre, Guy, 4, 126, 163, 171

Index

Tamosaitiené, Mrs A., 157
Tanabe, Takao, 14, 29
Tanguay, Georges-Émile, 45
Tardivel, Jules-Paul, 129, 166
Taylor, W. R., 99
Théâtre du Nouveau Monde, Le, 80, 81, 82, 162
Theatre Under the Stars, Vancouver, 64, 71
Théâtre-Club, Le, 81, 162
Thériault, Yves, 81, 82, 129, 162, 163, 166
Thomas, Lionel, 14
Thompson, Berwick & Pratt, 137
Thomson, Tom, 9, 84
Tikketuk, 35
Tonnancour, Jacques de, 21, 30, 127, 164
Toupin, Paul, 80, 81, 130, 161, 162, 167
Town, Harold, 3, 5, 14, 18, 26
Tracy, Clarence, 99
Trethewey, W. H., 99
Trottier, Gerald, 25, 26
Truchnovsky, Rose, 156, 158

Tungeelik, 158
Turgeon, Bernard, 66
Turnbull, Deborah, 74
Turnbull, Rupert Davidson, 15
Tweed, Tommy, 121

Urquhart, Tony, 30

Valcour, Pierre, 120
Vancouver International Festival, 62, 73, 75
Varley, Fred, 9
Voaden, Herman, 64
Volkoff, Boris, 56, 58
Von Gencsy, Eva, 55, 59

Wakelyn, Virginia, 59
Walter, Dr Arnold, 63
Wargon, Alan, 108
Water Colour Painters, 17
Watson, Sidney, 19
Watson, Wilfred, 89, 90
Wayne, John, 121

Webber, Gordon, 19, 75
Weintraub, William, 108
Weinzweig, John, 45, 46, 47, 49, 121
Whalley, George, 100
Whitehead, Alfred, 44
Wilder, Don, 108
Wilkinson, Anne, 90
Wilkinson, B., 100
Willan, Healey, 44, 45, 64
Willis, J. Frank, 121
Wilson, Ethel, 96
Wilson, R. York, 17, 20
Winnipeg Ballet. *See* Royal Winnipeg Ballet
Winnipeg Ballet Club, 54
Winnipeg School of Art, 14
Wiseman, Adele, 5, 94, 96
Withers, Ken, 59
Wood, A. Campbell, 141
Wood, Elizabeth Wyn, 6, 38
Woodhouse, A. S. P., 99
Woollven, J. B., 158
Wyle, Florence, 37, 39

Production credits

Designer LESLIE SMART

Lithographer ROLPH-CLARK-STONE

Binder T. H. BEST PRINTING COMPANY

Types TIMES ROMAN AND PERPETUA

Paper ROLLAND SUPERIOR OFFSET